The Claude Glass

The Claude Glass

*Use and Meaning of the Black Mirror
in Western Art*

Arnaud Maillet

Translated by Jeff Fort

ZONE BOOKS · NEW YORK

2009

Published with the assistance of the Getty Grant Program.
© 2004 Urzone, Inc.
ZONE BOOKS
1226 Prospect Avenue
Brooklyn, New York 11218

Printed in the United States of America.

Distributed by The MIT Press,
Cambridge, Massachusetts, and London, England

Library of Congress Cataloging-in-Publication Data

Maillet, Arnaud.
 [Miroir de Claude. English]
 The Claude glass: use and meaning of the black mirror in western art / Arnaud Maillet; translated by Jeff Fort.
 p. cm.
 Includes bibliographical references and index.
 ISBN 978-1-890951-48-1
 1. Claude glasses. 2. Landscape painting – Technique.
 3. Reflection (Optics). I. Title.

ND1505.M35 2004
751. 7'7'0284 – dc21 2004049072

Contents

To Yves and Sophie Rifaux, Yves who would surely have slipped away if he had had to pass through a door into another world a certain full-moon night in the little chapel of Saint-Martin, near Laives, in Burgundy

Acknowledgments

My first idea was to thank all the people who never answered my letters, but I shrank from such a long list! Instead, I much prefer to warmly thank all those who had the kindness to do so. This little publication — which, although modest, at least exists — is addressed to them. Such an approach allows me to redistribute the information thus collected to all those who helped me. Although still imperfect, this essay will be part of a thesis titled *Les Peintres et les instruments d'optique depuis la seconde moitié du XVIIIe siècle* (Painters and optical instruments since the second half of the eighteenth century). It goes without saying that any new information, and of course any criticism, especially the most unsparing, will be welcome.

I address my warmest thanks to Laure Beaumont-Maillet, head curator of the Print and Photography Department at the Bibliothèque Nationale de France, who during my fifth-year internship helped me to navigate through her department and readily mediated with other curators.

Among all those mentioned in the course of this study, the following people deserve special thanks: Anne Baldassari, curator of the Musée National Picasso, Paris; Renato Berta, cinematographer, Paris; Lars Kiel Bertelsen, assistant professor, University of

Aarhus; Neil Brown, senior curator of the Department of Classical Physics, Science Museum, London; Hubertus Butin, assistant to Gerhard Richter, Cologne; Françoise Cachin, retired director, Musée de France, Paris; Dr. Mario Ciolek, ophthalmologist, Paris; Professor Philippe Comar, Ecole Nationale Supérieur des Beaux-Arts, Paris; Jean-Louis Constanza, Paris; Professor Jonathan Crary, Columbia University, New York; Professor Rupert Feuchtmüller, University of Vienna; Professor John Gage, Cambridge University; Anthony Griffiths, curator in the Department of Prints and Drawings, British Museum; Dr. Gisela Hopp, honorary curator of the Department of Prints and Drawings, Kunsthalle, Hamburg; Paul Jay, former director of the Musée Nicéphore Niépce, Chalon-sur-Saône; Professor Martin Kemp, Oxford University; William Lubtchansky, cinematographer, Paris; Anne Lyles, curator of the British Collection, Tate Gallery, London; Marie-Madeleine Martinet, University of Paris IV; Olivier Meslay, curator in the Department of Painting, Louvre Museum, Paris; Malcolm Morley, New York; Rainer Müller, Hamburg; François Perrodin, Paris; Marie-Christine Pouchelle, Director of Research, CNRS, Paris; Pierre Schneider, Paris; Professor Jean Starobinski, University of Geneva; Jean-Marie Straub and Danièle Huillet, Rome; Dr. Robert Woof, director of the Wordsworth Trust, Grasmere, Cumbria; and Professor Henri Zerner, Harvard University.

I would also like to thank Jean-Philippe Chimot of the University of Paris I, who was the first to tell me about the Claude mirror while I was working on my master's thesis in art history, and Jean-Claude Lebensztejn of the University of Paris I, who, as the director of my doctoral thesis, gave me support and encouragement throughout. I thank them both for the kindness they have shown me without fail.

I would of course like to thank Zone Books and Jonathan Crary for pursuing the idea of an English version of a little book

originally published in an edition of only a hundred copies, for the French version was even worse than this one. I would also like to thank all those who gave their work and care, at every moment and up to the end, so that this publication could be realized, in particular: Jeff Fort, for the most faithful translation possible; Amy L. Griffin who tracked down the images; Julie Fry for her design; and, of course, Meighan Gale, who supervised and coordinated the editing process with a kindness and patience that can only be described as angelic. I am grateful to them all for their input and for having posed the most challenging and inescapable questions, from which this publication has greatly benefited. For, in the end, is it not the case that translating a book means submitting it to the judgment of the mirror?

Finally, I would especially like to thank Yves Rifaux, who recently passed away, and his widow, Sophie, who still oversees the Musée de l'Art de l'Enfance, to whom I owe, among other things, the publication of the first version of this work.

Readers will see that this work has been influenced by the thought of Jonathan Crary and Jean-Claude Lebensztejn, who are, "as if by chance," my editor and my thesis director. One makes of chance a necessity not out of complaisance or fawning but as a way of making opportunities fruitful. If one cannot live up to examples such as these, one must at least know how to associate with the right people. I regret only one thing: not having been able to take full advantage of all their suggestions, or those of all the people I have thanked here.

PART ONE

Prolegomena

CHAPTER ONE

Definitions

Characteristics and Aspects

In 1969, an exhibition at the Hayward Gallery in London titled *The Art of Claude Lorrain* included a small and singular object designated a "Claude Glass."[1] This instrument, known to very few people (most often indirectly), was finally being shown to the public outside the scientific museums where it seemed to have been relegated, if not simply forgotten, partly because of the lack of interdisciplinary connections between the fine arts and the sciences. It was shown again in 1973 at the Tate Gallery, in the Leslie Parris exhibition titled *Landscape in Britain*; but this time the mirror was accompanied by other optical instruments used by some painters, such as the camera obscura, the camera lucida, and the graphic telescope.[2]

Three words can be used as the lowest common denominator for all Claude mirrors: "convex tinted mirror." Such is the minimal definition of this mysterious object — minimal, but not sufficient, for there is no fixed model for the Claude mirror but rather all sorts of variations with different types of reflections and tints, different sizes, forms, and degrees of convexity, all corresponding to different needs.

What defines a mirror above all is its reflecting surface; and this surface is therefore the primary object of attention, both for

the artisans who produced these mirrors and for the painters, tourists, and poets who used them. In the rare treatises on optics that mention our instrument, the focus of discussion is, as with lenses, the quality of the finish: if the surface has no defects and if the mirror possesses an excellent tain, then the image will be good. If the opposite is true, the image will be the source not only of falsity and error but above all of dullness: it will be lackluster and will tend toward a slate color, writes the painter Pierre-Henri de Valenciennes, the author of an important treatise on painting from 1800.[3] These mirrors of poor quality flatten colors and render them indistinct. That is why mirror makers were advised to tint their mirrors within the mass itself, and to make them as opaque as possible, "for those that are made by placing a layer of black [in the case of a black mirror] behind a clear glass are not as pure, and they usually produce a double reflection created by the polished surface above and the one beneath, where the color is applied."[4] Therefore, to prevent these imperfect reflections, mirror makers often used metal or polished minerals, such as a piece of carbon for Yves Rifaux's mirror, obsidian for Pliny the Elder's or Dr. John Dee's, and jet for Francesco Colonna's (figure 1.1).[5] Only these materials appear to offer the sharpness and depth of black so sought after by their owners.[6] However, in my own experience, and in the opinion of contemporary painters like François Perrodin, mirrors with a black tain also reflect a very sharp image. There is a phantasmic element here concerning the purity of the materials that involves the gaze, unlike vision, in a cultural process to which we will often return in what follows.[7]

The choice of tint will become a central problem with regard to the desired effect, as we will see. Indeed, a wide range of tints are designed to meet users' various expectations. We are familiar with mirror makers and dealers urging customers to take their time in order to make the best choice of optical instruments. Indeed,

even with a white mirror, the "choice to be made in relation to the color of the shadows" depends on the quality of the tinning.[8] With a tinted mirror, the problem only increases.

The most common color for a Claude mirror is black. But between the white mirror and the black is a wide range of possible colors and values, including various values of silver. London's Science Museum even has a very dark green one in its holdings.[9] These different tains or colors, determined by the technique of producing the mirror, were used to create varying effects according to the weather: "The mirror with a black foil answers well in sunshine; but on cloudy and gloomy days, the silver foil answers better."[10] Whichever Claude mirror is used, the value of its color always tends toward *dark*.

The convexity of the mirror also plays a major role in relation to the perception of space and the problems of perspective. In my experience, this convexity has little in common with that of "spherical" or "witch's" mirrors. As Roger de Piles puts it: "I suppose this convex mirror to be of a reasonable size, and not one of those which, being segments of a small circle, impair the forms of objects too much."[11] It is not a hemisphere but "the segment of a large circle."[12] In reality, the Claude mirror is only slightly convex. Moreover, the mirror's convexity can be irregular, in some cases almost completely flattened at the center and gradually increasing around the edges. And in fact this convex form has not always been adhered to. I have seen a Claude mirror from the mid-nineteenth century signed by a famous optician Chevallier [*sic*] that was made according to the model of an axial mirror: this rectangular mirror, made of a single piece, consists of two planes, each with a slight outward incline, symmetrically divided along a central axis, like a rooftop.[13] Generally, the distortions of the reflected objects are more like those in a rearview mirror than those observable on a glass ball or on the back of a spoon. However, as we will see, a

17

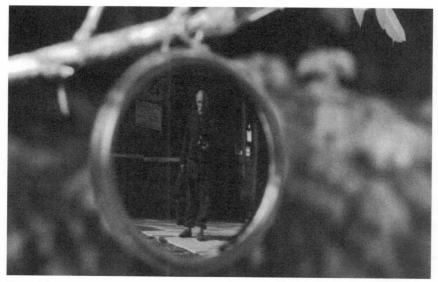

Figure 1.1. Yves Rifaux's black mirror, and his reflection in it (Musée l'art de l'enfance, Marcellaz Albanais, courtesy Sophie Rifaux).

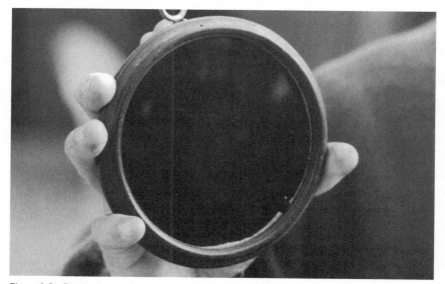

Figure 1.2. Black mirror, collection Yves Rifaux (Musée l'art de l'enfance, Marcellaz Albanais, courtesy Sophie Rifaux).

good number of artist-theorists such as William Gilpin and Valenciennes enjoin us to mistrust the distortions created by a too-pronounced convexity in the Claude mirror.

The convexity of the mirror, in fact, cannot be very pronounced, "otherwise distant and small objects are not perceived in it." But "if the glass be too flat, the perspective view of great and near objects is less pleasing, by representing them too near." Thomas West, in his 1778 guide to the Lake District, concludes, not without a certain logic, that "these inconveniences may be provided against by two glasses of different convexity."[14] One is thus able to observe different parts of the landscape according to the distance. Such refinement is a testimony to the highly elaborate use of these mirrors.

Their shapes also vary. London's Science Museum possesses Claude mirrors in four different shapes: square, rectangular, circular, and oval. The National Museum of Scotland in Edinburgh has a rectangular one, but with corners that have been considerably rounded off.[15] But in the minds of writers and poets of the eighteenth century, the Claude mirror is most often circular. William Mason described the mirror that the poet Thomas Gray carried with him on excursions. It had a diameter of about 4 inches, or 10 centimeters.[16] And Thomas West describes mirrors with diameters from 4 to 4.5 inches (or from 10 to 12 centimeters) and affirms that they could "admit a field large enough for the eye to take in at one sweep," however far away the observer may be.[17] But they are in general small enough to be held in one hand (figure 1.2). Generally speaking, if these mirrors tend to be round in the eighteenth century, they are more often rectangular in the nineteenth century.

To protect this fragile object and to avoid any scratches, especially on those with a vulnerable metallic surface, mirror makers would bind the mirror in a case lined with cloth — generally either

velvet or silk. This case takes the form of a "pocket-book" covered with dark leather or sharkskin.[18] When the cover is closed, the mirror is slightly smaller than a small paperback book. A clasp similar to those on compass boxes is often used to prevent it from opening unexpectedly. Easily transported, the mirror did not weigh heavily on tramping tourists, particularly as they climbed the steep heights that the vogue for the picturesque and for wide prospects encouraged in the eighteenth century.

Thus, Mason's description of the mirror that Gray carried with him on excursions turns out to be the archetype of the Claude mirror, although he calls it something else: "a Plano-convex Mirror of about four inches diameter with a black foil, bound up like a pocket-book" (figure 1.3a and 13b).[19] One might prefer Truman Capote's description, if only because it is less well known: "The object . . . is a black mirror. It is seven inches tall and six inches wide. It is framed within a worn black leather case that is shaped like a book."[20]

It would be an error, however, to limit the Claude mirror to this little instrument. Although larger mirrors are not Claude mirrors in a strict sense, since they are not portable, they nevertheless have the same characteristics. The criterion of size cannot be decisive: the Claude mirror manipulated by Graham Sutherland must have been at least 25 centimeters long (see below, figure 10.6). And the simple convex mirrors recommended to painters were on the whole quite large: the Nuremberg mirror of Gérard de Lairesse had a 1-foot diameter.[21] And the Abbé Jean-Antoine Nollet says that convex mirrors for painters must be large, otherwise they will disfigure the reflections.[22] That is why large black mirrors were also produced which could only be used by painters in the studio, such as the quite exceptional one in the possession of a private collector. This one is encased in a box made of cherry, with a cover inlaid with a thin band of lemon tree wood on the

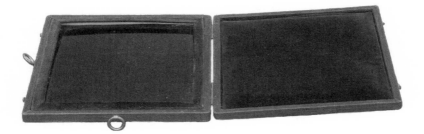

Figure 1.3a. Claude Mirror. Scientific Instrument Collection, Department of Physics, Middlebury College, Vermont.

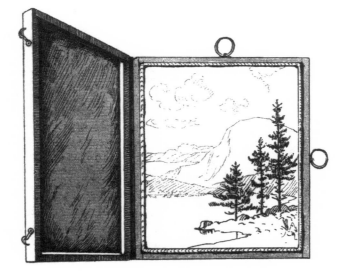

Figure 1.3b. Black mirror from Ernest Hareux, *Cours complet de peinture à l'huile (L'Art – la Science – Le Métier du Peintre), L'outillage et le matériel nécessaire à l'atelier ou en plein air* (Paris: H. Laurens, n.d.), p. 32.

left side to reveal the reflective surface. This mirror, which I date from the 1810s, measures 25.2 by 30.5 and 1.7 centimeters deep. On the other hand, the circular convex mirror of clear glass with a black backing, displayed with its stand in the physics lab of the Museo per la Storia dell'Università in Pavia, shows that there is no set definition of the Claude mirror. Instead, the black mirror takes on an endless number of variations. Neither should the ease of handling and the portability of the Claude glass mask the other sorts of black mirrors, for if the black mirror is reduced to the Claude glass, whose archetype was described by Mason, we would deprive ourselves of many other aspects of this obscure object. That, in general, it can be easily handled and transported does not mean that all other types of mirrors should be excluded, for by confining the Claude mirror to the archetype described by Mason, we would overlook other aspects of this mirror.

A pencil drawing by Thomas Gainsborough shows a seated man holding a mirror, in which, most likely, he contemplates a landscape (figure 1.4).[23] At first sight, this instrument does not resemble a Claude mirror in the classic sense, although it does have a somewhat dark reflection. Perhaps Gainsborough drew a simple convex mirror like those commonly produced in Nuremberg. Moreover, if the figure were looking at his own reflection, he would be positioned directly in front of the mirror. He seems, rather, to be following the advice given by Thomas West in 1778 concerning the use of the Claude mirror: "The landscape will then be seen in the glass, by holding it a little to the right or left, as the position of the parts to be viewed require."[24] Some specialists claim, without much basis, that this drawing is a self-portrait from the late 1740s or the early 1750s.[25] On this drawing the oval mirror, without the cover, seems to be about 30 centimeters along its broadest axis. It is therefore much less similar to Gray's mirror as described by Mason than the convex mirror held in the

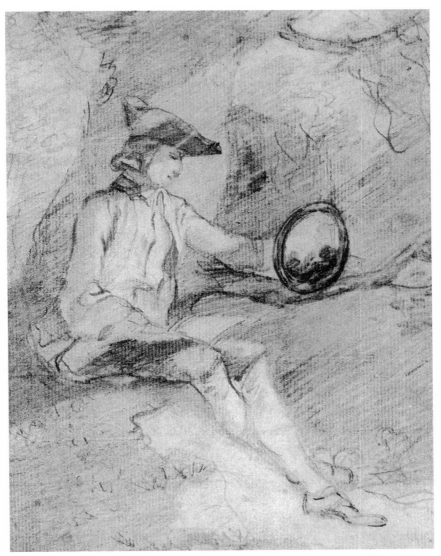

Figure 1.4. Thomas Gainsborough, *Man Holding a Mirror*, n.d., graphite on paper, 18.4 x 13.8 cm, catalog number Oo-2-27, British Museum, London.

Figure 1.5. [P. Fouché?], *A Virtual and Upright Image of Objects Seen in a Convex Mirror and Copied by a Painter*, engraving, in Emile Desbeaux, *Physique populaire* (Paris: Flammarion, 1891), p. 200, fig. 126 (W. S. Hoole Special Collections Library, The University of Alabama).

Conservatoire National des Arts et Métiers of Paris. This object cataloged in the holdings of the CNAM is a convex circular mirror 30 centimeters in diameter, made of metal and mounted on a stand, dating from the eighteenth century.[26] Its relatively low inventory number (867) indicates that it entered the CNAM when the collection was first being put together. There are others, with a similar diameter, that are sometimes mounted on a stand.[27] Like the Pavia mirror, these mirrors from Paris have a stand, which makes them much less portable. This drawback is compounded by their large size. In principle, these characteristics do not particularly indicate that they are Claude mirrors. Note how difficult it would be to hold a pencil in one hand, a sketchbook in another, and the mirror in a third! (See figure 1.5.) In fact, for this reason Valenciennes, following West, evokes the resolutely practical side of this instrument: "It can be easily carried along: one can set it up without difficulty, by attaching it to a tree or to a stick that one has placed in the ground. One can then copy nature in this mirror as one copies a painting."[28] A Claude mirror put up for sale in the fall of 1996 in Paris had two small rings on which to hang it.[29]

The definition of the Claude mirror fluctuates, then, and this makes identifying it just by these characteristics all the more uncertain. In addition, it is difficult to locate it in texts, since its description is very close to, or even identical with, that of the simple convex mirror also used by painters. Moreover, it is very similar to mirrors made of obsidian, coal, or jet. It is also very easy to make: for example, by applying black or a black leaf to the back of a plate of glass.

Problems of Naming

Identification, Conservation

In France, these instruments are virtually unknown, even by art historians. And yet at least two artisans sold them in Paris.[1] Since the first publication of this research in French, a few collectors who possess one or more examples have contacted me, but I have yet to locate a single Claude mirror in any of the large institutional collections in France. One finds a similar void in Denmark, Austria, and Germany.[2] Dr. Gisela Hopp of Hamburg has confirmed this. However, she referred me to an artist, Rainer Müller, who has done work at the Hamburger Kunsthalle and who had a small exhibition in 1997 that explored various aspects of the Claude mirror.[3] Although he has worked on this instrument for years, Müller has never found a single one in Germany, neither in a public nor in a private collection — indeed, not even in the Deutsches Museum in Munich, the largest technical museum in Germany.[4] Only England and the United States seem to have retained a few traces of these mirrors. And yet we know that Claude mirrors were widespread in France and Germany, as well as in England, toward the end of the eighteenth century and even more in the nineteenth. Indeed, in his 1803 catalog, Georg Hieronimus Bestelmeier announced an oval black mirror with a handle that

was meant "for young people, as well as for lovers of the arts" (figure 2.1).[5] How is it that all trace of this instrument has disappeared — or almost?[6]

Of course, some important nuances must be considered. In the course of my research, I realized that not everyone who had owned one of these mirrors had thrown it in the garbage; some had gotten rid of this "junk," along with other things, by giving it to secondhand stores and scrap-metal dealers. French examples are in the hands of individuals who have sometimes begun veritable private museums, usually devoted to photography. In fact, I find it difficult to believe that the large institutions do not have any in their holdings. They are no doubt somewhere in the depths of these collections, buried in boxes, left behind by the vicissitudes of history, curatorial fashions, and the personal historical tastes of the curators, and kept there, quite simply, because of a total ignorance of this instrument.

This ignorance, brought about by a more and more extreme hyper-specialization in every branch of study that makes interdisciplinary knowledge more and more difficult, is often reinforced by incorrect identifications. Such a case recently arose when Olivier Meslay, a curator at the Louvre, guided by an intuition, had two works by Bartolomeo Esteban Murillo reexamined — two paintings on black-marble plates (figure 2.2). It turns out that these two plates are not marble but obsidian.[7] Plates similar to these are often found cataloged in several European, American, and Mexican museums, whose curators, quite embarrassed, label them "'mirrors' of unknown use." We can expect to learn more about these problems from further publications by Nicholas J. Saunders.[8]

This lack of knowledge is sometimes compounded by prohibitions that prevent these objects from being exhibited. For example, the Musée National des Arts et Traditions Populaires in Paris possesses a mirror of about 28 centimeters in diameter, with

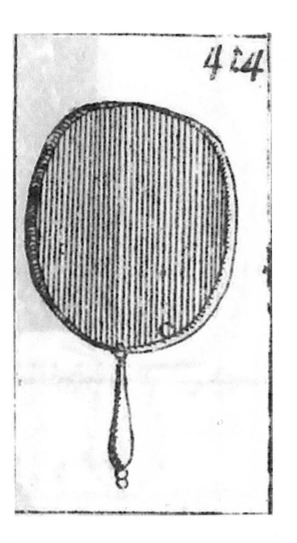

Figure 2.1. *Black Mirror*, in Georg Hieronimus Bestelmeier, *Magazin von verschiedenen Kunst und anderen nützlichen Sachen, zur lehrreichen und angenehmen Unterhaltung der Jugend, als auch für Liebhaber der Künste und Wissenschaften, welche Stücke meistens vorräthig zu finden* (Nuremberg, 1803: repr., Zurich: Olms Zurich, 1979), no. 414.

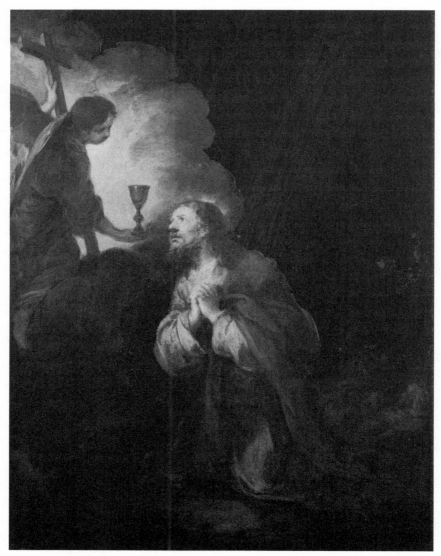

Figure 2.2. Bartolomeo Esteban Murillo, *Christ in the Garden of Gesthemane,* oil on obsidian, 35 x 26 cm. Louvre, Paris. (Erich Lessing/Art Resource, NY).

a slight outward curvature and a black backing, designed to be suspended from hooks. Its last owner, a Parisian sculptor, had hung it in his dining room. A complicated series of events came about: The artist got rid of this magic mirror by donating it to the museum in the early 1980s. A magnetizer who had come to examine it inserted some bits of paper inscribed with signs (for example, Solomon's seal) between the backing and the glass and recommended that it be kept in charcoal, which is reputed to absorb evil forces. This mirror is therefore not exhibited, since someone who knows how to cast spells would be able to use it, even through a glass case. In accordance with these magical recommendations, it is stored in a large case designed for black magic. The guards are afraid of it, and anyone who looks inside feels a great unease. Despite its ethnographic value, and for the reasons just mentioned, this mirror cannot be lent out, since it has no inventory number: thus it "doesn't exist"![9]

Translations, Distinctions, Confusions

The rare publications that mention the Claude mirror do so under the most varied names. Thus, in English publications of the time we find it referred to as "Claude mirror," "Lorraine glass," or "Claude Lorrain mirror." In English, the term "mirror" can indiscriminately be replaced with "glass." Indeed, in the Renaissance, the noun "mirror" designated the mirror in a metaphoric or even symbolic sense, whereas "glass" had a more material sense.[10] At the end of the eighteenth century, this distinction no longer had much currency, and later it disappeared altogether. In France, it is called the *miroir de Claude*. Marie-Madeleine Martinet's anthology seems firmly to have established this name in France.[11] And the denominations *vitre de Claude*, *miroir de/du Lorrain*, and *miroir de Lorraine*, found at random in a few substandard publications, are merely careless translations of the English terms. The confusion

generated by these insufficient translations only highlights the lack of knowledge concerning this instrument in France.

These difficulties in translating "glass" and "mirror" are compounded by another that ends up muddling the problem even further. Indeed, the Claude mirror and the Claude glasses are two somewhat different instruments that were confused for a long time, and in fact continue to be.[12] While the *Claude mirror* is a tinted convex mirror, the *Claude glass* is a filter made of colored glass, generally round, flat, and very thin.[13] Thus, the landscapes observed through a Claude glass are affected not in their form but only in their colors. They are therefore somewhat different from concave "reducing glasses"or the convex glasses discussed by Gérard de Lairesse.[14] Alan Fairford, writing to Darsie Latimer in Sir Walter Scott's *Redgauntlet*, makes the following mention of it: "Didst ever see what artists call a Claude Lorraine glass, which spreads its own particular hue over the whole landscape you see through it?"[15]

Each Claude Lorrain glass has a very well-defined color: blue, green, red, yellow, orange, dark brown, and so on. These filters are mounted on the arms of a fan-shaped protective frame, generally made of horn (figure 2.3). The user can unfold the arms one by one or choose combinations in order to vary the effects of the color. In 1803, Samuel Taylor Coleridge amused himself by simultaneously placing a differently colored glass before each eye, then changing the colors through various permutations.[16] In 1852, Gustave Flaubert looked through a number of different glasses; he wrote to Louise Colet: "Do you know how I spent my afternoon the day before yesterday? Looking at the countryside through colored glasses. I needed to do this for a page of my *Bovary*, which, I believe, will not be among its worst."[17] The Claude glass has at least two arms, each one for a different glass (for example, red and green), like the one in a display case at the Cuming Museum in the

The Multiplying Glass.—This glass is formed as a plano-convex lens, the convex side of the lens being cut in what the lapidaries term facets, consequently as many flats or facets as are cut in the glass, so many objects will be seen. They are sometimes mounted in a conical case, and by giving it a quick circular motion the objects appear to jump one over the other. Price, $0.50 to $3.00.

Fig. 709.

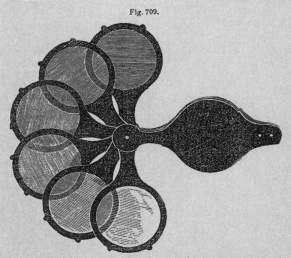

Claude Lorraine Glass.—(Fig. 709.)—This consists of a variety of different colored glasses, about one inch in diameter, mounted in horn frame and turning on one centre, for producing a great variety of colors and showing their combination; it also will be found both pleasing and useful for viewing eclipses, clouds, landscapes, &c.

Price, $1.50 to $3.00.

Claude Black Glass Mirrors.—Claude's black glass mirrors, for perspective drawing. These are very useful for the young artist, as they condense or diminish the view into the size desired for the intended picture, and all objects bear their relative proportions. Price, $2.50.

Figure 2.3. Benjamin Pike, Jr., *Illustrated Descriptive Catalogue of Optical, Mathematical, and Philosophical Instruments* (New York, 1856), vol. 2, p. 193 (courtesy Science, Industry, and Business Library, New York Public Library, Astor, Lenox, and Tilden Foundations).

Southwark borough of London.[18] The Science Museum in London has only three at the present time, all in excellent condition, exhibited in a display case next to the "Claude Lorrain Mirrors." One has three arms, and the two others have four. We might note that the term "Claude glass" is used interchangeably in both the singular and the plural. Used in the singular in sales catalogs, it nevertheless designates an entire set of glasses and their frames.

We know very little, really, about the origin of the name "Claude Mirror." It has become customary to say that it appeared — or at least was accepted — in the mid-nineteenth century. But this does not mean that the instrument was not called that before then. Indeed, the oldest association linking the name "Claude" to a mirror or a reflecting surface seems to occur in catalog number 51 of the London ironmonger Charles Robertson and Co. This catalog announces "Claude Mirrors in [their] cases." Unfortunately, it is not dated, but it is certainly older than another catalog of 1851.[19] This proves that the term was already used before the mid-nineteenth century, but it does not allow us to be more precise. However, a curious detail leads me to insist: why wait so long to call this mirror a "Claude mirror" when William Gilpin had already spoken in 1776 of "Claud Loraine glasses" in referring to his filters, which produced exactly the same colored effect? "The only picturesque glasses are those, which the artists call Claud Loraine glasses. They are combined of two or three different colors; and if the hues are well sorted, they give the object of nature a soft mellow tinge, like the coloring of that master."[20]

It has commonly been said that the Claude mirror was so called because it gave the landscapes reflected in it the somber light and golden tint associated with Lorrain's paintings. Adam Walker makes use of this comparison: "My black mirror presented me with many delightful landscapes in this park, that a Claude might not have disdained to copy."[21]

34

More generally, as we will see later in more detail, pictorial works like Lorrain's often represented at the time a sort of filter through which one looked at nature — as was the case for Goethe during his Italian journey: "Hovering over the ground all day is a vapor which is familiar to us only from the drawings and paintings of Claude Lorrain."[22] It is not surprising, then, that these glasses, and then the mirror, would come to bear this artist's name.

As for whether Lorrain himself used the mirror, no one knows, despite the rumor maintained by Rutherford J. Gettens and George Leslie Stout.[23] Marcel Röthlisberger, for his part, makes no claim that Lorrain ever used it. In truth, this expert on Claude Lorrain seems to know nothing about this instrument, or at least to have only a vague idea of it.[24] Paradoxically, and rather oddly, an irony of history has made it such that Claude Lorrain will remain a looming absence in this study, although his name occupies a central place in it and will be constantly mentioned.

In a similar manner, the Claude mirror was also sometimes called the "Gray glass." Indeed, at the end of the eighteenth century, our instrument was often associated with the poet Thomas Gray, who made much use of it. We find it named thus in 1787, in a sales catalog of George Adams, a London optician and artisan and a specialist in micrographs who sold it under the heading "Black convex mirror (recommended by the poet Gray)."[25] In 1792, it is mentioned by Peter Crosthwaite, owner of the famous Keswick museum, where tourists found all sorts of souvenirs and gadgets indispensable for their tours of the lakes, including "Gray's Landscape Glasses" and other glasses of "Claude Lorrain's."[26]

Problems of Historical Sources:

The Disappearing Mirror

The confusion surrounding the Claude mirror is not limited to its name; it also extends to the history and use of this instrument.

Explicit references to the black convex mirror are difficult to find, because this instrument was confused for a long time with the simple convex mirror. As we will see later, Roger de Piles presents a good example of this confusion: only an attentive reading reveals that it is a question of a black convex mirror and not a simple convex mirror, a point that seems to have escaped his commentators.[1] The simple convex mirror was already common in the Middle Ages. Indeed, as early as the thirteenth century, these outwardly curving mirrors of metal or glass were a specialty of Nuremberg and were even referred to as "Nuremberg mirrors." However, the convexity of these mirrors was not so much dictated by taste as imposed by technical or financial imperatives. It was easier and more economical to produce curved mirrors than flat ones. To simplify, we can say that curved mirrors were obtained by cutting a sphere made of blown glass or cast metal. Flat mirrors were by necessity quite small, for not until the late seventeenth century, when the "table casting" technique was developed, were large glass surfaces produced with a satisfactory result.[2] These curved mirrors were therefore well known, since they were the only mirrors available on the market. It is thus

astonishing to read in de Piles that after this medieval vogue, "these sorts of mirrors ... became quite rare" in the first decade of the eighteenth century in France.[3]

To understand the context of de Piles's statement, we must recognize the deep ambiguity of the convex mirror. This mirror troubles the mind because it seems to transcend it. As Father Jean Dubreuil explained in the seventeenth century, "I keep no spherical mirrors, neither convex nor concave; the reason being that, unlike those [all other mirrors] of which we have just spoken, they do not faithfully reflect their objects."[4] Is it that the convex — or concave — mirror refuses to conform to the rigid laws of optics? Let us say rather with the Encyclopedists, who offer a synthesis of the question based on the work of Christian von Wolf, Isaac Barrow, Sir Isaac Newton, Pieter van Musschenbroek, and others — all more or less contemporary with the Jesuit father — that "the laws for the phenomena of mirrors, whether convex or concave, are much more complicated than those for flat mirrors, and even the authors of the Catoptrics are very little in agreement among themselves on this matter."[5] But an ignorance of the laws that govern these mirrors in no way prevents them from being used. On the contrary, optical experiments proliferated no less than experiments in the applied sciences.

If it can be said, very schematically, that the seventeenth century was the golden age of physics — a golden age inseparable from the maturation of scientific academies and the creation of scientific periodicals — it is also clear that the results of this research were reserved for only a few elite specialists. The eighteenth century, however, was less rich in discoveries and inventions (with the notable exception of electricity and gravity) and more concerned with perfecting previous breakthroughs, and it attempted to supplement this lack by increasing the public's interest in the sciences. A veritable program for teaching physics, made possible by a skillful popularization of

science, was created both in schools and in universities, both at court and in salons. The Abbé Nollet, an emblematic figure of this pedagogical revolution, relied only on observed facts, belonged to no philosophy and no school, set aside all metaphysics, and made abstract principles comprehensible through demonstrations and experiments. And experimental physics, whose corollary is the descriptive study of phenomena, found its most favored sites: the physics cabinets.[6]

The amateur laboratories that flourished in Paris in the first decades of the eighteenth century were filled with instruments of every kind (among many other things). In the painting *The Physics Laboratory*, which represents Joseph Bonnier de la Mosson's cabinet, one of the most famous after the king's — Jacques de Lajoue painted it for Bonnier, who was most certainly his patron — we see that convex mirrors, and the black convex mirror in particular, were well known to those who frequented these laboratories (figure 3.1). In fact, this mirror is very similar to the one in Pavia. And yet if we compare this painting with the eight drawings that remain from Bonnier's commission from his architect, Jean-Baptiste Courtonne, the dark tain of the black mirror disappears in the drawings, whereas in the painting one can see the exact layout of the various objects present.[7] Consulting the *catalogue raisonné* for this cabinet, we find the different mirrors represented again, but there is never any question of a black convex mirror in this detailed inventory.[8] What are we to think of the black color visible in Lajoue's painting? Is it the painter's interpretation — a hypothesis that would reinforce the somewhat fabulous aspect of the painting?

While this painting attests to the presence of the black mirror *at least* within artistic circles, Didier d'Arclais de Montamy's testimony completely dispels any doubt on this point: "In the old mirrors kept in curiosity cabinets, the glass they are made of is coated with black on the back, because the secret of applying

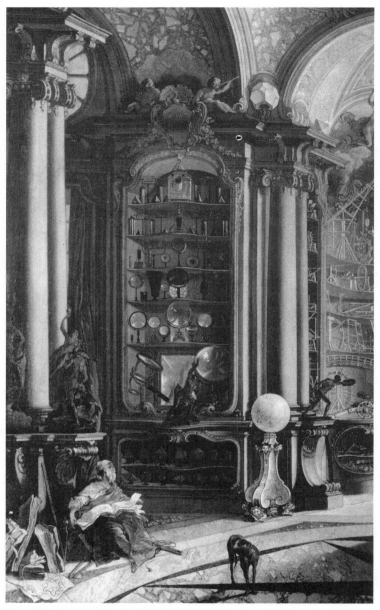

Figure 3.1. Jacques de Lajoue, *The Physics Laboratory* (detail), 1734, oil on canvas, Beit Collection (courtesy of the Alfred Beit Foundation, Blessington, Ireland).

quicksilver and tin had not yet been discovered."[9] Montamy goes further, explaining that a black tain, which "reflects the fewest rays" and therefore "causes no confusion," is preferred to a white tain, which "occasions confusion in the representation." The glass with a black tain thus offered "the highest degree of truth and precision" possible at the time.[10] This choice of color for the tain was dictated entirely by a technical imperative, an inability to obtain a better result with tains of another color. As for the tin-smith who would try in vain to create a tain of another color, Montamy advises him to "attempt to destroy all color in the glass by producing a transparent black," because "the parts of transparent black bodies that reflect light create the same effect as the parts of opaque black bodies."[11] The black mirror was therefore well known outside the cabinets and the circles of amateurs. Producing a black tain was virtually the only easy and relatively low-cost means for obtaining a good glass mirror. Why, then, would one have so much difficulty finding any mention of such a mirror?

In the second half of the eighteenth century, the popularization of experimental physics was growing steadily; entertainment became the spearhead of this pedagogy, so much so that in 1768 de Rancy proclaimed, "I want only to learn by amusing myself!"[12] Certain authors (Francesco Algarotti, Abbé Fromageot, Jérôme de Lalande) wrote for ladies, while others (Jean-Henri Formey, de Rancy, François Joseph de Saintignon) wrote for children, sometimes in the form of letters or even dialogues, so as to place the material within the reach of their readers while still entertaining them. Also during this period, entrepreneurs of traveling spectacles were marveled at by the general population, and those who managed to establish themselves in Paris by presenting physics demonstrations were able to reproduce, with considerable success, the experiments of the Abbé Jean-Antoine Nollet or Joseph Aignan Sigaud de la Fond. At the same time, they took advantage

of the opportunity to sell the instruments that were most liable
to make a strong impression on people. In this effervescence, it
became possible to find at just about any "Miroitier-Lunettier-
Opticien" everything you always wanted in the way of instru-
ments but were afraid to ask for:

> In addition to the ocular glasses and lenses found in their boutiques,
> such as simple spectacles, telescopes or long-range lenses, binocu-
> lars, lorgnettes and microscopes, and other similar things that
> they [the mirror makers] sell already framed or mounted, they also
> have cylinders, cones, polygon pyramids, boxes for drawing, magic
> lanterns, burning mirrors, in metal or glass, prisms, magnifying
> glasses, faceted glass, in short, everything useful and curious that art
> has invented in the realm of optics.[13]

The generalized conjuring away of the convex mirror continues
here, but it no longer deceives anyone: if there are "burning mir-
rors" — that is, concave mirrors — there must also be convex mir-
rors.[14] Indeed, Father Dubreuil has taught us that at bottom, there
could not be one without the other. Furthermore, the principles of
their production were similar at the time, and a number of catop-
tric laws apply to both of them. Among all the opticians of "sec-
ondary importance" — such as Bianchi, Bienvenu, Laisné, Letellier,
Charles Rabiqueau, or even Marc Mitouflet Thomin, whose shop
bore the name Miroir Ardent — the convex mirror, and the black
convex mirror even more, are systematically absent from the de-
tailed lists of names, manifestly hidden beneath the final indica-
tion "& other curiosities."[15] And yet the *Encyclopédie* recognizes
the utility of the "convex spherical mirror" for painters.[16] And in
England, William Mason affirmed in 1775 that a Claude mirror
"can be found at any optician's" but under the name "landscape
mirror" or "Gray mirror," as we saw above.[17]

PART TWO

A Suspicious Mirror

Demoniac Mirrors

The rarity of these curved mirrors, indicated by de Piles, is a result of their having been hidden away, for they had a bad reputation. People owned them, they were bought and sold, but no one spoke of it. And with good reason! The convex mirror is the devil's ass, as a late-fifteenth-century wood carving shows (figure 4.1).[1] But make no mistake, this comparison goes far beyond the reflection of the satanic hindquarters or the similarity of their rounded shapes. The convex mirror, commonly called a "witch" — although this is technically false — is for Alhazen a source of errors and later, during the seventeenth century, of "fallacies."[2] The notion of distorted vision caused by such a mirror can be traced back at least to the second half of the sixth century: in several texts, inspired by an anecdote from Pliny the Elder, a tigress is tricked by a convex mirror set up by a hunter who then takes her cub from her.[3] All these errors turn the convex mirror into a magical and diabolical object, as was shown quite remarkably by Jurgis Baltrušaitis and after him by Sabine Melchior-Bonnet. "The devil is the deceptive mirror par excellence, the *speculum fallax*; he is the father of lies who creates illusions, usurps resemblance, and causes man to turn away from his true model. The devil is sometimes allegorized in iconography through the image of a monkey playing with

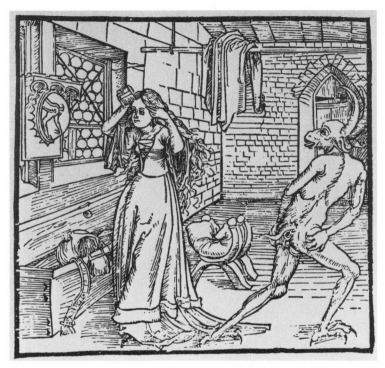

Figure 4.1. Attributed to Albrecht Dürer, *Vanity and the Devil,* woodcut illustration from *Ritter vom Turn* (Basel: Michael Furter, 1493).

a mirror, since each one counterfeits the world, for the devil wants to rival his creator by producing simulacra," Melchior-Bonnet writes.[4] Mirrors, which are supposed to celebrate the epiphany of vision, are used against nature — that is, against settled expectations — according to diabolical principles that make of them the devil's dark and illusory traps.[5] Witches, always a subversive force, recuperate convex mirrors, whose dim reflections lend themselves to all sorts of troubling phantasmagoria, for their éclat bewitches and blinds anyone who looks at them.

In an attempt to struggle against magic, the presumption of rivaling God, and these various subversions of vision, Pope John XXII sent out a letter on February 27, 1318, calling specifically for the pursuit of idolaters who used mirrors for their reprehensible rituals. Then, in 1326, he issued a bull, *Super illius specula*, declaring that the demon is particularly liable to be enclosed in mirrors and excommunicating all those who attempt to practice catoptromancy — divination with mirrors — or any other divinatory art.[6] Conversely, this bull amounts to an official recognition of the mirror as an attribute of the witch.

These magical practices endured throughout the following centuries, and the Church, constantly renewing its condemnations, was still pursuing them in the eighteenth century: in a work whose readership was large enough for it to be published in a third edition in 1712 (and again even later in the eighteenth century), Jean-Baptiste Thiers, referring to an arrest at the School of Theology in Paris, writes that "there was idolatry . . . in invoking the demons; in enclosing them in stones, . . . in mirrors."[7] These anathemas provoked by evil uses of mirrors help to explain the scarcity of the convex mirror observed by de Piles in the same period, an object that he — and others — nonetheless recommended to painters.

Finding references to convex mirrors is far from easy, but it is even more difficult to find references to black convex mirrors.

The latter remain in the shadow of the former. And yet the convex mirror cannot be substituted for the black convex mirror, for the tint is what makes all the difference — and this is precisely the problem. In truth, because of its dark color, this mirror has an even worse reputation than the simple convex mirror. Both the Claude mirror and the black convex mirror are in reality the same as the *black mirror*.[8] This black mirror enabled necromancers to conjure and to visualize the souls of the dead and thus to enter into communication with them:[9]

In 1842, the collection of curiosities assembled by Horace Walpole at Strawberry Hill was dispersed by the whims of the auction's bidders. Among the singular objects included in it was the famous black mirror of Dr. John Dee, physician, surgeon, and astrologer of Queen Elizabeth of England. It was a piece of the most beautiful black coal, perfectly polished and shaped into an oval, with a brown ivory handle. It had formerly been listed in the collection of the counts of Peterborough under this description: "Black stone by means of which Dr. Dee conjured the spirits." At the Walpole sale, an unknown person bought it for twelve pounds, and since that time, despite all the inquiries that have been made, no one has been able to find it. Neither the Peterboroughs nor the Walpoles had ever wanted to use this magical object, and they kept it jealously hidden away for fear of the great misfortunes that could be provoked by a misplaced curiosity. Elias Ashmole, author of the bizarre and terrifying *Theatrum Chemicum*, speaks of the black mirror in these terms: "With the help of this magic stone, one can see all the persons one wishes to see, no matter what part of the world they are in, and even if they are hidden in the depths of the most inaccessible apartments, or even in caves in the bowels of the earth." The last owners, terrified by such power, shrank before the experiment.[10]

The terror aroused by the black mirror seems to be maintained by fantastic literature as a whole, for if one calls on the demons often enough, they are sure to come. In Jean Ray, the black mirror brings forth an invisible creature that causes the death of anyone who would stand in the way of its owner. The author, as is customary, does not reveal the essential point, that the figure in question is Death. It is up to the reader to infer this, and the vagueness surrounding the story thus creates an intense atmosphere of disquiet and uncertainty.

In truth, this passage from Jean Ray applies especially to the atmosphere arising from it, steeped as it is in black magic and the *romans noirs*, which were part of the darker side of the late Enlightenment. Jean Starobinski has shown how in the eighteenth century, when they lost their luster and became a source of boredom, "light frivolities" then evolved into "macabre delights" (*plaisir noir*, literally "black pleasure").[11] An interesting document on the reception and use of the black mirror, this text cited by Jean Ray nonetheless contains a few imprecise details and small errors concerning this instrument and its history. According to Hugh Tait, the famous mirror of Dr. John Dee is the piece of obsidian — not coal — held in the British Museum (figure 4.2). This incorrect identification appears in the 1784 Strawberry Hill catalog, which seems to have diffused it widely. This specular stone is in fact an Aztec object. Obsidian, with its extreme hardness, was one of the Aztecs' primary mineral resources. And Dee surely acquired his stone during one of his journeys in Europe, just after Spain had reached the New World. It was most likely Horace Walpole who had the wooden case made that comes with it, in order to protect his precious acquisition. In fact, part of the label attached to this case bears the inscription "The Black Stone into which Dr. Dee used to call his spirits." The writing has been identified as that of Walpole himself. The object is roughly circu-

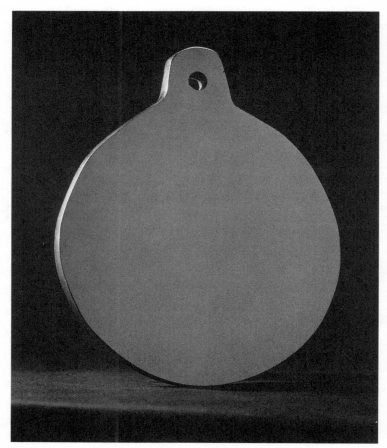

Figure 4.2. Dr. John Dee, obsidian mirror, British Museum, London.

lar, 18.9 centimeters in diameter. Its handle is cut from the mass
of obsidian, forms a prolongation of the mirror, and measures 4
centimeters long and 4.7 centimeters wide. The mirror's thick-
ness varies from 1.3 to 1.6 centimeters. Dr. Dee seems to have had
more than one such mirror, since he made a distinction between
his "principal stone" and his "usual shew-stone."

This mirror of Mesoamerican origin is interesting from several
points of view. Far from being unusual, such divinatory mirrors
were used by different pre-Columbian civilizations for sorcery
and necromancy. Obsidian inextricably links these objects with
the Aztec divinity Tezcatlipoca — whose name means "smoking
mirror" — the god of kings, sorcerers, and warriors who brings
war, discord, and catastrophe as well as good fortune. Tezcatlipoca
appears, therefore, as the incarnation of change through conflict.
Originally represented with an obsidian mirror on his head, he is
later figured with a mirror in the place of the foot he lost in his
legendary combat with the monster Cipactli. In the legend, the
mutilation occurs after his expulsion from Tamoanchan, kingdom
of the gods, following a sexual transgression in which this warrior
god seduces the goddess Xochiquetzal. This circular obsidian mir-
ror, represented in its prosthetic function, allowed the sinful god
to see into the hearts of men and to predict coming events. This
smoking mirror — so called because it was linked to the under-
world as well as to water and earth — had two sides, allowing one
to see and to be seen. It was thus a symbol of knowledge and of
the union of opposites, and it revealed one's sins and one's destiny.
The first monolithic mirrors of rectangular, square, or circular
obsidian did not appear before the Toltec period (ninth to thir-
teenth centuries) and were found throughout the Mexican plateau
and Oaxaca. The Spanish chronicler Juan Bautista de Pomar even
reports the discovery in Texcoco of a *tlaquimilolli* — a sacred bun-
dle — made of cloth decorated with human femurs surrounding an

obsidian mirror, a veritable hierophany, a tangible materialization of Tezcatlipoca. The circular mirror in the Natural History Museum of Paris, that black sun which had belonged to François I, was one of the most important pieces in the curiosity cabinet of Louis XIV, the Sun King.[12] For Christian Duverger, obsidian mirrors, responding in particular to the desire for ostentation, are among those objects specially created for wealthy Western buyers. Most of these objects are therefore not pre-Hispanic but "creations in the literal sense of the term: composites, designed essentially to prove a certain technical mastery, produced in response to an external curiosity that was indifferent to the meaning of the content."[13] Thus, if a history of European influences on the work of the Indians is still to come, a history of the influence of these mirrors on the Western world also remains to be written. It is very hard to measure the loss of these objects' ritual, cultural, and symbolic functions, for we are at present incapable of retracing the history of each of these mirrors, so difficult is it to follow their paths: the recent revelation concerning Murillo's paintings fully attests to this.[14] Let us note, as a provisional conclusion, that while obsidian plates were introduced into altars during the Christianization of the New World, this did not prevent Juan de Torquemada from likening Tezcatlipoca to the devil.[15]

One might wonder what Dr. Dee knew of all this. No one seems to know exactly how he procured his instrument. Whatever the case may be, the doctor went so far as to claim that one of his mirrors had been given to him by the angels themselves — a testament to the air of mystery in which these objects were deliberately shrouded.[16] Sir Walter Scott, in his attempt to demystify sorcery, reports that the spirits imprisoned in the black mirror do not actually appear in it and that the task of reading the mirror was confided to a third party — to a certain Kelly in Dr. Dee's case — which resulted in the astrologer's losing his fortune and reputa-

tion.[17] But enlisting a third party is a constant in catoptromancy: there is almost always a prepubescent boy or a young virgin girl who serves as an eye, seeing in the place of the sorcerer and responding to his questions, so that because of the child's youth, one "need not fear the nervous ramblings produced by erotic reminiscences."[18]

Catoptromancy

There are several variations of catoptromancy — divination by means of mirrors — all very similar in their methods but different in terms of the instrument used. In the register of the dark mirror, one can add palmomancy, thus named because a mixture of soot and oil is applied by a magician to the palm of a prepubescent boy or a virgin girl. He commands the child to fix his or her eyes on this mirror improvised with thick ink in the hollow of the hand. Aided by the magician's incantations and fumigations, the child then sees all sorts of things and persons appear, which are not necessarily fantastic. This technique, described by Johann Hartlieb in 1456, was condemned in 1265 by the Spanish penal code created by Alfonso X, king of Castile; the law imposed death on sorcerers and certain categories of diviners who indulged in this divinatory method, as well as others.[1] One finds a similar practice during the Byzantine period. Among the Arabs who still practice it, it is called "ink mirror" (*mandeb*), and among the Hindus it is called "lamp black (from smoke)."[2] A few Europeans reported having seen, learned, and even practiced this technique. In 1833, Léon de Laborde gave a detailed description of the sessions he attended.[3] Before pouring on the black oil, the Arab sorcerer traces a magic square grid containing nine numbers. The ink is

poured into the central square. The author also observes that what differentiates this Arab method from palmomancy — and in a general way all the divinatory methods from each other — is the tone of voice and the rhythmic cadence of the invocation; this is why he can describe in detail the steps followed in these divination sessions: without these two parameters, it is impossible to practice it oneself.[3] In 1837, Edward William Lane, the English translator of *The Thousand and One Nights*, related a very similar experience — so similar, in fact, that one may wonder whether he did not plagiarize the earlier text.[4]

Other variations of dark mirrors have been reported, notably by Louis Auguste Bellanger de Lespinay. Freshly arrived from Pondicherry in 1674 and in need of news from Europe so that he could best know how to proceed, he consulted the local diviners in order to be "spirited": the instrument used was "one of those shallow bowls greased with composite oil, which was very black and shiny."[5] Paul Sédir summarizes the long session reported by Colonel Stephen Fraser during his journey to India: The black liquid, viscous as the tar collected from volcanic cracks in the ground, prepared at great length and with great care, was put into an earthenware vase. During the ceremony, young girls stirred this black substance suspended over the fire. Later they spread it out, allowing him to see again "friends and family dear to his heart, as well as several other extraordinary scenes."[6]

There are yet other possible forms. In 1553, Kaspar Peucer described onychomancy. In this case, the ink mirror is applied not to the hollow of the hand but to the thumb. The images one believes one sees are only imposters of the devil who produced them.[7] This was enough to drive Thiers, writing at the high point of classicism, to condemn the practice.[8] Not all dark mirrors, therefore, were black mirrors. What counts above all is the shine of these dark mirrors, their capacity to produce a luster and thus

to fix the gaze. But all these mirrors are not systematically inter-
changeable: as an anonymous contributor to the *Almanach du
magiste* (Magician's almanac) observes, certain mirrors are less
successful for him than others; the ones that suit him best are the
"circular mirrors of paper blackened by carbon pencil or charcoal,
those made of pure black woolen cloth, or else of wood with
a surface slightly charred by a candle flame."[9] Jules Du Potet de
Senneroy's mirror is also based on this principle.[10] What these
surfaces have in common is that they are neither reflective nor
bright. The color black suffices to capture the gaze and to fix it so
that "things" will come forth.

Armand Delatte investigated this preference for the black
mirror over an ordinary mirror. He did not find any texts that
explained this, but, as he writes in reference to the anonymous
author of *Art Magic,* "perhaps the growing predominance of infer-
nal demonology and necromancy influenced this determination,
through a natural association of ideas between the shadows of the
kingdom of the dead and the color of the divinatory instrument.
Through an analogous symbolism, certain modern occultists be-
lieve that dark mirrors show only inferior or bad spirits," whereas
clear or crystal mirrors present only good spirits.[11] The demoniac
evocation inspired by the color black is not confined to the West:
the Zulu refused to look at the surface of dark pools, thinking that
creatures hiding below would swallow their reflection, that is,
their soul, thus bringing death.[12]

Yet if demonology worked its way into many areas, especially
in the nineteenth century, the black mirror and its derivatives
were not always perceived as demoniac. Bellanger de Lespinay
saw no blasphemy in and felt no "shame" about the black mirror,
and the recourse to catoptromancy, which he claimed to be very
useful for his affairs, in no way prevented him from being "highly
devout." It was those to whom such statements were addressed

who demanded that he not continue. Likewise, in his preface to Dee's book, which relates various sessions of catoptromancy during which the astrologer used his obsidian mirror, Meric Casaubon speaks of "natural magic."[13] Likewise again, when Paracelsus describes the necromancy practiced with a fingernail and a piece of coal — which, Delatte claims, is the first appearance of coal among the instruments used — these consecrated mirrors become constellated mirrors. It is no longer a question of devils or accursed genies. Paracelsus treats necromancy as a natural art that comes from the stars. Black mirrors became astrological mirrors because the stars, imprinting their influence into a piece of coal or a fingernail, bring forth signs of the future and the past. The power of words suffices to attract the stars as they accomplish their work according to man's imagination.[14] These mirrors, then, have nothing diabolical about them.

Magnetism, Hypnotism

Although the black mirror was not always considered maleficent, it was more or less systematically demonized during the eighteenth and especially the nineteenth century. The distinction between white magic (also called "marvelous" or "natural" magic by philosophers and magi) and black magic (called "Goetia" or "Theurgy" because supernatural effects are obtained by "invocations and enchantments of demons and devils") — a distinction to which Pierre Massé, for example, subscribed in 1579 — was an important factor in this demonization, despite its being derided and rejected by true magicians.[1]

A good example is provided in 1854 by Louis-Alphonse Cahagnet. A great connoisseur of magic mirrors, he points out the terrifying power of the black mirror: "Davies, a knowledgeable English cabalist, possessed a perfectly polished mirror of coal, in which he saw spirits and was able to converse with them."[2] This is a reference to Sir John Davies, a jurist, who published a poem in 1596 evoking a Vulcan mirror that shows "things to come, present, and past," a sort of miraculous shortcut between the three ages of life, which are thus brought together by the mirror.[3] Davies' mirror has therefore nothing terrifying about it originally.

In the nineteenth century, however, this instrument did become

terrifying. Indeed, we should recall that in 1779 Franz Mesmer published his *Mémoire sur la découverte du magnétisme animal* (Memoir on the discovery of animal magnetism). This work gave rise to a fluidist current of thought, then to an anti-fluidist countercurrent, following James Braid's *Neurypnology*, which appeared in 1843. For the fluidists, the magnetizer plays the primary role, since he makes the suggestions. The subject is maintained in a passive state. For the anti-fluidists, the patient is primary, for hypnotism is made possible only through the active will of the sleeper, that is, through autosuggestion. Although the metaphor of fluid is common to both the magnetists and the animists — whom Starobinski prefers to call "exofluidists" and "endofluidists" — the conception of the flow is reversed with the latter.[4] Thus, for Cahagnet the magnetizer suggests to the patient what he should see in the mirror, whereas for Georges Bell, the mirror of Cagliostro serves to hypnotize the subject, who sees in it what he wants. Note that for Bell, this latter mirror is not a black mirror but one made of polished steel, slightly convex, measuring about 15 to 20 centimeters in diameter, attached to a black-velvet cloth hung on the wall. "The mirror shone [hanging thus on its cloth] with a dark brilliance . . . and exerted an immediate and irresistible attraction on the eyes."[5] In both cases, the magnetized or the hypnotized person found himself halfway between science and occultism. And this was true despite the wishes of Cahagnet (following Mesmer) and Bell (following Braid), each of whom sought to found a science. Their strategy was to recuperate and to explain "magic mirrors," in the former case, and Cagliostro mirrors, in the latter — to the great astonishment, not to mention fear, of their subjects.

Through work such as this — and that of many others besides — the notion of the unconscious gradually developed. Particularly troubling to people like de Laborde, Lane, and Fraser — and they analyzed this very clearly — was the loss of mastery over their

bodies, over themselves: "I dread the influence these extraordi-
nary effects have on me. I try to resist it, but I cannot master it,"
writes Count de Laborde, who places all these experiments under
the sign of Mesmer.[6] The magician then remarks on "the influ-
ence that his gaze had on my entire person as it crossed my own,
for this influence was real: the play of the eyes, their fixity, seemed
to hold mine and arrest them." Achmed, the sorcerer conducting
the session, then calls the count over to him; at first de Laborde
resists, but then "in a few moments I saw my face, my eyes blurred
in the vacillating liquid surface [the ink mirror] I had in my hand."
This was nothing less than a crisis of the gaze, where the gaze is
the paradigm of control and authority: to the vacillation of the
gaze corresponds that of the will. "And soon something...I dare
not confess it, but I was afraid — afraid with a fear not of what I
would see but of the effect it would produce on me, of the re-
sponses that would be forced from me before this curious and
mocking public."[7] He expresses a fear of showing himself as he is,
of exposing himself — his drives, desires, and unconscious, in a
discountenanced attitude of lost restraint — to the judgment of
the other, to the inquisitorial violence of the gaze of others, un-
able to defend himself, completely disarmed. Someone who has
been magnetized is subjected even more to the will of the magi-
cian than someone who has been hypnotized. The fear comes not
from what one sees in the mirror but from seeing that violence
and power are being imposed on the magnetized person by the
mirror. This imposed violence and loss of control over one's own
will are all the more felt in that the narrator is a count, an aristo-
crat — and dignity, self-mastery, and restraint are precisely the
traits that such people of quality must maintain.

We see, then, how the notion of the unconscious emerges partly
in conjunction with the black mirror. Freud may never have claimed
that the unconscious was diabolical, but, as Robert Muchembled

remarks, that is because the father of psychoanalysis draws the rebellious angel into the maze of the human unconscious in the form of a son who rejects the orders of the tyrannical Father-God, who forces him to repress his drives by demonizing them. The implicit rehabilitation of these drives in no way leads to satanism but is related, on the contrary, to tendencies — widespread in the Europe of Freud's time — that attempted to free the subject from guilt. Muchembled adds: "Chase out the devil, and he returns at a gallop — without those falsely ostentatious Christians, but with something of Lucifer's beauty as imagined by the Romantics, not to mention a great deal of narcissism linked to the progress of culture and the individual."[8] The devil, we might say, is nothing other than the drives revealed to someone looking into a black mirror. The use of this object resonates with the constant evocation of an inner demon throughout the nineteenth and twentieth centuries. It is in a way the continuation and renewal of a movement initiated, perhaps, with the first use of these mirrors. If catoptromancy opens onto the world of the invisible and thus liberates a multiplicity of fears, the mirror — certainly in its origins — emblematized a horror of supernatural and diabolical powers. But as the science of optics progressed, this instrument came to reflect an image of its user's inner demons. It is in this light that we should understand the proverb "the mirror is the real ass of the devil," in relation to vanity, pride, envy, and so forth.[9] This is why Truman Capote, for example, speaks of a "demonic" mirror.

"Magnetism," "hypnotism": little does it matter which term is used. Beyond such labels, the interesting point lies in the black mirror's troubling capacity to absorb the gaze. Capote gives a brilliant description of the gaze caught in the maelstrom of such a mirror:

> My eyes distractedly consult it — are drawn to it against my will, as they sometimes are by the senseless flickerings of an unregulated

television set. It has that kind of frivolous power. Therefore, I shall overly describe it — in the manner of those "avant-garde" French novelists who, having chosen to discard narrative, character, and structure, restrict themselves to page-length paragraphs detailing the contours of a single object, the mechanics of an isolated movement: a wall, a white wall with a fly meandering across it. So: the object in Madame's drawing room is a black mirror. It is seven inches tall and six inches wide. It is framed within a worn black leather case that is shaped like a book. Indeed, the case is lying open on a table, just as though it were a deluxe edition meant to be picked up and browsed through; but there is nothing there to be read or seen — except the mystery of one's own image projected by the black mirror's surface before it recedes into its endless depths, its corridors of darkness.[10]

One might think that the description ends there, but the reader realizes at the end of the story that the narrator has never stopped looking into this mirror, that while he soliloquizes, his "eyes seek its depths."[11] Almost the entire story is therefore only the description of what the writer "saw" in this mirror. Only when the author raises his "eyes from the mirror's demonic shine" does he return to reality.[12] This short but very rich text admirably describes a form of autohypnosis in which all Cartesian consciousness, will, reason, and logic are banished.

This second state provoked by the black mirror is skillfully introduced into the story: a lady is speaking to the narrator, then suddenly breaks off, saying, "I see that you are looking at my black mirror." The next line begins a new paragraph: "I am. My eyes distractedly consult it."[13] This disjunction in the text perfectly translates the disjunction from reality that the mirror reflects, the abandonment to reverie, the loss of all will, all consciousness, until the end, when the narrator looks up and notices the absence of this lady with whom he has been conversing.

Disquiet

We ought no doubt to look to Antiquity for one of the most beautiful testimonies of the disquiet, and fascination, aroused by the black mirror. Pliny was struck by the dark image reflected in a polished obsidian mirror: "This stone is very dark in color and sometimes translucent, but has a cloudier appearance than glass, so that when it is used for mirrors attached to walls it reflects shadows rather than images."[1] The mirror reflects only shadows because only the dead can be seen in it. In archaic Greece, and more recently, shadows and shades are associated with the dead, the souls of the dead: in Homer, warriors killed in combat pass to the realm of shades. As Gérard Simon notes, if seeing is living in this world, "those who, like Calchas or Tiresias, have the gift of clairvoyance — the gift of seeing beyond — are blind to this world, the visible world."[2] Even earlier, obsidian mirrors were associated with death and were used as funerary objects. Archaeologists have found them in excavations of tombs in the Neolithic city Çatalhüyük, some eight thousand years old, in central Turkey.[3]

For the ancient Greeks, shadows signify absence, and for Pliny this is where the origin of painting and sculpture is to be found.[4] Indeed — in the art of modeling, or plastic art — before the departure of a beloved young man to foreign lands, a young girl, in love

with him, traces "in outline on the wall the shadow of his face thrown by a lamp."[5] The shadow, which in Antiquity is generally associated with the souls of the dead, makes it possible for the dead man, the absent one, to continue to exist in the form of an image. Thus the shadow, as a simple sign of the absence of a presence, attests at the same time to the presence of an absence, an absence that is not completely absent. The anxiety caused by the ambiguity of this obsidian mirror blurs even more the already-dim likeness of the reflected objects. Moreover, this underlying disquiet in Pliny only increases if we recall that elsewhere he speaks of those Egyptians who, when practicing lecanomancy, sometimes coated silver vessels with a substance that darkened the metal: a dark reflection and shadows are therefore closely associated — through divination — with death.[6] It is unfortunate that studies on shadow and reflection, like those of Victor Stoichita or Agnès Minazzoli (which deal with Pliny), speak of reflections, on the one hand, and of shades, on the other, but never of the reflections as shades that Pliny observed in these obsidian mirrors.

This Plinian mirror also calls to mind the mirror of Pausanias. The latter describes a curious mirror at Lycosura, in Arcadia, in the temple of Despoina, "the Mistress," daughter of Demeter: "On the right as you go out of the temple there is a mirror fitted into the wall. If anyone looks into this mirror, he will see himself very dimly indeed or not at all, but the actual images of the gods and the throne can be seen quite clearly."[7] It is difficult to know whether this mirror is obsidian. Some translations insist more on its dark aspect than others. However that may be, Jean-Pierre Vernant remarks that this mirror "inverts its natural properties," in that instead of reflecting the visible normally, it reveals the invisible and shows the divine in the brilliance of a mysterious epiphany.[8] Greek catoptromancy continually oscillates between

two poles, introducing an ambiguity into the image. Thus, the one who looks at his face sees it turned into a shadow. The face, which is connected with life for the Greeks, is effaced, replaced by a figure, which is related to death. To see oneself in such a mirror is thus to see oneself as one will be later, that is, as a shade. This mirror creates, as it were, a hole in the wall, a door onto the realm of the dead. But it also constitutes an epiphany, since the divinity is seen in all its glory and clarity. At issue here is the entire problem of seeing and being seen, a problem that continues to the present day. But the ambiguous relation of vision and knowledge is also evoked here, a relation that will decisively be put into play with the Pauline mirror.

This disquieting enigma that the black mirror constitutes for the gaze leads one to interrogate the meaning and the interpretation of the Pauline mirror. In his first Epistle to the Corinthians, Saint Paul declares that knowledge, at the moment it takes place, is only partial: "For now we see in a mirror, in a riddle (13.12)."[9] This imperfect knowledge is more explicitly marked in certain English Bibles like the Tyndale Bible (1534) and the Geneva Bible (1560). The translators replaced the Greek word *aenigma* of the original texts with the word "darkly," and the expression "through a glass, darkly" became current in the English language.[10] However, while the Pauline mirror — a designation itself surrounded by an enigmatic shadow — is inseparable from the epithets "dark" and "mysterious," this common interpretation of *aenigma* is based on a misreading. Among the different interpretations of *aenigma*, Jurgis Baltrušaitis raises the possibility that these sibylline verses are an allusion to catoptromancy, for this mirror would be an enigmatic reflection of the beyond. But Baltrušaitis adds that the mirror, as an inheritance of the Platonic tradition, is considered not always as defective or as something that obscures the reflected figures but as a symbol of precision and clarity:

The *aenigma* of the Apostle of the Gentiles is not a confusion but an encrypted figuration that signifies one thing by another, as written in the exact reflections of light. It is a catoptric prodigy enabling one to see the invisible and the immaterial images revealed in it, which are transfigured and vanish at the least inflection of the metallic surfaces. The vision is transcendent, but it is a question less of a magic mirror than of the magic of mirrors.[11]

Thus, if visible things are images of invisible things, the Pauline mirror reveals divine creations *clearly* but as an enigma, though without creating disquiet.

On a less sacred and more literary level, among the echoes of this Pauline type of thinking, the black mirror of Jules Barbey d'Aurevilly, arising from a striking comparison, also helps one to see more "clearly": "Her hair was dark, black as the blackest jet, the most perfect ebony mirror that I have ever seen shine on the voluptuous and lustrous convexity of a woman's head, but her complexion was fair — and it is by complexion, not hair, you should pronounce a woman brunette or blond. . . . She was blonde with black hair."[12] The moral of this passage is that one must not trust appearances, that one must look behind the mirror and pass through it. But beyond this echo of the Apostle's schema of knowledge, the writer returns to the schema of a more anxious knowledge. The opacity of the black mirror both veils and unveils what is presented to the gaze (a characteristic of veils themselves). The shadowy mirror never stops renewing this disquiet in relation to vision and knowledge. The black mirror's oscillation between disquiet and fascination generates a new disquiet in turn — adding even more to the first.

Disquiet seems to be a distinct privilege of the black mirror. And when the mirror is not black, it becomes so when revisited and reread. The *Grand Dictionnaire Larousse* thus wonders wheth-

er this obsidian glass was not used "perhaps even to make those convex mirrors mentioned... by [Seneca], which he describes as being used by the debauched to inflame their desires during their orgies"![13] We can imagine the scene (Seneca reread by the nineteenth century!): if this mirror was indeed convex and black, the party guests, suddenly seeing themselves up close in the reflection, endowed with organs that would make Priapus blush, ended up seeing themselves as satyrs, thanks to the dark reflection, which, from far away, instantly covered them with the dark hairiness befitting their roles. More effective and less expensive than certain pills now in fashion, the black mirror, turned into a priapic mirror, inflates the flaccid imagination simply by the power of suggestion and the excitation it elicits from a veiled and uncertain image. We will see that sex has a certain importance in relation to the black mirror's use by painters and poets. But it is also important to note, without developing this for the moment, that the Platonic tradition of the mirror finds itself tainted by Seneca's stoic vision of mirrors in general. As Seneca himself explains, mirrors, which ought to be used by man for the sake of knowledge, have been turned away from their true use by luxury and voluptuous pleasure: "Go on now and say that the mirror was invented for the sake of touching up one's looks!"[14] In fact, Roman Antiquity often associated the mirror with magical practices. Apuleius, accused of such practices, had to defend himself for having such an instrument in his possession.[15]

Pierre Larousse refers to a statement made elsewhere by Pliny to the effect that "the image reflected by these mirrors resembles a shadow; it is not a true image, the traits of the object are rendered, but the colors are duller. It is, in a word, an obscure representation of the object."[16] Such rereadings, not to say inventions, have their place within a strategy of recuperation. Thus, this obscure representation of the object has seduced painters whose

techniques and research into the fabrication of colors and essences led them to delve into alchemy — another source of disquiet, particularly for the Church — painters such as Francesco Mazzola, called Parmigianino, who played a decisive role "in the domain of the print by giving undeniable importance to the etching. He benefited no doubt from the alchemists' habit of using this acid in operations of transmutation."[17] The black mirror allowed him, as it did Giorgione, to resolve the problems of gradation, as we will see later.

The relevant hypothesis here is that this dark and disquieting aspect of the black mirror, with its power of suggestion, could only attract witches and necromancers who took up the instrument and diverted it from its original use. (This was the case, for example, with the tarot game.) Henry Carrington Bolton attests to this diversion when he points out that the mirror given to him for his occult experiments was the kind used by photographers, mounted on a wooden support.[18] Likewise, who can prove that the flat black mirrors originally produced for obtaining or analyzing polarized light were not also diverted from their scientific ends?[19] In this respect, artists are no different from witches. Recently, Rainer Müller constructed some black mirrors using roadside traffic mirrors, and others by modifying about thirty traveling alarm clocks, removing their hands and applying a black coating to the back of the glass (figure 7.1).[20] Laid out on a sort of black humus, these amputated clocks continue to function, greeting the visitors with their ticking sounds which fill the room, reminiscent of the genre of the Vanities. Perhaps the black mirror was originally an instrument assembled by and for artists themselves.[21] It is very easy to make one, using a simple piece of glass and applying a sheet of black paper to the back. But the black mirror attracted occultists because of its ambiguity: as we have seen, and as Cahagnet clearly indicates, witches' mirrors can be made of

Figure 7.1. Rainer Müller, black mirrors (courtesy of the artist).

anything that reflects, or even simply any black surface capable of absorbing the gaze — a sort of anti-mirror, since, paradoxically, this mirror no longer mirrors, no longer reflects.[22] The instrument no longer gives back an image; rather, it absorbs. Coal and charcoal then become eminently ambiguous, since a mirror made of these materials reflects light, but the materials themselves absorb the gaze as well as impurities or light. (Filters are traditionally made of charcoal, whose absorbent qualities are recognized in medicine as well as in alchemy and chemistry. Charcoal attracts evil spirits, as we have seen; and its black color absorbs light rays.)

However this may be, after being subverted by witches, the black mirror, with a few rare exceptions, could not be mentioned by name, or at least only in a roundabout way. This was all the more true because this object was associated with a supplement of sex and death, which, if it did not escape the readers of Seneca, Pliny, and Dr. Dee, certainly could not be forgotten by painters and poets.

A subverted object, the black mirror is also the object of all subversions past, present, and to come, the catalyst of all sorts of transgressions, and it is so even today. Anyone with any doubts on this score should type "black mirror," "specchio nero," or "Schwarzspiegel" on an Internet search engine, and he or she will have an idea of the actuality and the violence of these transgressions, quite often listed under the label "hard core." One finds a mix of perversions: lust, bondage, S-M, depravity, scatology, satanism — in short, everything that ordinarily shocks, defies, and transgresses society and the politically correct.[23] And the use of the black mirror as an image in one of the discourses of a revolutionary like Subcomandante Marcos is in no way foreign to these attempts at undermining the status quo.[24]

The Threatened Gaze

The black mirror unsettles and disquiets. Shadow, primitive, enig-
ma, debauchery, dim reflection, magic, alchemy, sorcery, necro-
mancy, subversion, death — so many causes for disquiet in the
black mirror. This disquiet arises, essentially, at that moment
when the onlooker tries to discern his own image in this mirror,
as we have said. Poliphilo provides a good counterexample in this
regard. Setting out on his quest for Polia, the amorous hero of
Hypnerotomachia passes between two walls of white marble, "in
the middle of which, on both sides, was a large circle of jet, . . .
which circle was so black and so polished that one could see one-
self as though in a crystalline mirror." Faced with his threatening
double, Poliphilo is at first taken aback. Overcoming this terrified
reaction, he identifies with (himself as) this new image of himself:
"I heedlessly passed between the disks, but when I was between
the two, I saw my figure from one side and from another, and I
became less afraid of it, thinking that it was two men."[25] As Sabine
Melchior-Bonnet remarks, as long as he does not take pleasure in
it, like Narcissus, man has nothing to fear from his reflection.[26]

But the black mirror is interesting because it subjugates the
one who looks (at himself) in it. There is — and we will return
to this — a paralyzing effect of this instrument, a fascination that
leads quite often to death. Every time a person looks into such a
mirror, he ends up sooner or later discovering the image of his
own death in it, just like Dr. Baxter-Brown in the short story by
Jean Ray, or like the governor Yaqub the Ailing, who misuses the
mirror of ink.[27]

Fascination

Quite frequently, those who look into a black mirror soon see a bluish color in the mirror's depths. Out of darkness blue emerges. Often this blue becomes phosphorescent to the point of shining out onto the objects around it, in the darkness of Dr. Baxter-Brown's room, for example, or in an anonymous writer from the *Almanach du magiste*.[1] Papus associates this phenomenon with other physical phenomena: these bluish effluvia are "similar to electrical effluvia," he writes.[2] But we prefer physiological explanations, for this phenomenon of phosphorescence is comparable to the Purkinje effect, in which red appears darker when seen in a penumbra, whereas blue seems brighter; observers like Philippe de La Hire and Lairesse — who eventually went blind — had already noticed this.[3] As described by Jorge Luis Borges (himself stricken with blindness), the world of the blind is a world of darkness, but this darkness is not the total blackness one might imagine; it is, rather, "a world of greenish or bluish fog, vaguely luminous." Borges is unable to specify whether it is a blue (tending to green) or a green (tending to blue).[4] But if this color becomes that of the blind, it also becomes the color of seers, that is, of those who can see the invisible world because they are blind to the visible one.[5] Thus, for the non-blind who wish to be clairvoyant — where clairvoyance, as an extension of the field of

consciousness, brings to consciousness what has heretofore been unconscious — the mirror will be extremely useful.[6] Clairvoyance requires a veritable ascesis in which the physical senses become dormant; the will then finds new forces, since, to see the invisible, one must cease to see the visible:

> It is thus that someone who wants to develop clairvoyance will first of all subdue his sense of smell with an appropriate fumigation, his ear with music of a special kind — while in the semidarkness of a small lamp he fixes his gaze on the magic mirror.
>
> These long explanations lead one, in sum, to look into the magic mirror as an instrument destined to absorb, to extract all physical light from the eyes.[7]

Working counter to the distractions of sight, the mirror absorbs all physical light. But if for Sédir the mirror must withdraw all physical light from the subject's eyes, the instrument must also "concentrate a parcel of hyperphysical light into one point in space."[8] Papus explains that "magic mirrors are organs for the condensation of astral light" and must "reflect psychic forces and astral images without absorbing them."[9]

As Armand Delatte recalls, all these processes of hypnotism — taken in the current medical sense, that is, including magnetism and other methods — come down to two methods: "sensorial and suggestive."[10] The sensorial element is constituted by fixing the gaze, whereas the suggestive element consists, in magnetism, of thoughts, feelings, and acts of will imposed on the subject by the operator and, in hypnotism (in the primary sense), of the concentration, imagination, and suggestibility of the subject. The resemblance between the phenomena of hallucination obtained by hypnotism (in the broad sense) and those described by theorists of catoptromancy is striking. In any case, the subject preserves

some consciousness of what is happening around him: if Victor Hugo and George Sand had not become aware of the fascination exerted by a dark screen set up before a fireplace, they would not have been able to provide their literary renderings of it.[11] Thus, if looking into a mirror requires a state of concentration on the object, combined with a state of detachment from this object's environment, here it is a question of an incomplete hypnosis that somehow involves a subconscious reverie accompanied by an effort at attention, such that one can remain conscious of these dreams. Moreover, if it is necessary to stare indefinitely at the center of the mirror, one must never become attached to the image, at the risk of losing it. This light hypnotic state is of the order of *fascination*, and because this "hypnotic state [is] light," the subject becomes "prone to receive hallucinations."[12] Today, hallucination and fascination are classified by doctors as "momentary states of modified attention." But beyond the numerous explanatory techniques and their respective vocabularies, there has been no significant evolution since William of Auvergne and Agrippa. We know almost nothing, not to say nothing at all, about how man functions at this level of experience.

Hence formulating a precise definition of hypnosis is difficult, especially since this definition has considerably evolved. At the very least, we can say that hypnosis opens a gap between what is thought and what is seen, and that it is subject to variable levels of intensity.[13] At times, it refers to a subjective state much like reverie: the gaze, characterized by distraction, gives the impression of oscillating, of wandering over the black surface, and thus of relying less on foveal vision than on peripheral vision, a sort of defocalization or perhaps afocalization. At other times, it designates a type of inverse attention, extreme but never utterly so: a sort of fixed, concentrated gaze, a foveal type of gaze, a fixation somehow related to the Freudian sideration of the gaze, a para-

lyzed gaze. The different intensity levels in hypnosis pass between these two poles. But quite often these two conceptions at work in the black mirror are superimposed, without really being distinguishable. It is in this continual dissemination of sense that one ought to envisage the fascination exerted by the black mirror.

This fascination and attraction of the gaze by the mirror — which was the object of so many studies at the end of the nineteenth century and was inseparable from a crisis of the gaze and the subject — are extremely interesting to us retrospectively, for at the beginning of the eighteenth century Roger de Piles declared that a good painting must be capable of producing precisely this effect. It is therefore not by chance that we will find de Piles recommending the use of the convex mirror.

PART THREE

A Reductive Mirror

Regarding the Eye and the Visual Field

Theoretical Foundations in the Age of Classicism

In the first pages of his *Principles of Painting*, de Piles affirms that the primary quality of a painting consists of surprise and the enjoyment of this surprise: "True painting, therefore, is such as not only surprises us, but, as it were, calls to us."[1] This call to the eyes that allows one to enjoy the details of the painting, even those that represent the most horrible things, is produced by a double movement of convergence: on the one hand, the painting *calls* with its force and with the truth of its imitation; on the other hand, the surprised spectator moves toward the painting as though to enter into *conversation* with it. To make his point, de Piles gives the often-used example of the ignorant and the connoisseurs who do not *see* the works of Raphael when they visit the Vatican.[2] This lack of a "call" in Raphael enables our theorist to develop his conception of painting and to explain the true attraction of the gaze.

This conception and this attraction are based on a principle of reduction, for the painting reduces the objects it represents, just as the black convex mirror does with the objects it reflects.

As Claude Lévi-Strauss has demonstrated, art is situated halfway between scientific thought and magical thought. The latter aspect can be seen as bricolage. The artwork is a reduced model, a

miniature, a "reduction either of scale or one that affects its prop-
erties." The reduction of a thing in a convex mirror allows it to be
"grasped, weighed in the hand, apprehended in a single glance."[3]
This implies a knowledge of the whole preceding that of the parts.
Even though this process partly involves an illusion, this illusion is
an intimate part of aesthetics. The reduced image, although not
made by hand, is, in this hand-held form, reduced to the size of a
hand and already constitutes a point of departure for an experi-
ment on the object. Thus, while the reflection in the mirror in-
volves a certain passivity, because of its mechanical aspect, it can
be the beginning of an experiment, an aid for the artist in the pro-
duction of an artwork understood as an active reduction to be
held in the hand. The renunciation of sensible dimensions is com-
pensated for by the acquisition of intelligible dimensions. In these
two senses — sensible and intelligible — which remain interwoven,
the Claude mirror is a reductive mirror.

The sensible reduction of objects reflected in the mirror oc-
curs on two levels: one concerns colors, the other involves the
visual field. This latter aspect was addressed at the end of the sev-
enteenth and the beginning of the eighteenth century by Roger
de Piles, the passionate theorist of coloring.

In seeking to attract the gaze and to call the spectator, de
Piles presents himself as a fierce defender of the fixity of the eye.
Against all the accessories or "by-objects" that adorn the edges of
a painting, he writes, "it is not proper to leave the eye at liberty to
gaze at random; because if it should happen to be detained on any
one side of the picture, this will frustrate the painter's intention.
... Whence it follows that the eye must be fixed" by "the most
essential" objects, thus letting those of less importance fall to the
sides of the painting.[4] This indoctrination of the eye is not inno-
cent; it is essentially political.[5] The dominion of unity rules over
each part of the painting: "So that we may define the whole

together [*le tout-ensemble*] to be, such a general subordination of objects one to another, as makes them all concur to constitute but one."[6] Even though de Piles wants to avoid the "dissipation" of the eye caused by the dispersion of details that would take away autonomy and induce a *flânerie* of the gaze, he does not want to immobilize the eye entirely: the painter must direct the gaze and deliver it from the randomness that would render it uncontrollable.[7] This thought (which is extremely classical even in a colorist defending the "call": such an opening of communication between the space of the spectator and that of the representation is properly Baroque) could not ignore the movement of the eye; it even recognizes this implicitly, since it seeks to arrest it and not allow the gaze to wander over the canvas, except within the uniquely authorized central area.

To this end, de Piles attempts to demonstrate that the flight of the gaze becomes impossible in proportion to a diminishing intensity of the colors at the periphery of vision. Indeed, the eye fixes on one object chosen among others: this object, "which appears at the center of vision," is the only one "that can be clearly and distinctly seen." The others, seen "by oblique rays [or lines]," become obscure and confused"; they "decrease, both in force and color, in proportion as they recede from the straight line, which is the center of vision."[8] This focalization occurs, consequently, by "default," through a gradual loss of sharpness in the shapes and colors seen as one strays from the center.[9]

De Piles therefore ends up praising nature itself, which guarantees the unity of what we see: it "thus *reduces* several objects into one glance of the eye, so as to make them but one."[10] Indeed, the organ of sight turns the objects we look at into a coherent visual unity, which is obtained through a reduction. It is then a simple matter for the theorist to enjoin painters to follow the example of nature, since they are its imitators.

That is why de Piles recommends the use of the "convex mirror, which improves upon nature as to the unity of the object in vision: All objects that are seen there with one glance of the eye, make together one whole, and a whole much more agreeable than that which the same objects would produce in an ordinary [flat] glass, or, I will venture to say, even in nature itself.... Let me observe, by the way, that glasses of this sort [that is, convex]... might be usefully consulted, for particular objects, as well as in general, for the whole together."[11] The convex mirror reduces the better to *unify* (we might note with some amusement that de Piles uses a convex mirror, whose optical properties are based on the dispersion of reflected light rays, in order to concentrate the gaze), but this unity is mechanical.[12] The mechanics of a reflection, however, are quite different from the machine of a painting.

"A Machine is a just Assembling or Combination of many pieces, to produce one and the same Effect. And the Disposition in a Picture is nothing else but an Assembling of many Parts, of which we are to foresee the Agreement with each other, and the Justness to produce a beautiful Effect," argues de Piles. The machine of the painting is therefore quite different from the mechanics of painting. The first designates a noble and intellectual part of the elaboration of a painting, which is, for a classicist, "composition," that is, the proper "Distribution and orderly Placing of Things, both in general and in particular," itself subordinated to "invention." The second, however, refers to the inferior and strictly material aspect of the painter's work, to what Du Fresnoy calls the "Hands of the Artist," which has properly executed only harmonies and assemblages. One thus imagines that the mechanics of reflection are still situated on this side of manual work. But if the mirror is just an instrument, it remains an aid for learning how to unite, for the painter and the mirror function according to the same process: the images they produce are judged beautiful

because both reduce the better to unite. But how does one use one's mirror, concretely speaking, in order effectively to "unite"?[13]

Putting into Practice

Unity is a classical principle par excellence, shared by a great many artists. Other painters also recommend the convex mirror and give advice on how to use it. One year before de Piles's *Principles of Painting*, the Flemish painter Gérard de Lairesse had taken the same point of departure. Much like the French theorist, Lairesse writes that "a well-considered disposition of objects" and "a carefully handled coloring" are not enough to produce a good painting if the painter cannot make "the eye wander with pleasure and, as it were, get lost" in the canvas.[14] But if Lairesse recognizes the free circulation of the eye within the canvas as an indispensable condition of a successful painting, for him — as for de Piles — there is no question of an anarchic liberation of the gaze. Quite the contrary, when it comes to drawing from nature "without looking up," Lairesse even recommends drawing the Amsterdam city hall — or any other building that the eye cannot grasp all at once — by the following method (valid "for all pieces with low horizons"):

> Then, I take a convex looking-glass, of about a foot diameter (to be bought at the *Nuremberg* toy-shops), and place it against the Inside of my drawing-board, or porto-folio: I contrive it in such manner, that it may either stand upright, or leaning back, according as I would see things from beneath, or higher. Thus I approach with the open porto-folio, and my back towards the object, till the building, tree, &c. appear as I would have it, and then design it from the looking-glass, on white or blue paper.[15]

The description of this method is interesting because Lairesse describes the vectorial movement with which the artist, begin-

ning with a general view, approaches the motif in order to find a reflection suitable for transposition into a drawing. However, this forward movement does not serve to frame, that is, to delineate, a view or an image, the placement of which would be determined in relation to the format.[16] It consists, rather, in selecting elements within the reflected motif by combining them and *uniting* them in a single reflection, on the principle of selection-combination derived from the classical theory of imitation. This movement is proportionate to the opening of the visual field: the number of elements (trees, buildings, and so on) reflected in the mirror is a correlate of the observer's distance. The mirror is defined less by its edges than as a surface reflecting an image. Thus, only the relation between the size of the format and the convexity has any importance, not the shape of the format. The painter's movement as he approaches his object in order to find the appropriate effect would have something almost Copernican about it, even though Lairesse does not speak of revolving around his motif. It is a question here of a "hodological" method of finding a good composition and of exploiting chance, one that calls back into question the fixity of the one who looks.[17] This forward-and-backward movement, by which the visual field is reduced or opened, is not always possible outdoors. The mirror then serves to get around difficulties encountered in the terrain:

> This method is very convenient for drawing all sorts of large works in narrow places or streets; even a view of twenty or thirty houses. It is also useful to landscape-painters in their country views: They may take whole tracts of land, with towns and villages, water, woods, hills, and sea, from east to west, without having to move one's head or raise one's eyes. It is likewise very natural and useful for those who are unfamiliar with the foundations of *optical perspective.*[18]

The mirror's convexity allows one to envelop a wide prospect within this instrument's narrow field and creates a surplus of distance for the artist when, limited by the configuration of the site, he cannot move back any farther: an "optical" distance is added to the physical one. The mirror is therefore very useful for those who do not know, or understand, the laws of perspective. Thus, the bricolage of a mirror sometimes allows the artist to compensate for a lack of theoretical and scientific knowledge by substituting the resolutely practical and concrete aspect of an experiment — rendered directly observable thanks to this instrument. In the pedagogical sense alone, the convex mirror is a successor to the camera obscura. But implicitly the black mirror goes further than the simple convex mirror because it allows one to reduce the shadows and thus to bring out perspectives by accentuating the lines of the reflected motif: it is no longer enough for the student simply to "copy" them.

Critique

These recommendations for the use of the mirror, to the point of proposing a method for this use, continue to be motivated in the first decade of the eighteenth century by the constant concern to bring optics into harmony with geometry.[19]

When a painter wants to open the field of his picture, he finds himself confronted, on his flat, two-dimensional support, with excessive lateral deformations. At issue here is the difference between the apparent size and the size projected onto the canvas, a result of the transition from three dimensions to two. Consider the example of a colonnade seen in central perspective: "Beyond the right angle, . . . a lateral surface occupies more space on the plane of the painting than it does when it is represented frontally, or at a lesser distance, and this is very paradoxical" (figure 9.1).[20]

The two major solutions found by painters are therefore either

91

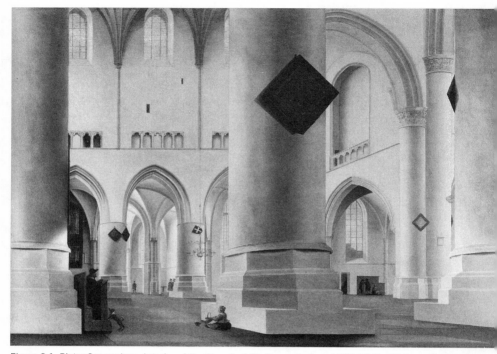

Figure 9.1. Pieter Saenredam, *Interior of the Church of St. Bravo, Harlem*, 1637, 59.5 x 81.7 cm, National Gallery of London.

Figure 9.2a. Distortion inherent in rectilinear perspective in Philippe Comar, *La Perspective en jeu: Les Dessous de l'image* (Paris: Gallimard, 1992), p. 68.

Figure 9.2b. Distortion inherent in curvilinear perspective in Comar, *La Perspective en jeu,* p. 69

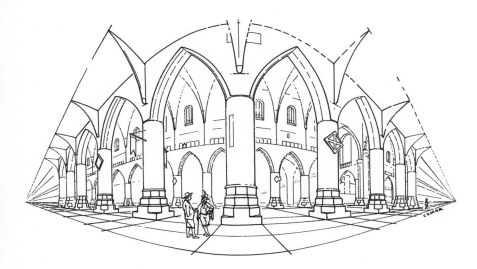

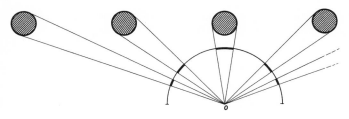

to move the plane of the painting back in such a way as to narrow the angle of vision, and thus to eliminate the problem of lateral deformations, or to deal with these deformations by trying to reduce them, by means of curvilinear perspective (or synthetic perspective), for example (figures 9.2a and 9.2b). The telescope or the optical tube fully accomplishes the former solution by delineating a very small portion of space. But the effect of the Claude mirror, because of its convexity, is closer to that of curvilinear perspective. It is in this respect that William Gilpin is mistrustful of this mirror that "enlarges fore-grounds beyond their proportion. Thus, if you look at your face in a speculum of this kind, you will see your nose magnified. The retiring parts of your face will appear of course diminished."[21] Gilpin points out the error occasioned by the mirror's reduction. This statement is interesting, for it contradicts, or I might say it caricatures, my own experience. In fact, I imagine that his mirror, which seems similar to Thomas Gray's, is quite simply one of those unsuitable mirrors whose excessive convexity creates exaggerated distortions.[22] Ordinarily, when the convexity is very slight, as I have already mentioned, the reflected image only slightly opens the field but does not deform it to the extent of Parmigianino's *Self-Portrait in a Convex Mirror* (figure 9.3).

It is interesting that Gilpin pointed out this deformation of the foreground reflected in his mirror, for this remark also recalls that for him, if "the Fore-grounds are essential to landscape: *distances are not*."[23] Indeed, as he reveals in his *Three Essays*, the foreground is like the "basis" and the "foundation" of every image. That is why "the foreground is more so [that is, more essential] than any other part in *forming a composition*."[24] This idea is quite common; one finds it in France, for example, in the marquis René-Louis de Girardin, the author of a treatise on the art of gardens: "In a real landscape the border is naturally formed by the fore-ground, and

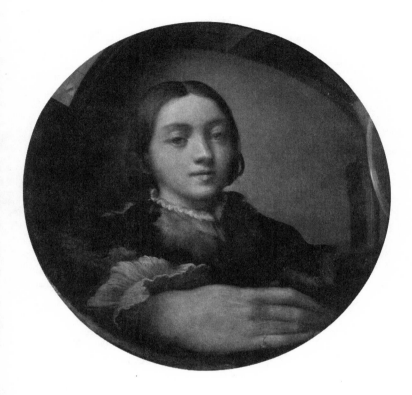

Figure 9.3. Parmigianino (Francesco Mazzola), *Self portrait of Parmigianino in a Convex Mirror,* 1524, oil on wood, diameter 24.4 cm. Kunsthistorisches Museum, Vienna (Erich Lessing/Art Resource, NY).

the masses in front."[25] The border or frame (*cadre*) is therefore less synonymous with a circumscription, a total delimitation of a section of countryside, than with a "fore-ground."[26] This observation would explain why, finally, all the users of the Claude mirror in this period seem to have repudiated the shape of its format — whether round, rectangular, or oval. The foreground's function as a basis for the composition renders the question of the framing (*cadrage*) irrelevant.[27]

Gilpin, pursuing his reflections on the convex mirror, its ability to bring together various objects in one glance and to ground the composition, states that the eye is unable to examine simultaneously the "*general effects*" — "*nature at large ... (composition)*" — and "particular objects." On the other hand, the convex mirror brings "composition, forms and colours" closer together. Thus the eye "examine[s] the *general effect*, the *forms of the objects*, and the *beauty of tints*, in one complex view."[28] Gilpin goes even further when he adds that a particular advantage of the convex mirror is that it does not alter the focus; that is, it does not alter the eye's accommodation. Indeed, Gilpin notes, when the eye contemplates variously spaced planes in nature, it requires different focuses, relative to the movement of the gaze from one plane to another. That is why our instrument can be useful, because "in the mirror, we survey the *whole* under one focus," which is inseparable from the importance given to the foreground.[29] This problem of accommodation obliges the painter to choose a manner, or even a method, since on the surface of the paper or the canvas he is led, in principle, to give equal treatment to the motifs in the center and those on the periphery, the near and the far. In his way, Gilpin says that the convex mirror allows him to grasp the landscape in a single glance, like a painting, and that the organ of sight does not need to focus, as it must with a telescope.[30]

These problems of accommodation intersect with that of the

distance of the motif. Gilpin complains that objects reflected in the Claude mirror are not presented with their proper distances, "but are evidently affected by the two surfaces of the mirror, which give them a flatness, something like the scenes of a playhouse, retiring behind each other. — The convex-mirror also diminishes distances beyond nature, for which the painter should always make proper allowance."[31]

The fruitful experiments of Rupert Feuchtmüller are very revealing in this sense. In his work on the Austrian painter Ferdinand Waldmüller, he reproduces three different views of Hallstätter Lake with Mount Dachstein in the background: an old photograph, a drawing, and an oil painting by Waldmüller.[32] Like the photograph, the painting brings Mount Dachstein very close to the spectator, whereas in reality the mountain is 20 kilometers away. The professor also found the location from which Waldmüller painted *Das Höllengebirge*, which is also reproduced in his work.[33] The spot is located above the Hoisenradalpe, and the Höllengebirge is 20 kilometers from there as well. With this in mind, Feuchtmüller reconstructed a black mirror by placing a black sheet of paper behind a piece of glass, correcting the reversed image with a silver mirror in order to reproduce Waldmüller's method and the effect of his paintings. In point of fact, the black mirror reduces the distances separating the motif from the spectator.[34]

This desire to give equal treatment to both foreground and distance, to both the center and the periphery of the painting, is nothing new. A number of artists, such as Roger de Piles, Gérard de Lairesse, and William Gilpin, all users of the mirror, had sensed that the visual field is neither homogeneous nor "isotropic." I agree that vision is only good in the foveal area and that outside this area there is a loss of precision caused by the division of labor between the rods and the cones in the retina;[35] but I am much more hesitant to say that while horizontal and vertical

shapes appear "normal" in distance vision, close up they appear to recede and in peripheral vision even to be curved, as though undergoing distortion. I certainly cannot say that I perceive such deformations, in any case not with such distinctness. And yet it is easily demonstrated on paper using geometric calculations — which scientists and philosophers have done. Therefore, if such deformations occur, it can only be at a primary cerebral level that we will call — incorrectly but for the sake of simplicity — unconscious.[36] The occipital cortex corrects these deformations. That is the entire problem of the interpretation of the horopter, the subject of work done by André Dubois-Poulsen and Roger Bonnet, who are briefly mentioned in Yves Legrand.[37] The horopter is the portion of space between a curved concave surface close to the observer and another curved convex surface farther away (figure 9.4). All objects in this space will be seen clearly. All those slightly outside it produce a diplopia, or double vision, that is corrected at the cortical level but that is also at the origin of the perception of relief. For my part, then, I will speak of a "psychological optics," not of "visual" or "retinal images" but of "mental images" — which are neither flat nor curved! Thus the Claude mirror, curvilinear perspective, and other modes of representation have nothing realist about them, strictly speaking, but *translate* this poorly systematized "unconscious" vision of the world around us.[38] In this regard, a video in the touring exhibit *Young Gainsborough* showed how the Claude mirror opens the visual field.[39] The horopter as we conceive it since the work of Marius Tscherning is directly related to the problem of opening the visual field. From a certain point of view, the mirror would provide us with a rough equivalent of the horopter. This comparison between the Claude mirror and the horopter, in terms of opening the visual field and suppressing depth, or relief, is therefore only possible if taken metaphorically.

Figure 9.4. Schema of the horopter.

Gilpin himself knew how to distinguish between theory and practice. The convex mirror is for the reverend more an intellectual aid than a strictly optical aid. The instrument serves as a metaphor that helps him to clarify the theoretical problems of accommodation relating to the spacing of the different planes in an observed scene, as these were evoked above: "This change of focus, in theory at least (I doubt, whether in practice), occasions some confusion."[40] Gilpin's not doubting the capacities of the eye in practice suffices to limit the importance of the mirror for him. The convex mirror therefore does not necessarily have to be used in a literal way when executing a sketch or a painting, and, as we will see later, this is very important when it comes to the theory of imitation.

On the metaphoric use of the Claude mirror on the optical level, we must add that geometric optics tends to present retinal images as projective drawings. The images one imagines seeing projected onto the curved surface of the retina would therefore undergo peripheral distortions. But here, too, it is a matter of a vision of the mind, a geometric projection, for a painting does not represent an image seen through an eye: the real object, like the painted object, is an object of the gaze. A painting is not an image of vision itself. And there is no eye within the eye to give a vision of vision, as there is a consciousness of consciousness in Edmund Husserl. If sight is also the sight of something, it is not seen by itself. One is therefore very far from the idea of the Claude mirror as an eye in the palm of one's hand. And this explains why someone like Gilpin or Gray can compare the reflection he sees in the mirror to a painting.[41]

Thus the Claude mirror, a reductive instrument, is a supplement to vision; but as Jacques Derrida has shown, the notion of supplement has two indissociable meanings.[42] In the first, the mirror is a surplus: coupled with sight, it constitutes an increase

by adding a plenitude to another plenitude. The black mirror emerges as a supplement of painting and is enriched by this cumulative function. But it also supplants. In this sense, the mirror is less an addition than a replacement: it is put "in the place of"; it fills a void. In certain cases, it supplements a breakdown, even an impossibility of sight: the mirror becomes a *prosthesis* of the eye when Gilpin writes that through the principle of reduction, it allows one to see the different planes with equal distinctness.[43] But it remains merely a surplus when he takes his distance from it, trusting to the sufficient capacities of the eye for painting, drawing, or simply seeing. The Claude mirror thus oscillates between these notions of prosthesis and surplus, each one being effaced by the other, without its ever being possible to dissociate them completely. These two functions, adding and substituting, belong to one and the same instrument. The black mirror is always exterior to sight and cannot be confused with it. That is why the mirror is a supplement to and not a complement of the eye.

CHAPTER TEN

A Reductive Mirror:

Regarding Tonality

Premises and Hypotheses

We have seen the implications of the phenomenon of reduction in the Claude mirror as they pertain to the visual field. Now we will look at those relating to colors, which become apparent during the Italian Renaissance.

In order to know whether their paintings were well composed, a number of artists used a mirror, placing it in front of the work as a test. Leonardo da Vinci himself recommends deferring to a flat mirror as a "master of painters." Indeed, he says, mirrors and paintings show many resemblances: both have one flat surface that, among other things, "by means of outlines, shadows and lights, makes objects appear in relief."[1] Similitude is the great creative principle in Leonardo, as it is in the Renaissance as a whole.[2] However, a certain disquiet enters into the process, for very soon he is unable to see the difference between the mirror and the painting: "I say that when you paint you should have a flat mirror and often look at your work as reflected in it, when you will see it reversed, and it will appear to you like some other painter's work, so you will be better able to judge of its faults than in any other way."[3] For a brief instant, the mirror creates an effect of surprise through reversal. This lateral shift produced by the mirror gives

the painter the impression of looking at a painting by another artist and in a certain way provides him with the necessary distance for judging his own work.[4]

For Girolamo Cardano, however, the corrective use of the mirror in painting takes a particular turn: "The mirror uncovers several things that were latent, since it shows things that are on the other side.... The mirror uncovers faults by changing the original order that made the painting agreeable in the first place."[5] This specular inversion, which "shows all things in a contrary order" and allows one to discover the first order of the painting, is in some ways similar to the workings of a decryption mirror. The order remains hidden "up close" but appears distinctly when seen "from afar." For Cardano, the mirror serves to make "comparisons," as long as we understand "comparison" in the sense of a contrast or a foil and not, as Leonardo did, as involving only resemblances.[6] In the eighteenth century, the use of the mirror will be defined through the evaluation of differences among a painting, a reflection, and an object.

On the other hand, this object provides another, no less interesting lesson, principally concerning color in the widest possible sense. For Leon Battista Alberti, the mirror enables the painter to judge the force of colors. Indeed, this great theorist recommends changing "the color with a little white applied as sparingly as possible in the appropriate place within the outlines of the surface, and likewise add some black in the place opposite to it."[7] This is done to create relief. Alberti then advises the painter to continue until he senses that he has "arrived at what is required." As for knowing when to stop adding white and black, the theorist claims that "the mirror will be an excellent judge. I do not know how it is that paintings that are without fault look beautiful in a mirror. ... So the things that are taken from nature should be emended by the judgment of the mirror."[8]

Although Alberti did not know how to explain this effect of the mirror, he completely understood how to use it to its best advantage.[9] He inferred that unlike the mirror, the eye is not necessarily the best judge, and he concluded that things are more beautiful when reflected in a mirror than when observed directly in nature. He grasped the way in which the mirror simplifies the diffuse play of colors, as well as perspectival scaling, thus allowing the painter to gain in intelligibility and precision.[10] For Alberti, the mirror serves to "illuminate" the painting. It makes the illusion possible.

But as Samuel Y. Edgerton Jr. remarks, "Alberti still observed atmospheric perspective through the 'dark' glasses of Aristotelian and Medieval optical theory."[11] Later, one again finds this perspective — which represents depth by means of an increasing darkness — in the experiment of the *galerie perpétuelle*, a veritable optical abyss created by placing two mirrors face-to-face. Depending on the quality of the mirrors, the light loses a bit of its intensity with each reflection. Thus, for mirrors that absorb an eighth of the light with each reflection, for example, all luminous reflection ceases completely at the eighth, and last, reflection. "Each of these mirrors repeats the objects more and more dimly as the reflections become more numerous." Eventually the eye can no longer distinguish anything other than darkness, because the light has been totally absorbed.[12] Now, in this catoptric box the operator is supposed to place between the mirrors some boxes "artistically" painted on each side (with trees, colonnades, and such), so that their reflection gives the illusion of "an entire walkway, very long, whose end lies farther than the eye can see." Edme-Gilles Guyot insists on the illusionistic effect of his box, but the illusion here is the reverse of an aerial perspective: the effect of depth is given by the progressive darkening of the view contemplated through the peephole in the box, whereas classical perspective

shades its tones from a dark foreground (generally brown) to a light background (commonly light blue).[13]

Now, according to this experiment, if every mirror already absorbs and reduces the light it reflects, every reflected image will therefore be slightly tinted, because it is thus tainted. This means also that every mirror is already in some way a black mirror. However, for someone like Leonardo this remains impossible, for there is an identity between the reflection and the reflected. If for him the mirror has something mysterious about it, its reflection is inseparable from painting, where painting is understood as a second-degree reflection. Thus when Leonardo asks, "Why are paintings seen more correctly in a mirror than out of it?" he can find no answer, since by refusing to distinguish between the illusion of nature and the conditions of the artwork, the master inextricably binds the latter to the former: art(ifice) cannot be superior to nature, and Leonardo states on several occasions that natural signs are superior to arbitrary signs.[14]

Despite this, it is in my view completely legitimate to ask whether a number of these mirrors, notably in Alberti's case, might not be black mirrors. Far be it from me to want to turn every mirror we find into a black mirror! The resistances produced by Neoplatonism during the Renaissance would forbid us to do so. But a series of observations obliges us nonetheless to pose the question.

Parenthesis on the Tain

These considerations on the absorption of the image by the mirror oblige us now to open a parenthesis, as though in response to an emergency — an incongruous, badly timed parenthesis, perhaps, but one that will be useful in everything that follows.

With the exception of metallic or stone mirrors, which are after all quite rare, Claude mirrors are most often made by tin-

plating a glass plate. They are therefore much like the mirrors we are commonly used to seeing, as Didier d'Arclais de Montamy stressed, except for the color of their tain. The tain is constitutive of the mirror itself. But the tain is not the glass: "It is hardly the surface of the glass that reflects the object represented in it; this reflection is formed on the tint behind the glass."[15] The tain was originally a thin sheet of tin or silver that produces a reflection, a function that is both specular and speculative. Paradoxically, it is also what blocks the gaze and prevents it from passing through the glass: etymologically, the verb "to reflect" means to fold, to flex back, to return, to turn back. Set off from the glass, the tain is a supplement to this glass, but an invisible supplement, for the tain must be effaced for the mirror to play its role and to reflect the image. To use a play on and with words, we could say that the tain must be extinguished (*le tain doit s'éteindre*). The entire process of mimesis requires it, for the effacement of this tain dulls all reflection. This fading prefigures a kind of blindness — but let us not get too far ahead, for we will return to this later.

Now, paradoxically, this alteration of the image — which Thomas West remarked when he proposed a choice between a black and a gray tain, depending on the desired effects — this difference between the reflected and the reflection would be the foundation of the entire question of mimesis in classicism.

We will therefore never cease passing through the mirror to see what is on the other side, to see this tinted tain (*tain teint*), and to bring out, to describe and to inscribe, on this thin sheet that is the tain[16] — but also "on the back" of the mirror[17] — a dissemination of the gaze and the image.[18]

Mimesis

More than two centuries after Alberti, Roger de Piles translated the Latin poem *De arte graphica* (1673) by Charles-Alphonse Du

Fresnoy; he also published a related series of "Remarques." In two separate notes, de Piles introduces a substantial discussion on the use of the mirror by painters, a question treated by Du Fresnoy. I will state my hypothesis abruptly: in this case, we must be dealing with a black mirror, even though de Piles never specifies its color, but only its shape, which he refers to as "convex."[19]

In fact, his entire demonstration presupposes that it is necessarily a question of a black mirror.

Let's take a look.

In the third, and last, element of *The Art of Painting*, which is called "Chromatics, or Coloring," de Piles, in this war opposing defenders of coloring and those who emphasize drawing, declares in a direct and provocative manner that light and shadow count "among the colors," for they are "nothing else but *white* and *brown* (or dark)."[20] De Piles then presents three "theorems" on light. He states not only that light and dark are part of a unity, in a synthesis called "clair-obscure" — "light-dark," or chiaroscuro — but also that the relations of light and dark should be understood as a means of composition. In a lecture presented to the Académie Royale on November 5, 1678, Henri Testelin will even go so far as to claim that light-dark is a principle not only of composition but especially of dynamic composition, evoking the "*agitation* and *movement* in [his] figures."[21]

In fact, de Piles is interested less in the correct rules for "the incidence of particular lights and shades" for each object than in "the knowledge of general lights and shades," which properly speaking is called *clair-obscur*, or chiaroscuro (rendered by de Piles's translator as "claro-obscuro"). This knowledge lies in the effective distribution of light and shadow that "ought to appear in a picture, as well for the repose and satisfaction of the eye, as for the effect of the whole together."[22] Initially de Piles opposes an imaginary chiaroscuro to the essentially geometric effect of the

lights. But later he subordinates the effect of particular lights to a generalized chiaroscuro, "as the whole includes a part." He notes in passing that chiaroscuro "adds to this preciseness the art of giving objects more relief, truth and apparency."[23] Here we find de Piles's entire art of compartmentalizing and hierarchizing the parts of the painting according to a pyramidal model. Thus, when it comes to chiaroscuro, he is attracted more by the effect than by its fidelity. Assuming the rules of correct incidence have been established, he is concerned only with an understanding of the composition as a "whole together," for chiaroscuro, which depends on coloring and not on drawing, must not be determined by its positioning, that is, by optical laws.

To demonstrate and to justify his claim that chiaroscuro is, through its *unity of light*, one of the means for creating a *unity of object* — that is, the painting, the other means being the *union of colors* — de Piles offers four "proofs." For example, chiaroscuro allows one to direct the gaze by preventing any "dissipation of the eyes" (second proof). Chiaroscuro gives a unity to all the other parts of the painting (lines, colors, drapery) (third proof), and so on.[24] But the first proof is of special interest to us here. Nature, as it presents itself to the painter in its infinite diversity, "is almost always defective." Chiaroscuro, then, enables the artist to "reduce it into a perfect state."[25] Thus, in order to achieve a pleasing pictorial effect, a harmony of composition, the artist is first directed to *reduce* shadow and light to a tonal unity.

But this observation remains insufficient: the painter must also take into account the degrees of force of his colors on a scale from white to black. De Piles is concerned to demonstrate this by speaking of the "repose" that is required by vision and that the artist paints in large areas of lights and shadows. He distinguishes two senses of the word "repose." He defines first a repose for the eye obtained by the shaded parts, then something like a play of

relations in which "the Lights may serve for a repose to the Darks" and vice versa.[26] There are two ways to obtain these different kinds of repose: One is natural and comes from light striking the bodies and masses, thus giving the lights and the shadows "naturally." The other is artificial and comes from the "bodies of colors," today called "value." To support his argument, the author refers to the concrete example of print engravers, who "dispose not their Colors as Painters do."[27] Indeed, " 'Tis not but the Gravers can, and ought to imitate the Bodies of Colors by the degrees of the Lights and Shadows."[28] But, says de Piles, it is impossible for them to reproduce the force of a painting that shows "Knowledge of Colors, and of the Contrast of the Lights and Shadows" — and he refers to Venetian works — "without imitating in some sort the Color of the Objects, according to the Relation which they have to the Degrees of White and Black," or without taking account of the "Bodies of Colors, in the Relation which they have to the Degrees of Lights and Shadows."[29]

Engraving, much like the black mirror, enables one to judge both the *clair-obscur* and the "Bodies of Colors" by reducing not only the lights and shadows but also the colors to a tonal unity. This shows the necessity for painters to refer to a coherent scale of values, developed in parallel with a scale of colors. It is therefore not surprising that after his declared enthusiasm for the prints that Rubens had had engraved, de Piles became interested in the "convex mirror," which he viewed as a painter's master.[30] We are beginning to see why I view it as a "black convex mirror." Indeed, Du Fresnoy argues, "The looking Glass will instruct you in many Beauties, which you may observe from Nature; so will also those Objects which are seen in an Evening in a large Prospect."[31] And de Piles comments that since the painter must give all his attention to the "masses" and "the effect of the whole together," he will quite naturally turn to the mirror. But is that not

precisely what the black mirror does — namely, distance "the objects," so that we "only . . . see the Masses, in which all the little Parts are confounded," and show the painter whether, when he examines his painting with the aid of this instrument, "the Masses of Lights and Shadows and the Bodies of the Colors be well distributed"?[32] De Piles even adds that there is a moment of the day most suitable for such observations, namely, "the Evening, when the Night approaches." However, taking advantage of such moments is less convenient than using a mirror, "since the proper time to make [this observation] lasts but a quarter of an Hour," whereas "the Looking-Glass may be useful all the day."[33] If the mirror can thus be substituted for the evening light, then we must be dealing with a black mirror. To those interested in contrasts de Piles thus offers a sort of "day for night" before its time, which will give them the leisure to study their observations. Perhaps he could have helped Sébastien Bourdon avoid the haste he describes when trying to capture a sunset's accidents of light, which "are only momentary."[34]

The most astonishing thing is perhaps yet to come: de Piles affirms that "Giorgione and Correggio have made use of this Method" — namely, the black mirror, if my supposition is correct — in order to judge the distribution of the "Masses of Lights and Shadows" and of the "Bodies of the Colors," as we just saw.[35] But they were apparently not the only ones. Thus, after Alberti, perhaps, and more certainly than Giorgione and Correggio, Il Bamboccio and Le Guaspre used it. Mary Philadelphia Merrifield informs us of this after a conversation she had with a certain "Signor A.":

Signor A. showed me a picture by Bamboccio (Pieter van Laer), and at the same time informed me he possessed a black mirror which was used by this artist in painting, and in which the subject was reflected, "exactly," he said, "like a Flemish landscape"; "and then," he added,

"they had only to paint what they saw in the mirror." This mirror was bequeathed by Bamboccio to Gaspard Poussin; by the latter to some other painter, until it ultimately came into the hands of Signor A.[36]

To be sure, this is not firsthand information from the mouth of the artist himself.[37] Nevertheless, this kind of report remains interesting as a testimony to the way in which the paintings of the masters were perceived, whether in the nineteenth century with Merrifield or in the seventeenth century with Du Fresnoy, when he writes that Correggio "painted with so much Union, that his greatest Works seem'd to have been finish'd in the compass of one Day; and appear, as if we saw them from a Looking-Glass."[38]

Thus, in a good number of cases, the mirror used by painters for painting and for judging their paintings is revealed to be a black mirror without its being expressly named. It remains for us to explain the physical and physiological reasons for this use.

A Smoking Mirror

Gilpin's use of Claude mirrors and glasses during his excursions renders the problem of tonality much more complex than it appears at first. Indeed, the dark tone to be applied to a painting goes beyond the relatively simple question of the composition as a "whole together." Even in his childhood, Gilpin felt the necessity of tinting his drawings: "I well remember ... when a boy I used to make little drawings, I was never pleased with them till I had given them a brownish tint. And, as I knew no other method, I used to hold them over smoke till they had assumed such a tint as satisfied my eye."[39]

He thus felt it necessary to tint his works brown, but not because he sought to give them the respectable tone of the grand masters' aging paintings — a technique that was commonly applied to copies made after these venerable paintings, often by

unscrupulous dealers.[40] Rather, he wanted to achieve a tonal unity in the light of the compositions, a unity he seems to have found in the paintings of Lorrain: "How often do we see in the landscapes of Claude the full effect of distance; which, when examined close-ly, consists of a simple dash, tinged with the hue of nature, inter-mixed with a few expressive touches?"[41]

To explain himself, Gilpin comments on two personal engrav-ings that he includes in his *Three Essays.*[42] They are two illus-trations of the same landscape; however, the light is distributed differently in each. The first gives us an idea of "a simple illumi-nation," namely, that "the light falls strongly on various parts, as it often does in nature" (figure 10.1). This engraving is thus pre-sented as something one can *effectively* perceive in nature. One can also interpret it as a simple reflection — the implication being that this reflection is a servile copy of nature without any de-formation, a sort of reflection in identity. The second engraving shows the same landscape, "only better inlightened," he says, for the artist's objective is to "take nature in her most beautiful form" (figure 10.2). This engraving shows how the painter "chuses to throw his light more into a mass." Massing light means, for Gilpin, that light "must not be scattered in spots," as on the side of the rock face in the first engraving, but "must be brought more to-gether," as shown by this same rock face in the second engraving. To conclude, Gilpin explains that this light, in the second engrav-ing, "must be graduate also in different parts, so as not to appear affected."[43]

We have, then, two engravings, one of which presents itself — this is the idea at least — as a view of nature as it "really" is, the other of which is a reduced view of nature where the light is massed. Now, the reduction brought about by the black mirror produces a similar divergence and a similar effect. This thought is also expressed by Uvedale Price, for whom Mr. Hamilton is the

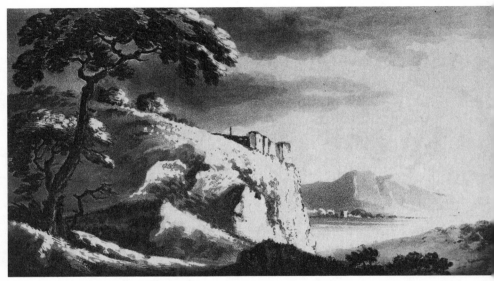

Figure 10.1. William Gilpin, *Landscape*, engraving, in William Gilpin, *Three Essays: On Picturesque Beauty; On Picturesque Travel; and On Sketching Landscape*, 3rd ed. (London: T. Cadell and W. Davies, 1808), p. 61.

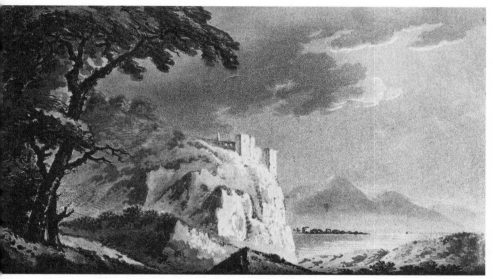

Figure 10.2. William Gilpin, *Landscape*, engraving, in William Gilpin, *Three Essays: On Picturesque Beauty; On Picturesque Travel; and On Sketching Landscape*, 3rd ed. (London: T. Cadell and W. Davies, 1808), p. 63.

spokesperson in his *Dialogue on the Distinct Characters of the Picturesque and the Beautiful*:

> "You will then certainly allow, that the real carcass of an ox reflected in such a mirror, would lose part of its disgusting appearance, though the detail would be preserved; and still more so, if the mirror should be one of the dark kind, which are often made use of for viewing scenery." ... "Let us then," continued Mr. Hamilton, "apply this to painting. If, for instance, the ox in that Rembrandt, which (as in the case of the dark mirror) is of a lower tone than nature, and in which the detail is skillfully suppressed, were painted in the same full light, and with the same minute exactness as this head of Denner, you would probably turn with some disgust from such a crude, undisguised display of raw flesh."[44]

The Claude mirror thus allows Price, through a reduction of the range of colors to contrasts of light, to reduce the repulsive aspect of this carcass, which would otherwise verge toward carrion. In a sense, the black mirror enables one to "smoke" the rawness of this flesh, the cruelty of the real. Again, one finds oneself less within a scale of tints (colors) than within a scale of tones (values).[45] Smoking is in fact not merely an image. Sir Joshua Reynolds literally smoked a painting by placing it next to a fireplace, originally in order to dry it; when the wind was caught in the chimney, a layer of soot was blown onto the canvas: this fortuitous darkening of the overall tint pleased the painter.[46] Price's black mirror carries out this extreme distancing in another way, for the purposes of looking at a painting recommended in 1715 by Jonathan Richardson in a chapter on composition. Richardson encourages the spectator to step back beyond the habitual viewing position, to the point of no longer being able to "discern what Figures there are, or what they are doing." The painting then appears only

"to be composed of Masses, Light, and Dark; the Latter of which serve as Reposes to the Eye."[47] Thus, the disappearance of the subject is followed by the appearance of a harmony of light, tempered by the counterpoint of dark areas, an effect quite similar to that of the black mirror.

The mirror's ability to smoke raw colors is also recognized at the beginning of the nineteenth century by François-Xavier de Burtin. He finds it necessary to explain that a mirror (here, too, I suspect he is referring to a black mirror) can only be useful for the painter and only in the process of executing a painting — as a way to reduce his work, to take some distance from it,[48] to judge it better and to correct it — and not for the spectators, who would later adduce the corrections the painter himself should have made:

> In no way do I approve the practice of judging paintings in a mirror: for a mirror denatures a painting's true *effect* by softening it and makes its rawness disappear, as well as its lack of accord and harmony. These reasons may make the mirror favorable to certain painters who use it to show their works to other people, instead of using it only for themselves while they are working on them, according to the example given by *Giorgione* and *Correggio*, in order to discover the effect of the colors, the masses, and the *whole* of their painting.[49]

Physiological Considerations in the Nineteenth Century

To fully grasp the reasons for smoking raw colors, we must consult the work of Hermann von Helmholtz from the second half of the nineteenth century. A specialist in physiological optics, Helmholtz worked to define the notion of brightness. In fact, the reality the painter would represent presents extreme differences in brightness, that is, in luminosities; put another way, there are infinite tones for a single color on a scale from dark to light. But the colors available on an artist's palette cannot offer such a wide

variety of tones: the visual impression, the brightness of a sheet of paper, even in full sunlight, cannot equal the luminosity of the sun itself. On the other hand, the human eye is sensitive to the relations between different levels of brightness; these are therefore experienced not absolutely but relatively. The artist must then seek to produce on the eye of the spectator of average sensitivity the dazzling light of the sun as well as the repose of moonlight. It is a question no longer of copying reality but of giving a "translation of his impression into another scale of sensitiveness, which belongs to a different degree of impressibility of the observing eye."[50] The painter's task is therefore to produce for the viewer "what appears [to be] an equal difference for the spectator of his picture, notwithstanding the varying strength of light" within an exhibition space whose proportions of observable brightness are quite different from those of the reality outside.[51] And these relations between different degrees of brightness can only be established "in a uniform light," that is, in relation to a given quantity of total light; this is the principle of Fechner's law.[52]

Helmholtz explains why painters make such an effort to accentuate contrasts, why "they make all dark objects more like the deepest dark which they can produce with their colors, than should be the case in accordance with the true ratio of luminosities": their canvases will be seen indoors. Thus, he writes, in Rembrandt's paintings — we might recall the ox carcass referred to by Uvedale Price, whether reduced in a black mirror or not — the light parts are represented as very light and brilliant, whereas "the shadings in the direction of darkness are very marked."[53] But is not the role of the black mirror also to accentuate contrasts, to bring out the bright parts through a supplementary darkening of parts that are already dark? Through his use of the mirror, Pierre-Henri de Valenciennes, among many others before Helmholtz, demonstrates an admirable intuition of the question, which he summa-

rizes in the following way: nature is so difficult to copy because it is too "brilliant." The black convex mirror will represent nature in a weaker light: "Since, then, the bright elements are less intense and brilliant than nature, the means used in Painting to render the luminous tone of these lights are equal in value with those reflected by the black mirror." If the painter wanted to render natural light, he could never "copy it to the point of illusion."[54]

Rather confusedly, Du Fresnoy had sensed the problem when he advised the artist not to paint "High-noon, or Mid-day Light, for we have no Colors that can ever be equal to it"; instead, paint "a weaker Light," like that of the evening.[55] Of course, this reduction of light correlates to the size of the painting. The smaller the painting, the less luminous it will have to be:

> Those who have only corporeal eyes with which to see this truth need only consider large paintings, and even the natural world, in these slightly concave mirrors or glasses, which several painters use for this subject, and see if they present to the eye such solidity, distinctness, and intensity of color, as those of which it is a question [that is, as those being reflected]; the same is true for cards and paper seen through a magnifying glass.[56]

This remark, directed at the stubborn, will be appreciated all the more if we note that it was made by Abraham Bosse, who violently criticized Du Fresnoy on questions of perspective.

By stating that painting imitates "the action of light upon the eye, and not merely the colors of bodies," Helmholtz and his age of discoveries in physiological optics gave (whether deliberately or not) a new momentum to the interest — at least for us — that one might bring to the Claude mirror.[57] If the reductive and discriminatory task depends directly on the eye, in a broad sense, it will not be accomplished as easily without this instrument.

This reduction effected by the Claude mirror, this divergence from the real, is a notion one finds in photography. Indeed, among the very few people in France who, to whatever degree, are familiar with this instrument, half of them work on photography — for example, Jean-Claude Lemagny, Paul Jay, Jean-François Chevrier, and especially Anne Baldassari.[58] As E.H. Gombrich writes, "The black-and-white photograph only reproduces gradations of tone between a very narrow range of greys." A few pages later, he mentions the Claude mirror, which was supposed "to aid the painter in this transposition of local color into a narrower range of tones . . . and was supposed to do what the black-and-white photograph does for us, to reduce the variety of the visible to tonal gradations."[59]

Thus the fact that Edouard Manet and Edgar Degas were familiar with this instrument is perhaps no longer as surprising as many people initially believed.

Speaking in his *Souvenirs* of Manet, whom he had known since childhood and with whom he studied for a time in the studio of Thomas Couture before embarking on a more literary and political career, Antonin Proust quotes his friend as saying the following:

> Yesterday, Renaud de Vilbac came by. He saw only one thing: that my *Guitarero* plays left-handed on a guitar strung to be played with the right hand. What is there to say? Just think, I painted the head in one go. After working for two hours, I looked at it in my little black mirror, and it was all right. I never added another stroke.[60]

Thus, when Manet speaks of using the black mirror — and X-ray examinations of the head seem to confirm his statements — he does so, apparently, in the manner of those Renaissance painters who saw it as a "judge" and "master."[61] But he says nothing more about it. He does not say that he used it to paint the *Guitarero*, which would explain the reversal — as in a mirror — pointed out by Vilbac,

Figure 10.3. Edouard Manet, *The Spanish Singer*, 1860, oil on canvas, 147.3 x 114.3 cm, Metropolitan Museum of Art (gift of William Church Osborn, New York, 1949).

but only that it was a means of verifying the work's equilibrium (figure 10.3). Degas tells us how to interpret this remark from Manet.

When Daniel Halévy visited Degas, as he regularly did, he would often read to him; on one occasion, he read this passage from Proust's *Souvenirs*, which had appeared in *La Revue blanche*. Degas offered this reflection: "You have read how Manet used a black mirror to gauge values. All that is very complicated. What can they ['all the people' bustling around his canvases] understand about it? Nothing!"[62]

As his master, Couture, had shown him, Manet avoided "seeing the succession of intermediate tones that lead from shadow to light." Indeed, for Manet:

> The light is presented with such unity that a single tone sufficed to render it, so that it was preferable, though it might seem brutal, to pass abruptly from light to shadow, rather than to accumulate things which the eye does not see and which not only weaken the intensity of the light but attenuate the coloration of shadows that should be emphasized. "For," he adds, "the shadows are colored with a very varied coloration and are not uniform."[63]

In this sense, the black mirror would do double duty in photography. Indeed, as Aaron Scharf has shown, before 1880 (when orthochromatic plates made photography more reliable) the low sensitivity of negative plates made it difficult to obtain images that were not highly contrasted.[64] To this it must be added that in Manet's time, a propensity for artificial lighting became very pronounced, which — in parallel and in conjunction with the technical problem of the plates — contributed to the elimination of most halftones, those "intermediate tones" of which Couture speaks.[65] We understand, then, that from this point of view, Manet could

not have remained insensitive to the experimentation that photography, in its relations to painting, made possible for him and that he would therefore have turned to the black mirror.[66]

Physiological Considerations in the Twentieth Century

A few decades later, Henri Matisse took the use of the black mirror even further in this physiological approach to its use that we are examining.[67] Indeed, in his hands, the black mirror would become a means of regulating the "succession of impressions," of suppressing the constantly changing variations of light.[68]

Matisse himself gave two detailed descriptions of an experiment he undertook around 1900 while working on *Path in the Bois de Boulogne* (figure 10.4).[69]

On this occasion, the painter used "a small wooden frame, 10 cm on the longer side, the inner rectangle being in proportion to the measurements of a canvas." Matisse thus framed and determined the section of the motif he wanted to reproduce. Next, using a plumb line, he looked for the "tree line closest to vertical" and indicated it on the canvas. Then, with the same method, he says, "I looked for the line of a branch most opposed to the vertical. And indicating every direction I used two brush handles, one of which I held vertically and the other at the same angle as the branch aimed at, doing this for all directions, even the lines of the ground."[70] In describing his own method, Matisse has given us a precious record of how the framing (*cadrage*) obtained by this makeshift viewfinder allowed him to lay out his composition and to give it a stability derived from a geometric rendering of the motif. Matisse was seeking above all to simplify, in terms of both his ideas and their plastic form. "The ensemble is our only ideal," he declared in 1909.[71] To achieve this simplification — which is also characteristic of fauvism — he needed to simplify the drawing as well as the color.[72] However, if Matisse also wanted to exalt

Figure 10.4. Henri Matisse, *Path in the Bois de Boulogne*, 1902, oil on canvas, 65 x 81.5 cm, Pushkin Museum, Moscow (© 2004 Succession H. Matisse, Paris/Artists Rights Society [ARS]).

pure color, he needed to simplify tints.[73] To achieve this end, he turned to the black mirror:

> For the tonal values I made use of a blackened mirror, which had the advantage, for my kind of research, of muting those passages of color which were so bright, they hit the eye directly (seeming to destroy the distance between their source and the eye) and also of enabling one to perceive the gradations from black to white directly — thus values, in the traditional sense.[74]

Matisse thus assembled the elements of a painting, delineated by a viewfinder, whose tonality was provided by the black mirror. This is almost a reproduction of the experiment by Alberti, who initially laid out his compositions with the help of an "intersection," a thin, transparent veil stretched over the frame and divided into a grid by thicker threads spaced at regular intervals; later, as we have seen, he tried in a somewhat confused way to find a solution to the problem of values.[75]

Following the liberation of colors inspired by John Ruskin's idea of "the innocence of the eye" (we will return to this below), impressionism had effectively liberated the eye; but at the beginning of the twentieth century, this liberation was conceived no longer as salutary but as chaotic, not to say anarchic. The calling into question of impressionism, as envisaged by Matisse at the beginning of the century,[76] moves toward an attempt to relinquish the "succession of impressions."[77] That is why Matisse used a black mirror: to fix the impression and thus have the time to paint it. Matisse himself said that although he rarely had recourse to this method, it was nonetheless necessary to him in "fixing my sensibility." At this moment of his development, he says, "I had an impression of the motif which changed every day I stood before the landscape of the previous day." Otherwise he would have had to

finish his "picture in one sitting to have got these sensations ab-
solutely right." At that time, Matisse sought to base himself on
"unchangeable things," on "fixed points," over which his "imagina-
tion would wander." That is why he compares this method of work-
ing to the farrier's "trave" (*travail*), the system of restraints (traves)
used to immobilize horses in order to work (*travailler*) on them.[78]

> One sees a landscape today, Tuesday, one's mind is clear, fresh: one
> has a certain impression of it. One returns on Wednesday, it has com-
> pletely changed, even though the landscape has not been modified, it
> has changed because you no longer have the same disposition. It is
> therefore necessary to be able to find oneself there again every day.
>
> I wanted to work with fixed elements, with unalterable things. I
> took up a small black mirror and I looked at the landscape in my mir-
> ror. One of the properties of this black mirror is that it suppresses all
> sensations of color, like a vermillion red that, when one looks at it
> with the mirror, always seems to come from somewhere beyond the
> surface of the image; it's a trumpet blast in the landscape, it didn't
> suit me. I did not want anything to exceed a rational construction
> that I could find every day.[79]

Variations in light, or any other change external to the artist, in-
terest him less than internal variations, his state of mind and vary-
ing dispositions. Matisse is interested less in what is represented
on the canvas than in the sensations provoked by the light and the
painting; the mirror thus suppresses the more troublesome sensa-
tions. The subjectivity of this conception sharply contrasts with
the objectivity of the instrument on which Matisse's eye finds a
point of support.

Almost twenty years later, the black mirror made another ap-
pearance in Matisse's work, but in a very unexpected way. In
Anemones with a Black Mirror and *Still Life with a Vase of Flowers,*

Lemons, and Mortar, the painter figured this mirror with a large area of solid black paint (figure 10.5).[80] But it is not a question of abstraction here. These paintings are Matisse's response to the problem of color, a problem he wants to resolve without depending on a scale of values — without a black mirror! Pierre Schneider has shown how, during his period in Nice, the anemones, providing a chromatic scale in the canvas, lose their colors by being lightened and create a "somnolence" in the color. This "dozing" of the colors will become inseparable from that of the motif, itself inseparable from a progressive defocalization of the gaze.[81] Indeed, we see in these black-mirror paintings how this triple sleepiness slowly sets in: the diluted tints of the flowers echo the black mirror, the very instrument of reverie, and both are related to that reverie of the gaze favored by a slight "unframing" (*décadrage*). As for the black mirror figured in the painting, it allows for a gradation of tones in the anemones without the interference of a reflection. This figurative return of the black mirror into Matisse's work will again allow him to do without this instrument as soon as his pictorial mastery has been confirmed. But in the meantime, Matisse knows that the laws of simultaneous contrast, and of the contrast of values, make it such that the colors of the anemones still appear less heavy for being placed against the completely black ground of the mirror. Moreover, as John Gage has shown, for Matisse black is not necessarily a "color of darkness," but the inverse. The scientific experiments of Gustave Le Bon on black light were known to the painter, who was inspired by them to bring forth the light of the color black. Black is used by Matisse not simply as a color but more specifically as a "color of light," an idea that was as new as it was paradoxical.[82]

The objectivity of Matisse's black mirror allows itself to be drawn into the whirlpool of a highly subjective painting, fed by the effects of drowsiness and reverie.

Figure 10.5. Henri Matisse, *Anemones with a Black Mirror*, winter 1918–1919, oil on canvas, 68 x 52 cm (© 2004 Succession H. Matisse, Paris/Artists Rights Society [ARS]. Private collection, courtesy Annely Juda Fine Art, London).

The same objective quality of the Claude mirror, however, led the English painter Graham Sutherland, in a rather surprising way, to execute a painting whose color is less subjective than it might appear at first glance. Or, to be more precise, this color, and the dose of subjectivity it contains, were not at all the ones the painter had initially foreseen. Indeed, in 1946 Sutherland painted a large panel for Saint Matthew's Church in Northampton, titled *Crucifixion*, certainly his most well known work. Sutherland would have preferred this crucifixion to be painted "against a blue sky — a blue background" — for a crucifixion with a blue sky, green grass, and warm colors is, "in a sense, more powerfully horrifying." The color the painter finally used, "a bluish royal purple, traditionally a death color," was for him "partly dictated by certain factors already in the church."[83] In his early etchings, Sutherland had formed tones of different luminous intensities based on a complex variety of multiple lines. These etchings in black and white show that he was already capable of detailed description and of observing, simultaneously, the requirements of mass and rhythm.[84] This mastery of tonality was confronted with the requirements of a particular luminosity imposed by "the level of daylight and the creamish-yellow Bath stone" of the church — all of which no doubt explains why Sutherland decided to use the black mirror (figure 10.6).[85] Indeed, the artist went so far as to work for ten days in the church before the unveiling ceremony, adjusting the tones to adapt his crucifixion to these new lighting conditions.[86] One can easily imagine that it was during this period of adjustment that the photograph in figure 10.6 was taken.

Sutherland's use of the black mirror is particularly interesting, since here the instrument serves no longer to modify natural lighting for the purpose of creating an artificial light (or at least a kind of evening light) but to re-create the contrasts of a natural light that has been contaminated by the artificial lighting of

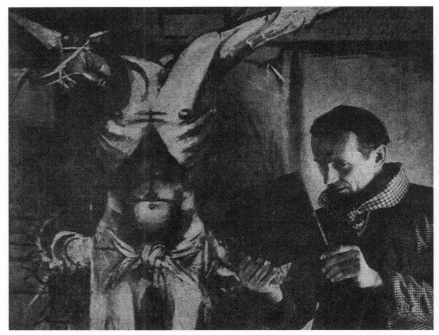

Figure 10.6. Graham Sutherland looking at his *Crucifixion* in a black mirror inside Saint Matthew's Church, Northampton. Photograph reproduced in *The Architectural Review* (March 1947), p. 106.

a church's interior. The black mirror is no longer a source of fantasy; rather, it enables one to correct the fantasy of a lighting system already in place.

By way of an amusing conclusion, we can point out that successors to Claude mirrors and glasses are still used today by photographers and filmmakers — here, too, out of a mistrust of possible fantasies of light and to avoid any unpleasant (because expensive) surprises during shooting. Film emulsion is in fact very similar, in terms of its reactions, to the function of the eye and the retina, in the sense that light provokes a photochemical reaction in the first case and a photo-electrochemical one in the second. A photograph shows the filmmaker Jean-Marie Straub using a Kodak contrast filter (figure 10.7).[87] This filter gives an *idea* — Straub's wife, Danièle Huillet, stresses this word — of what the contrast of the printed film will be. The eye and the brain never stop correcting for variations in light and contrast, but film does not do this, as the cinematographer Renato Berta pointed out to me. For black-and-white film, one uses a yellow filter tending slightly toward brown. There are others for color film, like the blue-tinted filter. For every degree of film sensitivity, a corresponding contrast filter has been created. It is therefore a question not of a colored glass like the Claude glasses, which modify colors, but of a filter that gives an idea of contrasts, like a Claude mirror. In fact, the cinematographer Claude Renoir (nephew of the director) used such a filter as a mirror, which he placed on his nose, sometimes very close to his eye, in order to see a very sharp reflection whose tint and especially tone would be identical with those observable in a good Claude mirror (figure 10.8).[88]

The black mirror that reduces light for artists is the same mirror that polarizes light for scientists. Polarization in fact amounts to reducing, selecting, and transferring light from three dimensions

Figure 10.7. Jean-Marie Straub looking through a contrast filter during the shooting of the single outdoor scene in *Von Heute auf Morgen*, September 1996 (courtesy Jean-Marie Straub).

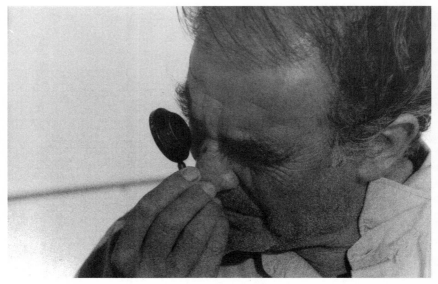

Figure 10.8. William Lubtchansky observing a reflection in his contrast filter (courtesy William Lubtchansky).

to two, particularly in the experiment of Malus that consists in positioning two black mirrors so that they are more or less facing each other.[89] And polarizing filters mounted on photographic lenses serve to reduce certain bright flashes of light.

In view of the preceding, we are in a better position now to understand Valenciennes's opinion and his recommendations concerning the black mirror. Because of the "disadvantages" associated with this instrument in relation to perspective, "one will be convinced that it must be used only in relation to color."[90]

PART FOUR

A Seductive and
Deceptive Mirror

An Idealizing Mirror

The Claude Mirror and the Picturesque

After focusing on the use of the mirror as a painter's master, we must now examine its use by landscape painters, poets, and tourists. This instrument is inseparable from an entire segment of eighteenth-century English aesthetics. And the fashion for the picturesque finally brought the mirror out of the obscurity and relative clandestinity in which it had remained up to then.

The abstraction of nature in the French garden was followed by the apparent liberation of elements that make up the English garden.[1] The latter, a landscape garden envisaged as an Eden, included a number of optical elements such as streams, lakes, and mirrors designed to create imaginary perspectives. Such a multifaceted universe was viable only if the spectator became a walker. Nature was thus no sooner rediscovered in the English garden than it was "transfigured and transposed into a domain of vision and symbolism."[2] This "rediscovery" of nature was contemporary with — even inspired by — the discovery in England of landscape painters such as Claude Lorrain, Salvator Rosa, Gaspard Dughet (Gaspard Poussin), and Nicolas Poussin. Their works were acquired by British collectors and museums and, for that reason, became known not only to artists but also to the aristocracy

of the "grand tour" and the intellectual and scientific circles.[3] Claude Lorrain was particularly hailed by the English. His work offered, among other things, the very example of the notion of assemblage developed by the classical tradition: perfect beauty is of this world, proclaimed Reynolds, but it resides in nature in a fragmentary state.[4] Reynolds reminds us that "Claude Lorrain, on the contrary [to the Dutch school], was convinced, that taking nature as he found it seldom produced beauty. His pictures are a composition of the various draughts which he had previously made from various beautiful scenes and prospects."[5] Going outdoors thus posed no problem for the classicists, who set out to capture the elements of nature that interested them in order later to compose their landscapes in the studio — that is, in order to select and combine — attempting to improve on nature, to purify it of all accident and to erase every trace of combination, in order to make ideal beauty emerge.[6]

To understand this trend, we must also recall that Claude-Henri Watelet defined "view" as "the portrait of a site made after nature."[7] For the artist or the tourist, the practice of the view allows him to transcribe artistically what he sees, what moves him, in the course of his wanderings. This way of looking can be classed under the "picturesque," that is, literally, that which can be converted into a *picture*.[8] In developing a theory of the picturesque, Gilpin established a distinction, at the beginning of his *Three Essays*, "between such objects as are *beautiful*, and such as are *picturesque* — between those, which please the eye in their *natural state*; and those, which please through some quality, capable of being *illustrated by painting*."[9] Choosing objects capable of being illustrated by painting is a problem that goes beyond the picturesque movement, for it concerns the whole of landscape painting. This statement also allows one to grasp the implicit but considerable importance of optical instruments that, as aids in the

realization of views and sketches, will enable the eye and the hand of the artist and the tourist to become accustomed to the production of landscapes.[10] In fact, a reversal occurs: up to then, the landscape engendered the painting; with the fashion of the picturesque and landscape painting, the painting comes to condition the landscape and, with it, our view of nature.

In this interplay between art and nature, gardens began to be laid out like the images of landscape painters. And in the wake of this reversal, painters began to draw gardens. Garden owners then began to demand such things for their parks as the three colors of aerial perspective (brown for the foreground, green for the middle, and blue for the distance) and "eye-catchers," those false ruins that attract the gaze, laid out along horizon lines in order to focus the walker's eye and corresponding to the highlights one finds in paintings.[11] In 1734, Alexander Pope summarized this way of viewing the garden in a well-known formula: "All gardening is landscape-painting."[12]

Since gardens were perceived and composed like paintings, particularly like those of Lorrain (the obligatory reference), it was quite natural to turn to the Claude mirror to find that deep golden light of the master's works. As Gombrich points out, the mirror enabled the landscape painter to reduce local colors to a scale of tonal gradations, from a mellow brown to a pale blue, in order to give an impression of depth.[13] Inversely, the mirror also allows the walker to find the foregrounds with a warm brown tone and the distant backgrounds with the light silvery blue of the landscape painters. In fact, the rawness of natural light constituted, as we have seen (at least in the seventeenth and eighteenth centuries), an anti-aesthetic effect,[14] disagreeable to the very organ of sight, sometimes cruel to the point of engendering ocular maladies or madness.[15] This led to the constant recommendation to contemplate the landscape in twilight. The Claude mirror

enables one to reduce natural light, the last obstacle to perfecting the illusion of the spectacle of nature understood as a painting. With the use of this mirror, "we are not dealing here with an attempt to reproduce nature in a picture" rather "the picture is projected onto nature."[16] Sometimes this reversal is made even more complex through a play of mirrors: "Not a breath of wind troubled the Lake this day; it was consequently a mirrour, and doubled every beauty, while my Convex Mirrour brought every scene within the compass of a picture."[17]

This reversal of relations between the object represented and the painting is extended to all of nature. Artists, like tourists, thus prefer to travel "on foot, like Emile," rather than "by postal coach" or even on horseback, so that nothing "that is worthy of being observed or copied" will escape their view.[18] All the same, this enthusiasm for observation and matters of art was not without a certain disenchantment, for if nature is seen more and more through the filter of art, it is also progressively domesticated, ordered, and industrialized.[19] Nature then finds itself cut into parcels by the enclosures of the property owners who disfigure it — if not by Jean-Jacques Rousseau himself in his methodical concern for botanical description.[20] Very quickly, the garden walls were cheerfully left behind, and, moved by a buried desire for a return to origins, one fled into the recesses of nature that had been spared by civilization:[21] proof of this can be found in the numerous guidebooks published at the time, among them Thomas West's *A Guide to the Lakes* (1778). They show that the walkers, disciples of the theory of the picturesque in their search for pictorial effects in nature, readily entered wild and natural places like the Lake District armed with mirrors, as well as telescopes, in order to enjoy the beauties rendered inaccessible by distance or danger. Moving beyond these material contingencies, these walkers went in search of the wild scenes depicted by Salvator Rosa,

sometimes risking their lives to reach even steeper sites than those, in a quest for ever greater pictorial effects.[22]

In time, the term "picturesque" gradually lost its original meaning and became more and more vague; by the 1820s, it had come to express little more than a certain appreciation for the spectacle of nature, although without leaving behind the reference to landscape painting or to viewing nature without the mediation of the painter's eye.[23] And when one has neither the eye of a painter nor a great deal of money, one may turn to the Claude mirror, which enables the walker to discover directly and accurately what a painter would have produced. This is the "democratic" aspect of this instrument — aesthetic pleasure for all and at a relatively low cost — in that anyone can attempt, without much effort or expense, to create a work of art — an attitude popularized by poetry, guidebooks and the practice of outdoor painting and sketching — as long as it remains clear that these "common men" were in reality "gentlemen," even if they were sometimes low on cash.[24]

Truth and Imagination

The pictorial gaze turned on nature in the second half of the eighteenth century was inseparable from the growing interest in the conditions of the sky and its variations of light. In this sense, Claude Lorrain's landscapes are sometimes interesting less for their idealization of the landscape than for a certain fidelity to intense luminosities and atmospheric effects;[25] one often tends to forget that in order to close one's physical eye (so as to see with the mind's eye, the ideal eye), one must already have opened it. Goethe himself is an agent in and a witness to this slippage from the material to the ideal when he recounts his arrival in Palermo on the afternoon of April 3, 1787, after four hours of travel:

No words can describe the misty transparency that hovered around the coasts as we sailed up to Palermo on the most beautiful afternoon: the purity of the contours, the general softness, the distinctness of the tones, the harmony of the sky, sea, and earth. To have seen it is to remember it for the rest of one's life. Now at last I understand the paintings of Claude Lorrain.[26]

It is worth recalling that Gilpin named his filters "Claude glasses" because of the luminosity they created. Here, too, it is interesting to note another slippage, for the different mirrors, and the Claude glasses especially, allowed tourists — those quickly passing visitors — to discover in an instant the luminous effects produced by nature, for which they would otherwise have to wait.[27] For example, glasses tinted blue or gray could spread a lunar light over an afternoon scene. The "sunrise" glass, which was yellow, quickly transformed the midday sun into a reddish twilight "without the obscuration of the morning mist."[28] Through the "hoar-frost," heaps of corn seen from a distance became mounds of snow. Mirrors or glasses thus enabled one to find, but not to create, a great variety of natural effects for a single landscape. Ordinarily, when such effects are produced by nature alone, one must be continuously present in a location to observe them. And a single passage would not suffice for the tourist to enjoy it and to engage in a detailed study. Those walkers pressed by the brevity of their visits could thus easily modify the weather and the luminosity of a day or a season in the space of a few seconds. These instruments reduced the wait involved in observing such phenomena, giving one a head start on the spectacle of nature and thereby legitimating these fantasies.

For a neoclassicist, nature is too vast to be grasped by man all at once. If the perfection of beauty is of this world, it can only be so in a fragmentary state, as we said earlier. The same is true for the

passing of time: filters thus reduce the time of waiting to a more human scale.

On the same principle, a view reduced in the Claude mirror is transformed into an ideal view, that is, one with a universal character. The Claude mirror eliminates particular details and imperfections. This removal of triviality brings forth an abstraction, that of ideal beauty. The mirror allows one to select and to combine different elements, which the reflection presents as a unity. This transfiguration of things through reduction is inseparable in the eighteenth century from metaphysical thought: Mercurius van Helmont, a cabalist and friend of Leibniz's, claimed in his demonstrations on the cosmos and the relations between macrocosm and microcosm that the largest down to the smallest balls of mercury reflect the entire universe, much like Leibniz's monads.[29] This quasi-metaphysical miniaturization of the landscape, which brings forth ideal beauty by way of a mirror, finds one of its most extreme forms in Coleridge, for whom the Claude mirror, in its relation to the landscape, serves as an analogy for explaining how the mind ordinarily receives the impressions of nature. Disappointed by the city and its evil, he writes with melancholy: "In the country, all around us smile Good and Beauty — and the Images of this divine *kalokagathón* are miniatured on the mind of the beholder, as a Landscape on a Convex Mirror."[30]

Soon all of nature is seen through the filter of the imagination. In Coleridge's hands, the Claude mirror and glasses become instruments that bind nature and poetry together. From this perspective, William Wordsworth attempted to distinguish things as they appear from things as they are, a distinction that gains particular importance when it touches on the imagination. Wordsworth distinguishes in this sense imagery, a means of poetically describing objects as they are, from imagination: "Imagination is a subjective term; it deals with objects not as they are but as they

appear to the mind of the poet. Imagination is that intellectual lens through the medium of which the poetical observer sees the objects of his observation, modified both in form and colour."[31]

Let us recall the disconcerting way in which Wordsworth moved among three conceptions of the imagination. Sometimes the imagination is conceived as purely subjective: the human mind imposes itself on the real world. At other times the imagination is an illumination beyond the control of the conscious mind and even of the individual soul. But most often, in an intermediary position, the imagination fosters a collaboration between the two other conceptions.[32] Thus, when Wordsworth suggests that the imagination is a lens that imposes its extreme subjectivity on the world, this should be interpreted in the light of these three conceptions, insofar as they ensure a continuity between mind and nature. When Wordsworth writes that his principal object was "to chuse incidents and situations from common life ... and ... to throw over them a certain colouring of imagination," so that these ordinary things would appear in an unusual light, he binds together two ordinarily incompatible notions.[33] Coleridge, too, mentions this connection at the origin of his collaboration with Wordsworth:

> During the first year that Mr. Wordsworth and I were neighbours our conversations turned frequently on the two cardinal points of poetry, the power of exciting the sympathy of the reader by a faithful adherence to the truth of nature, and the power of giving the interest of novelty by the modifying colours of imagination. The sudden charm which accidents of light and shade, which moonlight or sunset diffused over a known and familiar landscape, appeared to represent the practicability of combining both. These are the poetry of nature.[34]

One could ask whether this is not a veiled description of the effect of the Claude mirror and glass, for these are no different

from this intellectual lens that is the imagination: they, too, bind together "the truth of nature" (they are optical instruments) and the coloring of imagination (they are tinted).[35]

This romantic fusion of truth and imagination cannot help but blur the boundaries between them. This subversive activity is often at work in Coleridge, particularly in his *Notebooks*. This fusion engenders a confusion translated into errors of perception, which he extends and intensifies by experimenting with them on himself, in the manner of a child. These "childish games" involve "pressing [his] eyeballs close," experimenting with differently colored glasses, perceiving two leaves on a tree as a kite in the air, and so on.[36] While these perceptions nourish his dreams, the dreams — conversely — haunt, double, and parasite perception.[37] Every fusion entails a fission; this is the principle of Romanticism. And as Max Milner has shown, optical instruments, and particularly the mirror, play a primordial role in it.[38]

The ideal beauty rendered by the black mirror begins to take on a disquieting coloration, and this marks the beginning of a disenchanting future.

If nature in Coleridge leads to the idea through the intermediary of the imagination, the idea is nothing other than the union or fusion of the universal and the particular. The idea is an essence, but it is not an abstraction or the equivalent of an image. Neither concept nor image, the idea cannot be generalized or seen, for it is above form: it can only be contemplated subjectively, and it is made accessible only through symbols.[39] The black mirror and the Claude mirror cease being optical instruments and become pure symbols. This is the meaning to be given to Coleridge's convex mirror when he sets up an analogy between the *kalokagathía* (honesty, probity, nobility of soul) and his mirror.

Thus we have seen an imperceptible slippage that transforms the Claude mirror, a strictly optical instrument, into a purely

metaphoric or even symbolic instrument. These two aspects delimit a battlefield, two extremes between which the Claude mirror will oscillate. This space opened by the black convex mirror reinforces the deep ambiguity of this instrument, which constantly deconstructs an entire series of oppositions: optics/ metaphor, reflected/reflecting, ideal/disquiet.

Limits on the Use of

the Claude Mirror

Arguments of Nineteenth-Century Detractors

The Claude mirror had its golden age at the end of the eighteenth and the beginning of the nineteenth century. Although a number of amateurs continued to use it in the mid-nineteenth century, it seems no longer to have been prized by painters who, following John Constable, sought to render the natural light and color of things. John Ruskin played a considerable role in the devaluation of this instrument. Indeed, this rejection originates, curiously, in a long footnote in his *Elements of Drawing*. It is a decisive note, for in it Ruskin defines "the innocence of the eye": the artist must paint like a blind man who has suddenly recovered his sight. This "infantine" vision, however, has nothing childish or infantile about it. Perception, in order to be organized into knowledge, must be founded on the primacy of experience. We do not perceive the third dimension of the world, says Ruskin, but only patches of different colors, or "flat colors."[1] Painting grass green becomes an error because, as experience shows, "sunlighted grass is yellow."[2] The innocence of the gaze is a way of creating a tabula rasa, of unlearning how to look in order finally to become capable of looking. The innocence of the gaze is an insistence of the gaze. However, this "phenomenologist" comes up against the problem

we have already encountered in the representation of the bright colors of nature by pictorial colors. These patches of real color exceed by far the possibilities of painting, for they are brighter or paler than those offered by the palette. Thus, says Ruskin, "we must put darker ones to represent them."[3]

For Ruskin, however, darkening colors means not blackening them but modifying them with tints five or six degrees "deeper" in the gradation scales he conceived for each color. To darken, or, let's say, to make a light blue deeper and richer, one does not add gray or black, but mixes it, for example, with navy blue. To obtain a harmonious image, Ruskin tells us, one ought to gradually deepen the lighter tones, but not the darker ones, so as to bring the ensemble of masses toward the "middle tints." To differentiate the reduction of each color, Ruskin even imagines "pieces of glass the color of every object" of the landscape. These glasses would be quite different from Claude glasses, which globally color the light and reduce it to a general tint. The glasses imagined by Ruskin would reduce each color individually so as to re-create a natural light within the limits of the pictorial medium. Unfortunately, such glasses do not exist; it therefore falls to the artist to carry out this work.[4]

This explains in large part Ruskin's violent opinions on the black convex mirror, which he accuses of botching the colors it reflects without distinction:

> It is easy to lower the tone of the picture by washing it over with gray or brown; and easy to see the effect of the landscape, when its colors are thus universally polluted with black, by using the black convex mirror, one of the most pestilent inventions for falsifying Nature and degrading art which was ever put into an artist's hand.[5]

The black mirror is guilty of "dirtying" colors and "obscuring" light; that is its crime. On the one hand, Ruskin categorically

refuses to wash over colors with black, and, on the other hand, he is in search of a tonal harmony that is not dark but "middle." That is why he is so interested in photography, which offers a means of deepening shadows without darkening them in an exaggerated way — hence his invitation to copy the works of J.M.W. Turner using photographic reproductions of his *Liber Studiorum*.[6]

This notion of substituting photography for the Claude mirror is revealing: the mirror is condemned less for its reduction of colors or diminution of brightness than because, for Ruskin, it is manifestly the emblem of its eponymous model, the aesthetics and the light of Claude Lorrain, that somber luminosity which he had already attacked in his *Modern Painters*. Ruskin readily places himself under the aegis of Titian: either one applies gray to a group of colors to wash them over, which "represents the treatment of Nature by the black mirror" — which is to say by Claude Lorrain — or one reduces them with tints five or six degrees deeper, which "represents the treatment of Nature by Titian."[7] We therefore have two clearly defined models. Ruskin's position can be clarified further if we recall that Constable, at the end of 1823, had already responded to the problem when Sir George Beaumont recommended to him "the color of an old Cremona fiddle as the prevailing tone of everything," of every picture. Indeed, Constable answered by "laying an old fiddle on the green lawn in front of the house," thus demonstrating the difference between the warm tone of a violin and that of a fresh lawn.[8] But as Gombrich remarks, it is more subtly a question for Constable of establishing a connection between the local color and the range of tonal gradation available to the painter.[9] After this well-known anecdote, the rupture with convention and with Lorrain's model was complete. It was therefore difficult for Ruskin to turn back.

It is nonetheless surprising to discover that Ruskin's aversion

for the effect — the rendering — of the Claude mirror was greater than his attraction to its reductive principle. Even more surprising is that he continually proposed methods of visualization that formulated different ways of constructing an optical "truth" for given objects or motifs and that some of these methods are not unlike the tonal abstraction that is one effect of the Claude mirror.[10]

That Ruskin tolerated and even encouraged the use of magnifying glasses, to the point of recommending that one always have one on hand, in the pocket of one's vest, is thus not surprising at all.[11] These instruments simply help one to see better, to use one's eyes better, and to compensate for the defects of vision; they are not used to interpret vision. On the other hand, these glasses permit a direct view of nature, whereas the Claude mirror, in addition to reversing the image, shows a secondhand nature, since the user must turn his back to the motif in order to contemplate it.[12] This attitude is completely unacceptable to Ruskin and the Pre-Raphaelites, whose credo calls for using one's own eyes — the consequence of a verist ideology, an ideology of "live" and direct experience.

Continuity/Discontinuity

As Lindsay Smith suggests, the Claude mirror in Ruskin can be considered the emblematic instrument of monocular vision: in the eyes of the author of *The Elements of Drawing*, it has the great advantage of not privileging depth of field and of showing the scene within a frame that is integral to it. In this sense, it must be opposed to the stereoscope, which emphasizes binocular vision, producing depth of field through the juxtaposition of two almost identical images, combined in the brain to form a three-dimensional image. This image does not require an awareness of the frame, since the "sight of the binocular frames prohibits the possibility of a stereoscopic effect."[13] According to Smith, the Claude

mirror would therefore tend to illustrate the rupture defined by Jonathan Crary, in the passage from a geometric to a physiological optics at the end of the eighteenth and the beginning of the nineteenth century.[14]

But the Claude mirror also allows one to bind together and to enjamb, as it were, these two distinct periods, which therefore have an ambiguous status.[15] Two examples we have already developed will suffice to demonstrate this.

First: Gilpin remarks that the human eye is not capable of seeing simultaneously a general effect and particular objects or of accommodating both the foreground and the background at the same time. The convex mirror thus turns out to be very useful in that it enables the eye to "examine the *general effect*, the *forms of the objects*, and the *beauty of tints*, in one complex view" and to "survey the *whole* under one focus."[16] These optical problems are thus physiological, and the mirror compensates for the histological and accommodative impossibilities of the eye.

Second: Faced with the inability of pigments to render the brilliance of nature, Valenciennes suggests that one use the black mirror to decrease the brightness, which would then be reproducible in a painting and "equal in value with those reflected by the black mirror."[17] The painter attempts not to reproduce the light but to translate its force into another scale. Valenciennes sensed that the eye was sensitive to the relations between different levels of brightness, viewed relatively as a series of relations. In Helmholtz's terms, he attempts less to copy reality than to translate an "impression into another scale of sensitiveness, which belongs to a different degree of impressibility of the observing eye."[18] These relations are indeed physiological, and the mirror plays an active role in this translation.

While Gilpin and Valenciennes belong squarely within a neoclassical *aisthésis* (which for Gilpin includes the picturesque), they

constantly multiply all sorts of physiological remarks, ensuring a transition between seventeenth- and eighteenth-century geometrics and nineteenth-century physiology, enjambing this fundamental rupture between the classicism of the eighteenth century and the modernity of the nineteenth.[19] The term "rupture" is a linguistic convenience; indeed, it designates not a clean break but an interpenetration of these two periods, which are sometimes so noticeably interwoven that their co-presence becomes possible at a certain moment of history. The Claude mirror is thus also an instrument that participates in the transition between these two periods. And it can serve as a transitional element because it was used before and continued to be used after. The use of the black mirror is not limited to a period dictated by the fashions of tourism. Nor could it be buried by Ruskin. Otherwise, it would be difficult to explain how this mirror was used, for example, by Manet in 1861, by Matisse around 1900, and by Sutherland around 1946. These painters looked to the mirror less for visual characteristics — the proper element of the picturesque — than for a specific mode of vision, and they were interested more in sensation itself than in the objects of sensation. As an example, Coleridge was an agent of this reversal when he wrote, "Ladies reading Gilpin's &c. while passing by the very places instead of looking at the places."[20] This object is thus inseparable from modernity as defined by Crary.

Although Ruskin's attitude helps us to explain in part the disappearance of the Claude mirror from the hands of tourists and amateurs, it is insufficient for understanding what led certain artists to continue to use it, for these latter were able to dimly perceive what, in this mirror, went beyond the aesthetics associated with Claude.

The Mirror Criticized by Its Users

Ruskin's theories and those of the Pre-Raphaelite movement were not the only sources of criticism directed at the Claude mirror and glasses. In fact, these instruments seem to have been met with skepticism very early. In an English comic opera titled *The Lakers*, the librettist, the Reverend James Plumptre (1770–1832), presents a minor satire on the gentlemen and gentlewomen who toured the Lake District hoping to convert nature into images befitting the picturesque. When Miss Veronica Beccabunga looks at a landscape spread out before her, stretching from Derwent Water to Borrowdale, she examines it by turns in the gold, then the dark, then the blue filter of her "Claude Lorrain Glasses," exclaiming all the while:

> Speedwell, give me my glasses. Where's my Gray? (*Speedwell gives glasses.*) Oh! Claude and Poussin are nothing. By the bye, where's my Claude-Lorrain? I must throw a Gilpin tint over these magic scenes of beauty. (*Looks through the glass.*) How gorgeously glowing! Now for the darker. (*Looks through the glass.*) How gloomily glaring! Now the blue. (*Pretends to shiver cold.*) How frigidly frozen! What illusions of vision! The effect is unspeakably interesting.[21]

Plumptre wrote this opera in 1797. He published it anonymously in 1798 and sent a copy to Gilpin in 1801, adding a letter of explanation and apology for the "Gilpin tint." Plumptre was himself a fervent believer in these picturesque walks; he was stigmatizing neither the theory nor the effects of the picturesque but the affected attitude of tourists who took themselves for artists in their pursuit of the picturesque.[22] Proof of this comes later when Miss Beccabunga looks at her prospective husband through her filters and says: "I'll throw a Gilpin tint over him. (*Looks through glass.*) Yes, he's gorgeously glowing. I must not view him with the

other lights, for a husband should not be either glaringly gloomy, or frigidly frozen; nor should I like to be haunted by a blue devil."[23] Gilpin went even further in his criticism and was more concerned than anyone to distance himself from the Claude Lorrain glass.

It is certainly tempting to believe that the drawings of the reverend artist, in their oval format and their rusty tint, are somehow an imitation of the image one sees through these filters or reflected in these mirrors.[24] Nonetheless, as Gilpin writes with a sudden gesture of recoil:

> How far the painter should follow his eye, or his glass in working from nature, I am not master enough of the theory of colour to ascertain. In general, I am apt to believe, that the merit of this kind of modified vision consists chiefly in its novelty; and that nature has given us a better apparatus, for viewing objects in a picturesque light; than any, the optician can furnish.[25]

The glasses, like the mirror, are in the end little more than gadgets, in the sense defined by Jean Baudrillard.[26] In the paragraph preceding this passage, Gilpin expresses regret that his view from a window of a hermitage in Scotland, one of the most interesting of its kind, must be seen through windowpanes composed partly of red and green glass. He adds that for those who have never seen such "deceptions," these panes offer a new and surprising effect, transforming "the water into a cataract of fire, or a cascade of liquid verdigrease." But these deceptions are "tricks" in comparison to the dignity of such a scene. These colored panes are certainly amusing, but it would be better, writes Gilpin, if they were placed in frames with handles so that one could use them as one pleased, rather than being permanently installed, constantly imposing their colors on the spectator.[27] Distancing himself from the fashion of the gadget, Gilpin in another work even remarks how easy

it is to replace a Claude mirror or glass by closing one eye and sim-
ply looking with the other eye half-closed, in the small opening
left by the squinting eyelid.[28] On two occasions, he expressed
himself unambiguously: the interest of these instruments resides
in their novelty, which is the result and the effect of fashion. The
renewal of vision they provide is a kind of amusement; they are
toys — for adults. Let it be noted, however, that while these instru-
ments can be considered little more than gadgets, this amusing but
useless object, which simulates complex technology, is also similar
to Baudelaire's "joujou" in the sense that it constitutes an initia-
tion into art and its production.[29]

This aloofness from the instrument is all the more interesting
in that it comes from one of its greatest proponents. It is a very
delicate matter to judge the influence this object may have had on
painters, much less on poets. It is more revealing, however, to
measure the resistance to this instrument and its use. This resis-
tance marks the limit point of the mirror or the glasses. The fact
that for Gilpin these glasses are at bottom only gadgets that mere-
ly seduce with their novelty is perhaps less unexpected than one
might tend to believe at first, for the eye, above all, remains the
best judge. What is being attacked here is the theory of imitation.
For similar reasons, Valenciennes will put the reader on guard
against the use of optical aids before undertaking a critical inven-
tory of them.

It is essential to see to what extent some of Gilpin's engravings
cease being the faithful copy of reflections observed in a Claude
mirror and become veritable and entirely separate works. Michel
Conan has shown how in Gilpin the landscape is "constructed
through a succession of vertical planes, alternately light and dark.
Each vertical plane is treated as a frieze, and the depth of the
image is suggested by the difference of scale between the successive
planes" — in such a way that these works are like "a second nature."[30]

However, as Gilpin remarks in another work in which he criticizes not the Claude glass but Gray's mirror, this instrument gives to nature "a flatness, something like the scenes of a playhouse, retiring behind each other," caused by the double reflection of the two surfaces of the mirror (recall that Gray's mirror is not tinted in its mass but coated with a black backing). He complains that the mirror is unable to present objects "with that *depth*, that *gradation*, that *rotundity of distance*, if I may so speak, which nature exhibits."[31] But although Gilpin's engravings tend to look like layered planes, which certainly indicates the influence of the mirror, the artist worked to mask this succession of planes through subtle gradations. He attempts in his engravings to reproduce that "rotundity" of natural distance — the artist being limited only by a lack of mastery in the processes of aquatint engraving — even while distinguishing himself from it, in order to give not a servile copy but an ideal vision.[32]

In the neoclassical theory of imitation, painting opens a space in which, it is believed, the painting itself works to repair this divergence, this breach. Painting itself opened this space, in an original reductive moment now obscured. Recall that nature, while perfect in its principle, is nonetheless subject to breaches, that is, to accidents that affect it in its particularities. This breach in nature is itself doubled by another in art, for art is always lacking in relation to nature: it is "fictive in its truth and . . . incomplete in its resemblance."[33] This double *imperfection* of art is then supplemented by a counter-breach that has no other name than the "ideal" and no other end than to supplement the accidental breach of nature. But in fact the ideal supplements twice over, for it also supplements the inferiority of art by enabling nature to rejoin its principle; this logic of the supplement therefore serves not to fill or to annul the breach but only to cover it over, to supplement it, that is, to use Jacques Derrida's phrase, to "return to it [nature], but without annulling the difference."[34] This regulated

system of gaps and breaches between art and nature finds itself naturally brought back among the arts themselves, for each art has rules proper to its imitative mode.[35]

Thus, the Claude mirror *tends* in the direction of the neoclassical theory of imitation, a central theory that — at the end of the eighteenth century — was the source and the standard for any other theory. Indeed, nature reflected in the black convex mirror is always fictive and incomplete, that is, lacking in relation to nature itself, because reflected (mechanical aspect) and reduced (fragmentary aspect) by this mirror. However, this double imperfection of nature's reflection tended to be supplemented, that is, idealized, by the mirror itself, for the reduction of the reflection removes numerous details and other particularities: the mirror tends to abstract. It tends also to unite the reflected elements, to produce only one homogeneous whole, a harmony obtained by the chiaroscuro it spreads over the reflected scene. The supplement of ideality arises from the very convexity and blackness of this instrument, but this convexity and this blackness, in an original moment now obscured, introduced this breach between nature and its reflection.

And yet the mirror does no more than tend to idealize, just as it does no more than tend to select, to combine, and so forth. Certainly, the vectorial movement of the convex mirror enables Lairesse to compose, in principle, but his instrument only gives an idea of composition, since the artist alone will succeed in fully realizing it. The artist has in himself the capacity to invent, and in that sense he is irremediably distinct from the mechanics of reflection.

We have seen that ideal beauty does not exist in nature, or, to be more precise, that it does exist, but in a fragmentary state of dispersion. As Reynolds puts it, "This great ideal perfection and beauty are not to be sought in the heavens, but upon the earth. They are about us, and upon every side of us."[36] The artist (as de

Piles remarks) is a bee that goes out to gather from every flower what is most suited for making honey.[37] "But," Reynolds continues, "the power of discovering what is deformed in nature, or in other words, what is particular and uncommon, can be acquired only by experience." Indeed, "it is from a reiterated experience, and a close comparison of the objects in nature, that an artist becomes possessed of the idea of that central form, if I may so express it, from which every deviation is deformity."[38] Thus, only experience and comparison can enable the artist to produce ideal paintings. Reynolds possessed a camera obscura — now in London's Science Museum — that has the shape of a large book when it is folded down, and one can assume that he used this instrument less to make servile copies of nature than to establish comparisons.[39] Indeed, the comparison between a "view of nature represented with all the truth of a *camera obscura*" and the same scene "represented by a great artist" will reveal "how little and mean" the former is and how grand and noble the latter.[40] More than a model or a guide, the camera obscura served essentially as a foil. An irremediable breach separates mechanical vision from artistic vision, for while the camera obscura allows one to select and to combine, to some extent, it falls far short of the inventive capacities of the artist. And "invention" is indeed the key term of neoclassical thought, because invention is "understood as the faculty of combining in a new way the broken-up bodies taken from individual nature, compared and then arranged. Invention is what holds together the members of the combinatory."[41] The superiority of the painter over the mechanical rendering is manifestly evident; it emphasizes style and composition — selection-combination, even correction — and as a consequence it affirms the freedom of the artist, as a man, over the machine.

One might think that this role of selecting, which had devolved to the camera obscura, was also ascribed to the black mir-

ror. But while this instrument allows one to reduce the reflected object, there could never be any identity between the mirror and the painting: the reflection cannot be confused with the image of the painting and cannot be substituted for it. The reflection is an *equivalent* of painting: it is described *like* a painting but *is* not one. As Claude Lévi-Strauss wrote, "It is not the resemblances, but the differences, that resemble each other."[42] What Lévi-Strauss means here is that this principle can be developed only in the establishment of at least two series, where the terms of each series differ among themselves — the mirror reduces mechanically, but the painting does not. They are both equally different supplements. The resemblance is thus "between these two systems of differences." This essential difference between the reflection and the painting thus makes it possible to compare them and to know the properties of one and the other. Indeed, as Rousseau put it, "first one has to observe the differences in order to discover the properties."[43] That is why Gilpin, after at first relying on the mirror, later got rid of it.

The Claude mirror does not serve, then, to provide an "already finished" painting, which the classical artist would then only have to (re)copy — a sort of "ready-to-copy," or almost a readymade, one would be tempted to say. And yet how is it possible to know whether an artist ever tried to paint or trace on a black mirror — whether Murillo, for example, when he painted on his obsidian mirrors, did not paint the reflection of his models? Indeed, Malcolm Morley executed a self-portrait *on* a flat mirror: after attaching a sheet of Mylar to a plain mirror, the artist drew the reflected lines of his face directly onto the transparent plastic film (figure 12.1).[44] This method makes it possible "to draw your self-portrait or anything else." But that is where the mechanical aspect of the reproduction ends: "You can reverse the film, so you don't have the reflection of a mirror."[45] The simple reversal of the

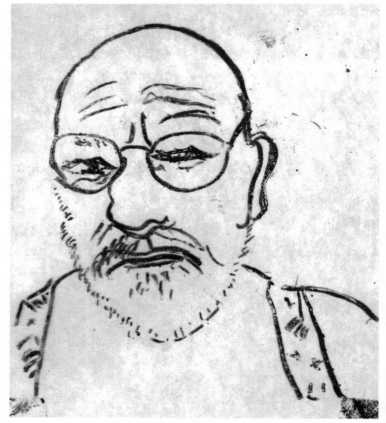

Figure 12.1. Malcolm Morley, *Mylar Self Portrait* (detail), crayon on Mylar, 16.5 x 14 cm, photograph by Jean-Claude Lebensztejn (courtesy of the artist).

transparent film suffices to annul the lateral shift imposed by the mirror. The conditions of imitation for Morley arise less from drawing, as they do for classical artists, than from the gesture of reversing the plastic film.

Indeed, for adherents of classicism, imitation is based on drawing.[46] We know now that an artist such as Canaletto did not disdain to use a camera obscura in executing his drawings. Giuliano Briganti cites a scholar, Terisio Pignatti, who built a camera obscura similar to the one used by Canaletto. He sought out the observation points of the canal from which Canaletto had worked, in order to draw the same views as those in his sketches. The result? Not even close. Canaletto's drawing remained incomparably superior, "infinitely more lively, more animated in every part," whereas the scholar's drawings were rigid and mechanical.[47] There is more: moving further and further from a mechanical reproduction, Canaletto begins with a light sketch made with his camera obscura so as to reverse the perspective, in order to construct not "a receding image, but one that is approaching."[48] Without trying to determine exactly what role the camera obscura had for Canaletto, and without entering too deeply into the ambivalences of drawing, we see clearly from this example that for classical artists the element of formal difference that separates drawing and painting from a simple mechanical reproduction — from a simple reflection — is the line. What does it matter that a classical artist may have traced on a black mirror or even — why not? — painted on one. The gap between art and mechanical reproduction is maintained. It therefore allows the artist, once again, to compare one with the other and to know the specificities of each, with the sole aim of affirming, in the end, the superiority of art and imitation over any process of mechanical reproduction.

This detour through the classical theory of imitation — in which drawing becomes the technique of imitation that gives rise to art — might seem rather odd for speaking of an instrument that, it is said, should be used "only in relation to color."[49] But if it serves for learning to master color and masses — which is why de Piles and Gilpin readily mentioned this instrument — the Claude mirror, by reducing colors to a scale of values, also simplifies the masses that this scale brings into relief. But shading, or massing, is a technique that belongs as much to drawing as to color. Better, this is what at bottom articulates these two poles, which are so often opposed. But above all, the mirror favors the role of comparison in the imitative process: the black mirror is a didactic tool. In this sense, it could have been recommended by Marie-Elisabeth Cavé as a way to "learn to have a just eye,"[50] for she advocates a thorough apprenticeship in the problem of values before surveying the problem of tints.[51] In fact, Cavé proposes a method for learning how to draw: "The model will first be traced, then copied, then reproduced from memory."[52] This tracing is obtained principally by using a Rouillet gauze. One then looks "at objects through the gauze placed before nature, and the masses of shadow and the light will appear to you without their details," which is also the effect of the black mirror.[53] She even goes so far as to proclaim that "gauze is truth," but this truth — which is the truth of expression — necessarily comes through memory.[54] The truth of expression depends on "a great capacity for observation" and "a great memory for comparison."[55] Learning to draw from memory thus means learning to compare, for memory is a reservoir of images. Learning to see is thus learning to compare through a system of transfers made possible by the act of tracing or by the gauze. In fact, "the stretched gauze is like a daguerreotype: it does not kill art; it only illuminates it."[56] Photography, like tracing, helps one in the process of learning to see; that is, it helps

one to have a just eye, an eye that selects, purifies, even corrects. Indeed, in the classical doctrine of imitation, the eye must be just, and not just an eye.[57] Making use of a camera obscura, a photographic camera, and such situates these instruments at a halfway point in this apprenticeship.[58] But then, since Cavé and Delacroix refer to photography, why do they not speak of the black mirror, which by this time (the second half of the nineteenth century) is almost free from the Claude aesthetic? Because the mirror's reflection is transitory — a dramatic question we will return to later. However that may be, if these instruments are the guarantors of the eye's precision (*justesse*), they must also facilitate an apprenticeship in the just eye. And the black mirror in particular must become just, and not be just a mirror.

The Claude mirror, in its mechanical rendering — and because of the reductions and other fallacies it occasions — is less an instrument of precision optics, like the camera obscura or the graphic telescope, than an apparatus that enables one to transpose reality into a melodious harmony. By effecting such a transposition, the mirror is sharply distinguished from other instruments with a more "scientific" purpose. It thus escapes the implicit accusation against the flat effects imposed by the latter in their mechanical simplicity.[59] It offers the classical artist an aid in imitating, in acquiring a just eye, because of the exactness (*justesse*) of the tones it presents, thus outdoing the camera obscura, contrary to what Mason claims.[60] But at the same time, the effect of the black mirror remains mechanical, even though — because of the instrument's blackness — this effect is less pronounced than with other instruments. And as one might guess, it is this systematic aspect that Ruskin implicitly reproaches in the mirror.

Introducing a Paradigm: The Fall

Thomas Gray, along with Gilpin, was among those best able to perceive the sweet harmony offered by the mirror. During his visit to the Lake District, the poet mentions this fortunate effect several times:

> From hence I got to the *Parsonage* a little before Sunset, & saw in my glass a picture, that if I could transmit to you, & fix it in all the softness of its living colours, would fairly sell for a thousand pounds. This is the sweetest scene I can yet discover in point of pastoral beauty. The rest are in a sublimer style.[61]

However, two days earlier he had gone to the same place, and the scene had taken on a much less pastoral tint:

> Straggled out alone to the *Parsonage*, fell down on my back across a dirty lane with my glass open in one hand, but broke only my knuckles: stay'd nevertheless, & saw the sun set in all its glory.[62]

No one seems to have attached much importance to this anecdote. True, nothing is explicitly defined. I have the sense that Gray fell on his back because he was too absorbed in the enjoyment of his mirror and wasn't looking where he was going, much like Plato's head-in-the-air philosopher who falls into a well while contemplating the stars.[63] Otherwise, how to explain that Gray falls with his "glass open in one hand"? Afterward, gripped by the immense emotion and the splendor of the sunset, the poet remains on the ground nonetheless, so as to contemplate the scene in which he is immersed and which renders him oblivious of his horizontal position.

But if the poet fell while looking into his mirror, then even after he was on the ground, he kept his back to the contemplated

scene, such that the sunset was visible in all its glory only thanks to the mirror. Certainly, nothing is explicit, and this interpretation may appear forced. But then why is it that in the French version of the *Letters of Thomas Gray*, the expression "stay'd nevertheless" is translated by its exact opposite: "Je me relève malgré cela [I got back up despite that]"?[64] And why did Mason, in the 1775 edition of *The Poems of Mr. Gray*, take the liberty of eliminating the anecdote of the fall, condensing the scene to "Straggled out alone to the Parsonage, where I saw the sun set in all its glory"?[65] What kind of conspiracy is this?

Such censorship can be explained, I think, by the fact that this most vivid testimony of the spectacle provided by a Claude mirror — since it goes so far as to hypnotize, to paralyze its user — was probably seen as double-edged, because of its literally down-to-earth, even slightly grotesque aspect. Did Mason sense the possibility of a caricature? Indeed, this anecdote recalls the adventures of Dr. Syntax, that "Romantic Don Quixote" (as the French translation presents him), a caricature of those seekers of the picturesque who falls into the water, so staggering is the spectacle![66]

But beyond the amusement afforded by this reversal, might there not be something profound, obscure, and much more terrifying than the odd humor of this scene might lead one to believe?

Toward Deception and Beyond

The Hunt for Illusions

The analogy that developed in Europe between the search for the picturesque and hunting was completely explicit in the second half of the eighteenth century. As Malcolm Andrews correctly notes, terms from big-game hunting, such as "'capturing' wild scenes" and "'fixing' [savage landscapes]...as pictorial trophies," were used by tourists to dramatize their encounters with wild places, which they then converted into landscapes to be sold or hung on the wall, like hunting trophies.[1] Such a vocabulary is very revealing of the state of mind associated with these encounters. The *image hunter* is therefore not a recent notion, and the expression "to shoot pictures" attests to the persistence of this analogy.[2] If this comparison turns out to be very pertinent in its results — drawings, sketches, paintings — it is no less revealing in terms of the processes by which these two activities function. Indeed, what interests the hunter, like the walker, is at bottom less the trophy on the wall than the pleasure derived from tracking the prey, whether animal or pictorial:

The first source of amusement to the picturesque traveller, is the *pursuit* of his object — the expectation of new scenes continually

opening and arising to his view.... And with this pleasing expectation we follow nature through all her walks. We pursue her from hill to dale; and hunt after those various beauties, with which she everywhere abounds.

The pleasures of the chace are universal.... And shall we suppose it a greater pleasure to the sportsman to pursue a trivial animal, than it is to the man of taste to pursue the beauties of nature? to follow her through all her recesses? to obtain a sudden glance, as she flits past him in some airy shape? to trace her through the mazes of the cover? to wind after her along the vale? or along the reaches of the river?[3]

Hunting, whether for game, butterflies, or images, is thus clearly envisaged as a sport (although the notion of sport did not have quite the same meaning as today).[4] Proof of this can be found in the anecdote lamenting the accident of the tourist Charles Gough, who died while climbing the steep slopes of Helvellyn in order, quite likely, to use his Claude glasses, which were found shattered in his pocket.[5] This "sport of hunting" is obviously very far removed from any need for food and is thus reserved for those gentlemen and gentlewomen who, freed from all material worries, can indulge in this sport as a leisure activity, that is, for their pleasure: hunting considered one of the fine arts.[6]

The most beautiful example of this pursuit of the rare image is described by Gilpin, who used his mirror during a journey in a post chaise. The author is "rapidly carried from one object to another. A succession of high-colored pictures is continually gliding before the eye." And "the transient glance of a good composition happens to unite them."[7] This spectacle resonates with Marcel Proust's description in which the narrator runs from one window to another through the car of a winding train, attempting "to reassemble, to recollect on a single canvas the intermittent

antipodean fragments" of a landscape observed in the early morning. However, if the transversality of the glance allows Gilpin to constitute a continuous picture through a continuous succession of images, in Proust it creates the picture in a completely different way, since it reconstitutes this picture from a series of discontinuous images. These are two radically different transversal ways of pursuing the continuity of images, since the latter, in its discontinuity, resembles a cinematographic vision of the world.[8]

However, while the source of pleasure remains the pursuit, especially in the case of the *Pirsch* — the hunting practice in which the hunter is alone against the beast he is tracking down[9] — the ultimate motivation for the game hunter is his list of kills, of which he speaks with a great deal of ostentation.[10] Just as the trophy recalls the hunter's pursuit, "a few strokes in a sketch" are enough to bring to mind "the remembrance of the beauties they humbly represent; and recall to our memory even the splendid colouring, and the force of light, which existed in the real scene," Gilpin declares. He takes this argument even further when, comparing memory to animal rumination, he wonders whether we do not experience "more pleasure in recollecting, and recording, from a few transient lines, the scenes we have admired, than in the present enjoyment of them."[11] Enjoyment, then, comes less from what was seen than from the act of remembering.

For Gilpin, memory has a predominant place in aesthetic pleasure because he implicitly recognizes that the Claude mirror never allows one to fix a view. He can only lament the transience of the reflections in the mirror, since he exclaims that "we should give any price to fix, and to appropriate the scene."[12] The fall is all the harder because these images caught on the fly in a post chaise have been transposed into a visionary dimension, for "they are like the visions of the imagination; or the brilliant landscapes of a dream. Forms, and colours, in brightest array, fleet before us."

The dream vanishes with the reflection that engendered it. This disappointment is followed by a note by Gilpin, citing the passage mentioned above from the *Memoirs* of Thomas Gray, who tells us that he has seen in his instrument "a picture, that if I could transmit to you, & fix it in all the softness of its living colours, would fairly sell for a thousand pounds."[13] Everyone is therefore ready to pay any price for an image that is itself priceless because of its evanescence. This is because the Claude mirror is not only deceptive;[14] it is above all "disappointing" (*décepteur*), in that it does not fix the reflection, thus catching the tourist, as well as the draftsman, in his own trap by taking his image away in the very moment he most hoped to capture it. Meanwhile, this image returns to limbo, like the wolverine eluding the hunter and his traps just when he thinks he will catch it.[15]

That is why Matisse's use of the black mirror may appear surprising to us in retrospect, for it would seem to contradict the general opinion on the transience of reflected images. For Matisse, the black mirror became a means of regulating "the succession of impressions" and was thus compared to the farrier's "trave" (*travail*), that apparatus used for restraining (*entraver*) animals.[16] It allowed him to eliminate the constantly changing variations of light "kicking out" (*ruant*), so to speak, into the eye — we recall the vermilion red (in one of the excerpts from "Bavardage" cited earlier) that, like a kick from a boot, gave the impression of striking out from the surface — or, we might say, "kicking over the traces [ruant dans les brancards]" of his black glass. One might therefore believe that the black mirror, which for Gilpin and Gray activates the imagination because of the *transience* of the reflected images, also activates the imagination for Matisse, but because of the images it *fixes*. But that's not the case. It is again a question of illusion: that of a mirror that fixes images but inevitably brings disillusion once again. One might guess that Matisse eventually

perceived this; otherwise, why was he so quick to give up this instrument, dismissing his relation of his experience as mere "chatter," and why did he not want to publish it afterward, a detail on which Pierre Schneider insists? While the mirror must have fascinated Matisse because of the transience of its reflected images — just as it fascinated Walpole with its power of suggestion — and while the black mirror allowed him at first to look for "serenity through simplification" of drawing and especially of tints, this instrument quite visibly comes to disturb any such serenity.[17] This would explain, then, why he preferred to use photography, which could fix the different stages of his work — mistrustful as he was both of the succession of these changing and unfixable reflections and of the shifting movement of his sensations.[18]

The hunt for images entails a supplement that goes by the name "disappointment" (déception), as I have already said.[19] This dangerous supplement of the black mirror exposes the hunter, like the artist, to death. The enjoyment of the hunt — whether for images or something else — takes place at the cost of the hunter's life, as the myth of Actaeon reminds us. This specular movement of the black mirror, as it catches the hunter in his own trap, has something lunatic about it: the black mirror is a lunar instrument. Indeed, beyond the possible relation between this instrument and the hunt — therefore with Diana, lunar and lunatic goddess par excellence — the black mirror is like the moon. This "planet, that is, an opaque body," reflects the light it receives directly from the sun. But in return, this "secondary" light is "infinitely weaker than that which emanates directly from the sun."[20] The moon, writes Valenciennes, attenuates the dazzling force of the sun, just as the black mirror dims the "brilliant and striking" objects of nature.[21] For this painter, the moon is equivalent to a black mirror. This is true on the condition that one never lose sight (in an equally specular mode) of the fact that while the moon is the mirror of

the sun during the night, the black mirror is a kind of night in the middle of the day — a quality that Plumptre, like many others, describes when he evokes the moonlight tint cast by his Claude glasses.[22] That is why every image caught in this instrument, like Diana caught at her bath by Actaeon, is destined to vanish, and the hunter to die, in both cases leaving only the darkness of the mirror or of the night. The level of disappointment is always proportionate to that of the catch. This, then, is the price to be paid by a Gilpin or a Gray, this dangerous supplement of the image reflected in a black mirror. The supplement of idealization is doubled by a supplement of disappointment. The principle of life is confused with the principle of death, appearance with disappearance. And in wanting to separate them, the poet, like the theorist, admits something that limits and contradicts this surging forth of the image — namely, its transience.

From Disappointment to Blindness

There are two points, then, that this explanation retrospectively illuminates with its black light. On the one hand, the black mirror has an eminently ambiguous status. But it is no more ambiguous than the picturesque, which drew it out of obscurity. Indeed, this movement tends at times toward the beautiful and at times toward the sublime. We can cite Gilpin's description of the course of a river: At first, everything is "tranquil and majestic." Suddenly a small "cascade, though to the eye above the stream, it is an object of no consequence," causes this ideal beauty to topple over and to plunge, as it were. Through this almost imperceptible cause, everything becomes "agitation, and uproar; and every steep, and every rock stared with wildness and terror."[23] More than a middle term between the beautiful and the sublime, one that would exclude all reconciliation of these irreconcilables, the picturesque obscurely harbors a toppling motion within itself.[24] This little waterfall

imperceptibly tilts the spectator from the beautiful to the sublime, from pleasure to ravishment, from enchantment to disappointment. Thus we can better understand what was at work, unconsciously perhaps, in the fashion of the picturesque and the compulsive use of the black mirror: after idealization comes disappointment, just as illusion or capture engenders disillusion or loss.

This explanation tends at the same time to cast a particular tonality over the scene of Thomas Gray's fall. In the myth of Actaeon, the hunter catches Diana at her bath: the sexual dimension of hunting suddenly emerges. The poet was surely not aware of such a dimension, but the translators seem to have felt the ambiguity and the danger of such an anecdote. Indeed, soon enough, the enjoyment of the spectacle becomes inseparable from the fall of the one who looks; the fall is even a condition of possibility for the enjoyment of this spectacle, for without this fall the poet would surely have passed it by. But through a perverse effect, this enjoyment paralyzes the spectator and leaves him in a horizontal position not unlike that of the dead: the supplement of enjoyment sinks the spectator into an ecstatic state that exposes him to death.[25] But here this ambivalent enjoyment is made possible only through the mediation of the Claude mirror. Thus the analogy between this fall and the loss occasioned by the reduction of the black mirror — even if one remains unaware of this loss — is blindingly obvious. If the Claude mirror reduces the landscape to a human scale, to the size of the hand, it crystallizes the scene, as it were, and places it at a distance. But inversely, too, the mirror crystallizes the gaze and places at a distance the one who looks. This latter aspect engenders a certain repression: the contemplator is literally thrown back (*re-jeté*) by the reflection.[26]

Moreover, the black mirror, of course, is related to the practice of sketching, in that it aids the draftsman with the rendering of masses. But, as Jean-Claude Lebensztejn has shown, the sketch is a

drawing that one does "with only one hand," so to speak.[27] The practice of sketching, veritable libertinage, is no less a means of communicating enjoyment and death than the handling of the black mirror. In fact, the description of himself that Gray gives (himself) is not without a certain autoerotism. The effect of the enjoyment of the spectacle is similar to that of an orgasm, that *petite mort* which, too, provokes the fall and the abandon of the one who indulges in it. The ideal, doubled by disappointment, is doubled again by onanism, that other dangerous supplement.[28] Seeing the "sun set in all its glory" is close to seeing it in all its turgidity. The pastoral turns into the sublime.[29] And this mirror that Gray holds "in one hand" is indeed a mirror "that one holds with only one hand." The poet's laudable intentions, and, more generally, the democratic use of the mirror mentioned earlier, are thus tainted by a shameful solitary practice.[30] Does Gray not isolate himself and turn his back to the landscape in order to indulge with his mirror in a little intimate business, in his little private spectacle?[31]

The enjoyment of the hunt ends sooner or later with the fall of the hunter. It is thus less of an evil when one falls only from the height of a man, as Gray did: one dies only halfway. But if one falls from the heights of Helvellyn, like Gough, one dies completely. Gough's death rises to the level of the spectacle and the prospect he coveted in his glasses. The walker in search of pictorial effects in nature finds only death, and the mortal fall ends up concretizing disappointment. The fashion for the picturesque brings the mirror out of hiding, but this does not happen without shocks and misfortunes for these amateurs of the picturesque, who themselves become the objects of a mortal spectacle, reflected, so to speak, in a black mirror.

But what a strange spectacle, this reflection offered to the gaze of a lone onlooker, of which he can never speak! Gray the poet saw in his mirror a spectacle that was literally unspeakable: "& [I]

saw in my glass a picture, that if I could transmit to you, & fix it...."[32] The use of the conditional marks the limit and the failure of the narration, which the poet wanted to present as the exact reflection of the things seen and of the impressions felt before these things. This desire for description aroused by the black mirror is paradoxical — in the sense of this term defined by Gilles Deleuze.[33] Gray is no different from "Actaeon, [who] in the myth *sees* because he *cannot say* what he sees: if he could say it, he *would no longer see*."[34] The fall of Gray and that of Gough are like the curse proffered to the users of the black mirror and glasses, the "si poteris narrare, licet!" that Diana directs at Actaeon: and now you are free to tell what you have seen in your mirror, if you can.[35]

The mortal fall thus concretizes a double disappointment. It is no longer a question of a mere simulacrum, doubly threatening the life of these walkers, amateurs of the sublime and the picturesque, habituated up to now to being ravished by the terrifying spectacle of nature and to speaking of it freely, without ever being in danger or even troubled by disquiet. Such is the exorbitant price the black mirror demands for the enjoyment one would derive from it.

This exorbitant price takes on its full meaning if we realize that disappointment, by way of the fall, leads to blindness, both literary and literal. The mirror that compensated for the deficiencies of what is called natural vision, and vice versa — in Gilpin, Matisse, Sutherland, and others — in a metonymic relation conferring an instrumental status on this object, is affirmed more than ever as a prosthesis, since it comes closest to the eye and can be detached only with difficulty from the hand that holds it, even in the case of a fall.[36] An internal structural link binds this prosthesis to the eye. Indeed, if our prosthetic mirror supplements a lack in the eye — here, that of seeing the landscape in a picturesque light — because of its (mechanical, and disappointing) nature, it always

does so incompletely. Supplementing a lack in the eye, it is less than an eye, since this mirror itself demands to be supplemented. The logic of supplementarity, whose corollary is a logic of delay, describes an infrastructure that accounts for the origin of the gaze as an aftereffect. And in this delay blindness is born. In this series of supplements, vision merges with blindness. The deficiencies of vision, constitutive of vision itself, render the use of the mirror critical: this prosthesis both seduces vision by compensating for it and threatens, in return, to blind it. The mirror, which, as Derrida describes the supplement, "is unequal to the task" and "lacks something in order for the lack to be filled,...participates in the evil that it should repair."[37] And the problem cannot be resolved by grafting the black mirror onto other optical instruments such as the camera lucida, as Charles Chevalier claimed: on the contrary, the deficiencies of these apparatuses accumulate and only lengthen the chain of supplements, reinforcing the eye's lack of "sight."[38] The black mirror blinds. Disappointment is thus revealed as necessarily blinding, and the fall of Gray and of Gough as inevitable. The history of the black mirror is also the history of a blindness.

The black mirror is therefore less "ridiculous" than Jean H. Hagstrum would have us believe, no more ridiculous, in any case, than his narrow conception of the Claude mirror.[39] Once again, the deep ambiguity of this instrument shatters the univocal and idealizing aspect of the mirror. To take up the two essential principles of nature from the eighteenth century, as defined by Jean Starobinski: the mirror is at once concentric when it idealizes and eccentric when it disappoints, leading to death and blindness.[40] The logic of supplements continually deconstructs these oppositions.

Cadrage/Encadrement[41]

It is quite certain that the first direct comparison between the black mirror and photography dates from June 8, 1839 — that is,

even before François Arago disseminated knowledge of the photographic process. On this date, Sir John Robison of the Royal Society of Edinburgh, frustrated in his attempts to describe the first views of the daguerreotype, announced that they "are nearly the same as that of views taken by reflection in a black mirror."[42] As Geoffrey Batchen observes, the first daguerreotypes were very similar to black mirrors, beginning with their format and their reflective quality.[43] This comparison was consistently renewed by historians of photography, who saw in the manipulation of the Claude mirror a foundational gesture of photography — namely, framing as a compositional feature (*cadrage*).

In postulating a rupture in the scopic regime, Jonathan Crary locates its most critical moment roughly between 1810 and 1840.[44] He defines the transition from a period that, in the history of vision, relies on geometric optics to another founded on physiological optics. He thus shows that the birth of photography had nothing to do with earlier optical apparatuses. Between the camera obscura — which provided a model for classical theories of knowledge and representation — and the appearance of photography, a veritable epistemological rupture took place. The spectator of the classical period, then, gives birth to the observer of the modern age, an observer transformed in every sense — physiological, psychological, social, aesthetic, philosophical, ideological, and so on. Before this rupture, the camera obscura was the model of an objective visual apparatus: the image was perceived as given independently of the subject, guaranteed by a superior — generally theological — principle. The dissolution of this model and principle made room for a new conception of vision, which then became subjective; and the image, subtracted from all external reference, became the product of a visual experience located henceforth in the very body of the observer. The disembodiment of the spectator was then followed by the

exposure of the observer. And, as a corollary, if the image is con-
stituted in the body of the observer, this body at the same time
becomes part of the representation.

Thus, when a spectator or an artist entered a camera obscura,
he found himself by definition cut off from the world — an argu-
ment that is less obvious with a small, portable camera obscura
but is still approximately functional. On the other hand, follow-
ing the use made of the black mirror, the observer could already
initiate this becoming aware of the body, of his own body, as an
integral part of the reflection, particularly in terms of his position
in space. But Thomas West refuses to consider the spectator's
body as a locus of visual experience: "The person using it [the
Claude mirror] ought always to turn his back to the object that he
views:... The landscape will then be seen in the glass, by holding
it a little to the right or left, as the position of the parts to be
viewed require."[45] West would have the spectator turn his back on
the scene viewed, which is the very image of the picturesque. He
thinks in terms of internal composition and not of framing (cadrage),
as we have already seen with de Piles and Lairesse. West is still
incapable of taking the spectator's body as such into considera-
tion. This question of the body is totally unexamined and must
remain so as long as he thinks in these terms.

On the other hand, as Ewa Lajer-Burcharth points out, when
Jacques-Louis David showed his Sabines at a paying exhibition in
1799, with a psyche (a large, freestanding pivoting mirror) set up
across the room so that it would reflect the painting, contemporary
commentators noted the illusion produced by the interpenetration
of the painted bodies and those of the visitors. For Lajer-Burcharth,
the mirror forces the spectator to consider his or her body as a part
of the aesthetic experience, which by nature is not only discursive
but also determined by a spatial organization in which the interac-
tion between painted bodies and viewers constitutes a second cen-

ter of interest. Lajer-Burcharth thus sees the entry fee and the mirror as two aspects of this participation: "If the entry fee represented the 'share' the artist asked the visitors to take in his project, the presence of the mirror served as the material tool for securing their bodily participation in the painting." She goes on to argue that the observers' bodily participation was not only physical but psychic as well.[46]

This experiment with the psyche and the *Sabines*, which David repeated in 1807–1808 and again in 1824, seems to be not an isolated instance but a more common practice than is often believed, although this remains to be demonstrated. In any case, such a participation clearly illustrates a heightened awareness of the body in the formative process of images and in the new scopic regime discussed by Crary.

Between West's use of the mirror and David's, one can locate a third type, a sort of middle term. When tourists began to say that one should hold the mirror over one's shoulder in order to look into it, this can be seen as initiating the process by which the modern observer was being formed. Although holding a mirror above one's shoulder in some sense elides this shoulder and, in general, the body that holds the mirror, such an elision is a form of recognition in its very negativity — although, indeed, West evacuates the problem and passes it over in silence: he literally does not see it.[47] One can always object that this becoming aware was itself limited and imposed by the movement of the spectator turning his back to the contemplated landscape, an attitude required, as it happens, by the reflective phenomenon of the mirror, which imposes this half-turn on the spectator. In any case, this gesture marks a renewal in the use of the Claude mirror, which henceforth aids in situating visual experience in the very body of the observer. This also means that the process of image formation involves appropriation, since situating the origin of the image in

the body is a form of appropriation. But there are different kinds of appropriation.

Here, in my view, lies the origin of and the difference between the notion of framing as a compositional element determined by a singular point of view that selects from a larger whole (*le cadrage*) — for if the image is constituted in the body of the observer, this body in turn is located in the world — and that of framing as the placement of an image within a frame (*l'encadrement*). For neoclassicists, the latter is what made it possible to appropriate horrific scenes in their natural state — in a form of recycling proper to kitsch.[48] The recuperation of terrifying landscapes created by industrialization on the outskirts of London is described by William Chambers:

> England abounds with commons and wilds, dreary, barren, and serving only to give an uncultivated appearance to the country, particularly near the metropolis: to beautify these vast tracts of land, is next to an impossibility; but they might easily be framed into scenes of terror, converted into noble pictures of the sublimest cast, and, by an artful contrast, serve to enforce the effect of gayer and more luxuriant prospects.[49]

Later, Théophile Gautier, in an article clearly inspired by the aesthetics of the sublime, will do just that when he describes the photographs of Mont Blanc taken by the Bisson brothers. Consecrating the superiority of photography over painting in terms of the inability to "frame [mountains] in a painting" because "their dimensions surpass every scale," he triumphantly affirms that only "the stubborn research of science" has been able to "imprison [Mont Blanc] in the narrow frame of a photographic plate."[50] This framing (*encadrement*) of the mountain is the condition for the spectator's delight, for he can thus enjoy such terrible spectacles in perfect calm. Thus, when Karl Gotthard Grass

contemplates another glacier with a black mirror, or when Plump-
tre uses his Claude glasses in caves to create an infernal atmos-
phere, his filters maintain the separation between him and the
spectacle, giving him the illusion that he is sheltered.[51] That is why
Gough's fall, which threatens to annul this distancing of danger —
and therefore to cause the body to lose its neutrality in the pro-
cess of perception — is immediately recuperated, framed (enca-
drée) literally in poems by Wordsworth ("Fidelity") and Walter
Scott ("Helvellyn") and pictorially in an engraving that represents
the lifeless body of the unfortunate.[52] This recuperation is, of
course, illusory.

On the other hand, Gautier's neoclassical inspiration does not
prevent him from making a very Romantic remark in this text. A
large photograph of a glacier is compared to a sea in which one
could perceive only a small ripple: "One sees it continue beyond
the frame of the plate beneath its snowy foam." The frame, which
up to now has kept the spectator at a distance, suddenly tends
to reduce this separation. To see the sea continue beyond the
frame — this happens because the spectator "tries" to go behind
this frame, this "mask."[53] Thus, an effusion or an overflow occurs
between the space of the spectator and that of the photograph. "If
Romanticism means anything, it is perhaps this: an effusion that
erases the borders between the arts and between art and life. That
is why the Romantic work aspires to be a vignette and a fragment,
an allusion to a totality, an opening onto the outside."[54] Gautier's
remark is a rather late one in comparison to the paintings of Cas-
par David Friedrich, who explored every possible variation on these
effusive effects between the painting and the spectator. Now, this
effusion is to mimesis what subjective vision is to epistemology:
two complementary approaches to the notion of framing (ca-
drage) and to the Claude mirror as an instrument of aesthetic
appropriation in a so-called modern sense.

This effusion and this subjective vision lead us to reconsider the convex mirror of Du Fresnoy and de Piles. Indeed, the Baroque, too, opened passageways between the space of the spectator and that of the work, but in a mode quite different from that of Romanticism: we have seen this with the call of the spectator who intrudes into the space of the painting and who, in turn, "provokes" a reaction from the painted figures. In Romanticism this opening tends to occur through the erasure of the frame, whereas in the Baroque the frame itself is redoubled and exceeded. Du Fresnoy thus suggests:

> As when we see in a convex mirror the figures and all other things advancing more strongly and vividly than even natural objects do, and the vivacity of the colors is increased in the parts full in your sight, while the goings off are more and more broken and faint as they approach to the extremities; in the same manner may bodies be given relief and roundness.[55]

Like the frame from which a figure seems to come forth into the space of the spectator, the convex mirror gives relief and roundness to the reflected objects, makes them protrude more than it is possible to observe in nature, and darkens the turning (receding) parts as they approach the edges. Du Fresnoy even adds later that a good work of art must, without the slightest movement, enable the artist's eye to "turn" around the piece. Likewise, de Piles, in the "Explication de termes" he placed after his commentary, defines the relief of a figure when "it seems round and detached from the painting." Colonna had already remarked that a black ground causes white figures to be "thrown out from the work."[56] And Pliny, even earlier, invoked contemporary theories of reflection to explain the difference between the concave mirror, which "welcomes" the air carrying the image, and the convex mirror,

which "flings it back."[57] This surging forth of the image, especially in the black mirror, also recalls for us what the initiates of the magic mirrors saw in a hallucinatory way.[58]

Is this why Abraham Bosse — the unconditional defender of perspective, of painting as an opening onto the space of representation, and of Poussin prospects — condemns without appeal Du Fresnoy's use of the convex mirror?

> They do not understand how to make objects recede and turn into the distance by using an arrangement of parallel planes. For these gentlemen are, as you know, accustomed to making an entire painting have the same spherical, mirroring effect, which amounts to representing objects the way the eye sees them, which is an absolutely false and ridiculous thing to propose.[59]

For Bosse, it is a question of representing things not as the eye sees them but as the mind of the geomete conceives them, that is, according to the different planes that, in their successive formation, create the depth of the picture. A dogmatic critic of the effect of relief, of any vision that tends to curve its objects, and particularly of Du Fresnoy, who defended coloring and Baroque principles, Bosse argues that one must see through a sheet of white silk, for vision is not concave but plane, like a flat curtain.[60]

A Devaluing Mirror

Devaluation

Gerhard Richter's Mirrors

We have seen that the use of the Claude mirror did not die with the advent of the aesthetics of Ruskin and the Pre-Raphaelites. Matisse and Sutherland each furnished us with a very specific example by turning to this instrument, henceforth called the "black mirror" and thus rid of its aesthetic à la Claude Lorrain. But now we may well ask how, at the present time, artists could give new meaning to this mirror.

In the remarkable formulation of Witold Gombrowicz, the greatest Polish writer of the twentieth century, modern thought was primed by Immanuel Kant. Indeed, with Kant, a certain reduction of Western thought is effected: "Thought... becomes conscious of its limits."[1] We can only know phenomena. Gombrowicz argues later that modern thought rests also on the notion of becoming as it developed out of G.W.F. Hegel.[2] These two notions are at work in the modern black mirror.

If from Plato to Jacques Lacan there is no philosophy without the mirror, that is because the mirror loses its interest insofar as it tends to affirm at least two tendencies: the mirror reflects a double that is identical with the reflected object and that always refers back to the number one. On the other hand, there is a way

of thinking these two tendencies and their irreducible separation: the condition of possibility of the double that is doubled and doubled again is based on the number two, but asymmetrically. This asymmetry, obtained by the reduction that the black mirror brings about, makes it possible to maintain the irreducible *divergence* or *breach* between the two tendencies, between two images. However, if this number two becomes the primary element of the proliferation of doubles as a form of becoming, the mirror reflection does no more than present a double that has little to do with any becoming. And to think a becoming of the mirror is pointless, since the mirror by itself is only an object. But the black mirror could become for us the emblem of the thought of becoming.

Gerhard Richter's mirrors, in my opinion, must be seen from this perspective. Richter has produced certain mirrors that are very similar to the black mirror. They were included in an exhibit at the Anthony d'Offay Gallery in London in 1991 (figure 14.1). These mirrors consisted of glass panels coated on the back, manually or otherwise, generally with neutral gray pigments, sometimes blood red or brown or blue (the work was originally carried out as a commission from a bank). Richter used other colors as well. This fragile pictorial surface is covered with a protective sheet. Some of the mirrors are framed for reinforcement, like the one in the Musée des Beaux-Arts in Nantes.[3] They therefore allow one to see, alternately, the layers of pigment behind the glass or the objects reflected on the glass. Richter, who had already exhibited plain glass panels in 1966, stated: "It's about glass again. This time glass that doesn't show the picture behind it but repeats — mirrors — what is in front of it. And in the case of the colored mirrors, the result was a kind of cross between a monochrome painting and a mirror, a 'Neither/Nor' — which is what I like about it."[4]

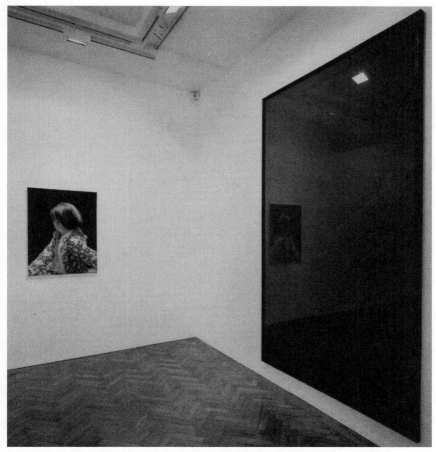

Figure 14.1. Gerhard Richter, installation in the Anthony d'Offay Gallery, London, 1991 (by permission of the artist and the Marian Goodman Gallery).

Richter had already expressed an analogous thought concerning some of his earlier figurative paintings in which he carefully blurred the contours and lines of the figures with a dry brush, just before the thick paint had completely dried: "Those [paintings] have the same blurred look, whereby something has to be shown and simultaneously not shown, in order perhaps to say something else again, a third thing."[5] The indistinctness of a work that does not quite show itself is the only way to capture something that one is unable to say otherwise. It was clearly with this point of view in mind that Richter made the following notes in 1981:

> Mirrors:
> (a) *Gläser* [*Four Panes of Glass*] of 1966, *Graue Bilder* [*Gray Pictures*], and *Farbtafeln* [*Color Charts*];
> (b) Picture in itself, cropped effect, likeness to photography, ready-made character (Berges furnishing store);
> (c) Polemic: devaluing of all other pictures; provocation of the viewer, who sees himself instead of a picture.[6]

Without addressing each of these points in detail, we see to what extent the mirror, as Richter conceives it, differs from the black mirror as used by the amateurs of the picturesque. Richter's mirror is quite large and is a scenic instrument contrasting distinctly with the intimacy of the small private spectacle the mirror offered in the eighteenth century; in that respect, it resembles David's psyche mirror.[7] But that is where the comparison ends, for Richter's mirror has lost every aesthetic or idealizing effect. It has a "ready-made character"; that is, the mirror loses the aura it had acquired and takes on the status of a work of art only through the artist's choice and not through the aestheticism of the reflections it presents. These modern mirrors, like other works by this painter, "are devoid of objects." They are only "the object of

themselves. This means that they are devoid of content, significance or meaning, ... without a reason, without a function and without a purpose."[8] Richter devalues the mirror and is interested only in its nonartistic aspect. For him, it would be pointless to negate "the artist's productive act," as he puts it; "it's just that it has nothing to do with the talent of 'making by hand,' only with the capacity to see and to decide *what* is to be made visible. *How* that then gets fabricated has nothing to do with art or with artistic abilities."[9] This large mirror thus gives back to the disconcerted spectator not only his own image but also that of the other works, which it devalues. We see very clearly, then, how for Richter the mirror exceeds simple reflection through its reductive, disappointing (*décepteur*), and now *devaluing* aspect. But this devaluation, as we will see, though crude or cruel, has nothing tragic about it.

This devaluing mirror defies every attempt at definition, because it never stops changing; what this work reflects is never the same; it varies with the different exhibition sites and evolves with the coming and going of the spectators: it is a work caught up *within* a process of becoming.

Richter's devaluing mirrors push the critique further than those of John Knight's *Une Vue culturelle*.[10] But they are also considerably different from Michelangelo Pistoletto's mirrors.[11] Whereas Pistoletto inextricably mixes images from reality with painted images, Richter, by widening the gap, creates a space of indistinctness between the reflection and the monochrome. Richter's painted mirrors are located between these two zones (the painting and the mirror), but to the exclusion of each zone. These mirrors offer a thought of the interval, a line of flight, as Deleuze would say — that is, the beginning of a becoming.[12]

Richter readily used a simple mirror as a master painter, even with abstract canvases, but I do not know whether he is aware of

the Claude mirror or what he might think of it; while I was researching this study, his assistant informed me that the artist was so ill that he had suspended all his projects (figure 14.2). In any case, what seemed to be a source of negative imperfection for Gray's mirror, degrading the quality of the reflection, appears in Richter as the source of an imperfection that is not positive but affirmative, that is, the source of an affirmation of affirmation, an affirmation of the image, an affirmation of the pictorial act and of life. The black mirror as Richter might conceive it is therefore the polar opposite of the Pauline mirror, at least as this latter is commonly understood. Indeed, even if Saint Paul describes the mirror as a metaphor of imperfect knowledge in the present, he nonetheless predicts the advent of light: "For now we see in a mirror, in a riddle, but then we will see face to face. Now I know only in part; then I will know fully, even as I have been fully known."[13]

Richter, however, awaits no sublation (*relève*), no light from the black mirror, not even the hope of a glimmer. The veil of darkness will not be lifted.[14] Quite to the contrary, pictorial research for Richter obliges one to plunge into the night of devaluation. This devaluing mirror is artistic only in the sense that "art is wretched, cynical, stupid, helpless, confusing — a mirror-image of our own spiritual impoverishment, our state of foresakenness and loss."[15] Thus, when the artist uses his tinted mirrors to reflect his own paintings, his works are not illuminated or clarified: the mirror "devalues all other pictures." And if Richter's works have no meaning other than themselves, they are never clarified by this hanging of mirrors, by this mirroring, for his painting is not an obscurity, a mystery, that is, a quest for the meaning of meaning.[16] Richter claims that he wanted to detach himself from Marcel Duchamp's conceptions. These latter are rife with "all that mystery-mongering — and that's why I painted those simple glass panes and showed the whole windowpane problem in a completely different light."[17]

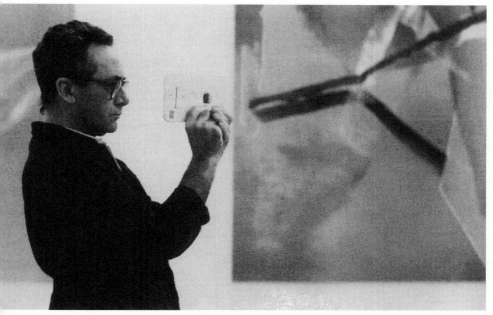

gure 14.2. Gerhard Richter in his studio in Cologne using a mirror to look at one of his paintings (1984). eproduced in Gerhard Richter, *The Daily Practice of Painting*, trans. David Britt (Cambridge, MA: MIT Press, 995), p. 142 (by permission of the artist and the Marian Goodman Gallery).

The obscurity of the artistic meaning — that is, of the devaluation — to be given to these mirrors that thwart all interpretation is in fact a clear obscurity, but one that has nothing to do with the chiaroscuro that hides this meaning beneath a mystery. That is why these mirrors are hung not in dim light but in the ordinary lighting of an exhibition space. In modern thought, there is no pure darkness or pure light: light is dim, and darkness is illuminated. Only under this condition can one distinguish and differentiate anything — hence the importance of different scales of gray in contemporary thought and art, particularly in Richter, as much in his monochromes as in his figurative works. The modern black mirror (which, like painting, is more gray than black) equalizes and flattens both light and dark without ever dialecticizing one through the other, presenting them equally and thus showing the visible as a whole — and devaluing it.[18] Indeed, because a certain artistic — and devaluing — meaning, liberated from the aesthetic, comes to the surface of the mirror, this mirror prolongs the visible indefinitely and opens it to infinity.

Devaluation in the Work of Other Contemporary Artists
A supplement of disappointment comes to subvert the supplement of idealization found in the neoclassicists; as for the supplement of devaluation in contemporary art, it kills the aesthetic. If we look for other instances of this devaluation, aside from Rainer Müller's exhibition *The Black and Convex Mirror*, we find François Perrodin's *Tableaux* (figures 14.3 a–c).[19] Before creating these works with a black tain at the beginning of the 1980s — around the same time that Richter was producing his mirrors with a silver tain — Perrodin had worked on some paintings in neutral gray "in which the gray tain was interesting because it resulted in a loss of the image." Whether gray or black, these works express an "interrogation vis-à-vis representation," via the relation among "the

frame, the pane, and the background," which emphasizes the question of the "tain" and thus reverses "the status of the painted surface."[20] The question of the tain allows him, on the one hand, to affirm "this type of plane as a fictive space" and, on the other hand, to question "the immediate relation to the surrounding space." For the artist, it is therefore not "a problem of painting, but of a picture." This type of object, which "allows one also to address the issues and the function of representation," involves a kind of work that is necessarily historicized, for it attempts to take up the challenge of postmodernism, and of Richter in particular: "To the production of painting within the framework of 'capitalist realism,'" as Richter called it, Perrodin responds with "the reactivity of the picture/object of representation."[21] Having met Richter on one occasion, Perrodin asked him why he had not developed this path: "His response was very clear: he thought he had exhausted what he could do with it."[22] This is hardly surprising in view of what was said above.

In the course of his insistent interrogation of representation, Perrodin points out the tendency of the gray tain to make the image disappear, but he admits at the same time that when it comes to the black tain, he is fascinated "by the absolute distinctness of the reflection. There is no loss of color, not even a change of color, as one might expect with a change in brightness. Shifting the scale of values toward the deeper ones does not cause a chromatic shift, but seems above all to attenuate the contrasts."[23] These remarks were made in reference to Christian Boltanski's *Images noires* of 1996 (figure 14.4).[24]

Boltanski's *Images noires* was presented as an installation consisting of two hundred clip frames (plain glass frames with no border, only a black back) of different formats. On each one, a thin band of black was added around the front edges, creating the effect of a frame. The works in *Images noires* also recall the empty

Figure 14.3a. François Perrodin, *"29.20" 1994*, 1994, 60 x 60 x 5 cm, wood, glass, alkyd paint, photo by André Morin (courtesy of the artist).

Figure 14.3b. François Perrodin, *"12.6" 1986*, 1986, 60 x 540 cm, wood, glass, vinylic paint, private collection, photo by Canubis (courtesy of the Galerie Philippe Nelson).

Figure 14.3c. François Perrodin, *"15.1" 1986*, 1986, 30 x 48.5 cm, wood, glass, vinylic paint, private collection, photo by Canubis (courtesy of the Galerie Philippe Nelson).

Figure 14.4. Christian Boltanski, *Images noires*, *Nightfall* installation, Anthony d'Offay Gallery, London, 1998 (© 2004 Artists Rights Society [ARS], New York/ADAGP, Paris, by permission of the artist).

clip frames that Boltanski has used in other works dealing with mourning and disappearance.[25] In *Images noires*, the artist takes his search further, for the photographs have disappeared; there remains only the clip frame that would have contained them. The presence of these empty frames emphasizes the absence of the photographs, of the *images*, but at the same time underscores the presence of this absence taken another degree higher — a photograph itself being the trace of an absence — a presence not yet completely forgotten, resembling in this way Pliny's mirror.[26] These clip frames negate the function of a clip frame and its aesthetic aspect, since no image is placed between the back and the glass. The black sheet is perceived less as a monochrome than as the trace of an absence. The works in *Images noires*, devaluing the image itself, show nothing but the reflection of the disarmed spectator confronted with his own reflection, his own interrogation. These images have become mirrors.

Nevertheless — as with Richter, but in a completely different way — this devaluation is a point of support:

> One of the artist's desires is to give an account of reality and at the same time to protect it against oblivion and death, and this effort is bound to fail; failure is there from the beginning. For example, Giacometti knows that he cannot grasp life: he will do his brother's bust and his wife's portrait again and again without ever achieving his aim, but this explicit failure is part of the beauty of his work.[27]

This explicit failure is the condition of possibility of the artwork; it is what makes its beauty, because it constitutes an attempt to do more, to be more. Certainly, nothing lasts. Every attempt, every system, every work, ends up falling to pieces.[28] But as everyone knows, what matters is the impulse of the starting point. This inexorable fall is thus what gives this impulse all its value. It is

this impulse that the spectator must look for in the works of the painter. It should be felt like "an artistic emotion in the first degree, bound to life."[29] Thus Boltanski "returned to the work of fabricating objects that are linked to reality, of course, but that are not exactly reality." Attempting "to do something hybrid that might lead in an imprecise way to different feelings, to diverse realities," he created, among other things, *Images noires*, which evokes at once the clip frame and the mirror, presence and absence, "and other things besides."

We can thus measure the distance separating Boltanski's *Images noires* from Richter's mirrors, beginning with their titles. The dim light in the exhibition of *Images noires* develops the mysterious character that the artist accords to the works and emphasizes the proliferation of interpretations: "One can always offer many interpretations of a work; it is the spectator who, with his lived experience, interprets what is before him."[30] The indistinctness of the mirror in Richter operates in the mode of neither/nor — an in-between space or an interval. But with Boltanski, it comes through a both/and — an all-at-once. The ambiguity of the black mirror is continuously perpetuated in different modes.

But above all, Boltanski has remarked that for some time now, "human representation is tending to disappear" in his work. "The body is present no longer through the photograph but through allusive objects or compositions"; so it is with *Images noires*, among other works. His latest exhibitions evoke spaces that are "calm, less sentimental, in which it is not possible to attach oneself to the contemplation of a face, to the anecdotal."[31] Boltanski is thus relinquishing little by little the "sentimentalism" and lyricism of thought that have been associated with him — a sign that he has reached a certain "maturity." And only a certain maturity can allow one to grasp what is cruel in all devaluation, for while an artistic principle, a principle of life, may be extracted from all

devaluation, devaluation never stops turning against art and life themselves. This is what constitutes the "explicit failure."

The devaluation generated by the black mirror is a reductive and disappointing principle that forces one to eliminate all sentimentalism: its effect is thus to carry art to a state of nonpersonal power, to abstract art from all our private affairs. A properly terrifying force of life flashes briefly across the black mirror. The mirror, by liberating artistic practice, is itself liberated, but at the price of a superhuman effort, the same effort required by literary creation, absolutely obliged to deal with the stupidity that devalues it, as Flaubert himself showed: this is no doubt why Flaubert eliminated the passage in which Emma Bovary looks through the various colored glasses of a window, because this passage was too great an intrusion of the private into his work.[32] This effort is once again the exorbitant price demanded by the modern black mirror.

Devaluation, this complex notion that contains within itself that which both kills it and constitutes it, thus necessarily passes by way of abstraction.

Abstraction(s)

The devaluation of the image entails a progressive loss of the image: Richter ends up painting abstract canvases, and Boltanski no longer presents an image at all. This progressive loss of the image is inseparable from abstraction. We have seen abstraction at work in the classicism of Du Fresnoy and de Piles, as well as its continuation in Gilpin's neoclassicism. "To abstract is to separate," proclaims a dictionary from 1764, perpetuating a definition from the seventeenth century.[1] For these painters, figural meaning becomes concrete: separation leads to the selection and combination of elements that make up the painting. Abstraction was thus the condition of possibility of figuration, of mimesis. Conversely, in 1941, Piet Mondrian relates how in his youth he was already seeking to abstract himself progressively from figuration by taking advantage of natural effects of light very close to those offered by a black mirror: "I preferred to paint landscape and houses seen in grey, dark weather or in very strong sunlight, when the density of the atmosphere obscures the details and accentuates the large outlines of objects. I often sketched by moonlight."[2]

This reversal of the notion of abstraction allows us to extend our thought on the black mirror. We have seen that Matisse was familiar with the black mirror and that after having used it to

paint in his youth, he depicted it in paintings done almost twenty years later. In *Anemones with a Black Mirror* and *Still Life with a Vase of Flowers, Lemons, and Mortar*, the mirror is no longer figured as anything other than a field of black paint. Earlier we said that it is not a matter of abstraction here, in a strictly art-historical perspective. But there is another — more philosophical — way to see it that is indeed concerned with abstraction.

During the years of research on "my" instrument, when anyone asked me what I was working on, I would invariably answer, "On the black mirror," without adding anything more. This was always followed by a heavy silence. Then: "But if it's black, what can you see in it?" The truth is: not much. "Black mirror" is a beautiful oxymoron that does not cease to surprise and discountenance: a mirror that reflects nothing, or almost nothing. As Truman Capote writes, "There is nothing there to be ... seen." The visible is thrown off, as it were. Since Plato, the visible has been placed under the dominion of shadows and reflections. As for thought, it has never stopped being suspicious of the black mirror — and of mirrors in general — which never ceases to lay deceptive traps and to lie. Traditionally, our mirror doubles vision by betraying it: the ancients even said that this object opened a breach into the invisible. This abstraction of the real leads, certainly, to the unreal, but above all to a mistrust of the real.

As Bernard Marcadé remarks, the mirror in general, although it is the very image of thought, is led to relinquish thought. If specular reflection (*reflection*) entails the reflection of thought (*réflexion*), it is also opposed to it. The mirror develops, then, according to two contrary and contradictory modes: specular and speculative. It reflects a reality external to it while at the same time reflecting its own reality. Commenting on the Pauline mirror, Saint Augustine makes a clear distinction between "seeing a mirror" and "seeing through a mirror."[3] For our purposes, this

distinction is all the more true for the black mirror in that it em-
phasizes, excessively, the contradiction between these two poles.
If the black mirror no longer opens this breach into the unreal, if
it no longer makes us cross through the mirror, it also does not
reflect reality back to us. Much like Roy Lichtenstein's mirrors
(figure 15.1) or Rainer Müller's *Schwarzspiegel* (figure 15.2), which
produce not only reflections but especially "blackness" itself,[4] the
black mirror of Matisse's *Anemones* no longer reflects anything
in reality, not even the brightly colored bouquet placed before
the instrument (figure 10.5). One can thus follow the scattered
occurrences of these blackened surfaces, especially during the
period in Nice, by tracing the appearance of this mirror with swan
handles and the growing tendency to dilute the reflections by
darkening its specular surface.[5] The black mirror no longer re-
flects anything but itself. This sheds light on a statement Yves
Rifaux once made concerning his charcoal mirror: "I dream of a
mirror that gives only its own image."

With this turning back onto itself, the black mirror abstracts,
but this abstraction turns against this object. Indeed, when Ma-
tisse paints a black mirror, it is perhaps the better to rid himself of
this instrument, which he had formerly used and abandoned — a
sort of catharsis perhaps. By painting a mirror that reflects only
itself, Matisse liberates the gaze from the dominion of this black
surface, which habitually tends to focus it. Let us not forget that
in his childhood the painter once liberated himself from a hypno-
tist: about to "pick some flowers" from the floor of an indoor hall,
he exclaimed, "No, I can see a carpet!"[6] Matisse liberates the gaze
through the sort of defocalization that we have already discussed,
and he cuts the mirror off at the edge of the painting to ensure
that this black pictorial surface does not in turn absorb and stun
the gaze.

But if we look closer, this black mirror hypnotizes the gaze all

Figure 15.1. Roy Lichtenstein, *Mirror #8 (24" Diameter)*, 1970, oil and magna on canvas, 61 cm diameter (© Estate of Roy Lichtenstein).

Figure 15.2. Rainer Müller, *Schwarzspiegel*, 1997, numbered silkscreen with thick paint strokes on the back of an invitation to the opening, 21 x 21 cm, private collection (courtesy of the artist).

the same, but not in the mode of fixation. The mirror is the re-
flection of all painting prior to Matisse: the mirror, like this can-
vas, captures the gaze by distracting the gaze. This black field, like
other of his canvases almost hallucinatory, becomes part of a tech-
nique proper to Matisse that consists, on the one hand, in "dis-
solving our gaze by distraction" and, on the other, in bringing the
gaze "into a hypnotic state through the saturation of vast fields of
color." The hypnosis of the gaze lies not in its fixity but "in the
insoluble oscillation of our perception (fixation/gaze)."[7]

This figured mirror is thus the reflection of a technique in-
volving flat fields and defocalization (distraction), but it also
reflects his way of seeing, of considering painting and the gaze.
Matisse was not without a certain heliophobia, but the Matissean
experience of the distracted gaze is an experience of time; it re-
quires duration, which a state of overwhelming bedazzlement
obviously rules out. Matisse was so blinded by the sun, and so
obsessed with the fear of going blind, that he "had some glasses
made, with Zeiss lenses as big as plates" — a size chosen so as not
to narrow his field of vision.[8] And we might recall that one can
paint neither the sun nor its light. Making light appear thus be-
came a central problem, to which Matisse responded by saying
that "the painting must have the power to generate light."[9] This
auto-generation of light would be obtained by fields of color, as
Yve-Alain Bois has shown, and more precisely by a black field, as
John Gage has argued.[10]

The dark eyes of the portraits correspond to this blindness of
the gaze: if light can only emerge from black, the gaze can only
take place by becoming opaque. In response to Gage's interpreta-
tion of this figuration of the gaze in light of the black light — in
which black light makes seeing possible — Jean-Luc Nancy writes
that this black veil reflects the gaze itself.[11] In those paintings
showing "gazes without pupils, ... in which the eyes are blank

holes, disappearing in their depths ... are only — and all the more — the very eyes of the painting."[12] The black mirror, which reflects only itself, thus becomes the very image of the gaze. And, by a similar analogy, the black mirror of the *Anemones* also becomes a figuration of the gaze, a portrait, or rather a self-portrait. By making of painting the gaze of the gaze, Matisse returns the mirror to the mirror but also, and especially, returns the gaze, and his own gaze as a painter, to themselves.

Matisse: *Self-Portrait as a Black Mirror.*

This large field of black, considered here an abstraction of the gaze, of a gaze of the gaze, is an abstraction that, too, gives back only itself, at bottom, and is valid only for itself.

An Irremediable Loss

Eye Blink

Before beginning to see the red then bluish effluvia mentioned above, Papus insists that to see shapes appear in a magic mirror, it is not enough to take a distracted look at it after dinner. The first difficulty imposed by the arduous task of fascination, and against which the will must struggle, is the blinking of the eyelids:

> When one stares for a few moments at the center of the mirror, one feels a characteristic stinging in the eyes, and one is often forced to close one's eyes momentarily and thus to destroy all the effort made up to then. The blinking of the eyelids is due to our impulsive being and is purely reflexive; it is thus necessary to combat it with the will — and this takes only a few days — by doing a daily session of twenty minutes maximum. At the moment, then, of feeling the characteristic stinging of the eyes, one must harden one's will in order to prevent the eyelids from closing, and success comes quickly, as we have said.[1]

Blinking the eyes detaches the gaze from its fixation and gives it a rest. But this rest amounts to a loss of the perceived image. However, blinking the eyes was not always perceived as a rest. When Edmund Burke explains "why darkness is terrible," he states that

plunging the gaze into darkness causes the eye to make a painful muscular effort, for the iris is dilated beyond the normal range in search of the least parcel of light.[2] And for Eliphas Lévi, if Du Potet's mirror does not cause bedazzlement, it tires the nervous system as a whole.[3]

In general, however, even if the black mirror is disquieting, it gives vision a rest. According to Capote's female protagonist, Paul Gauguin, Vincent van Gogh, and Auguste Renoir all made use of the mirror for this purpose. It helped them "refresh their vision. Renew their reaction to color, the tonal variations. After a spell of work, their eyes fatigued, they rested themselves by gazing into these dark mirrors. Just as gourmets at a banquet, between elaborate courses, reawaken their palates with a *sorbet de citron.*" Then she adds, "I often use it when my eyes have been stricken by too much sun. It's soothing."[4] If the attribution of such a use of the black mirror to these three painters appears doubtful, it is no less subtle for all that.[5] If we consider Renoir, for example, such a use would not be at all surprising. Although Renoir "was against eyeglasses with smoked lenses, which disturb the balance of nature's colors," he always protected himself from the sun and from light by wearing a hat and long hair, demanding that his family do so as well. He was very careful to choose lamp shades that would prevent one from "having the lamp right in one's eye" and special oil lamps: "They gave off a very soft light, a feature Renoir especially favored since he made a great to-do about protecting his children's eyesight, as well as his own."[6] Let us recall how the sun threatened Matisse with blindness and how it was a source of ocular maladies for Marc Mitouflet Thomin and Caylus in the eighteenth century.

The black mirror thus ensures a breath for sight. As Jacques Derrida has written, the eye blink is nothing other than the breath of sight.[7] It is the absolute speed of the moment, the critical moment

par excellence, for then sight no longer sees; it is blinded. But in this critical moment, this suspension of perception, sight is realized and constituted. The black mirror, like the blinking of the eye, plunges the organ of sight into blindness, but this blindness is no less salutary for all that. The mirror or the blink reveals the invisible, but this invisible is not dialectically opposed to the visible — another world, a double. On the contrary, the eye blink, like the black mirror, shows that the invisible is constitutive of sight itself, as a part of the visible, like the blind spot, the *punctum caecum*, which is implicated in vision at its very origin.[8]

This critical paradox turns this instrument into a skewed (*louche*) mirror.[9] Etienne-Jean Delécluze taught us that eyelids skew the gaze when their blinking loses its synchronization: "There is nothing so common as seeing portraits and even figures in paintings whose *eyelids are skewed*, because each one of them does not have a movement analogous to the other. In vain, then, does the painter try to place the pupils in agreement with each other; the gaze remains vague, uncertain, and even skewed."[10]

The eye blink and the black mirror are skewed, for they induce an eclipse in "seeing." This eclipse can be associated with the Claude mirror or glasses that were used to observe solar eclipses.[11] Now, the analogy between the eye and the sun has a long history. And the black mirror provides a light similar to that visible during an eclipse.[12] This eclipse of the gaze imposed by the blinding mirror helps us to explain why this object is so despised. This mirror, this supplement, is superimposed on the eye that is in danger of being blinded by itself, thus doubling the threat of blindness. To the originary self-blinding of the eye is added an instrumental blinding.[13] And the black mirror is endlessly skewed.

In discussing the black mirror (which neither of them use), Philippe Comar and Denis Laget both told me that they could obtain

the same effect by squinting. Gilpin had already clearly formulated this idea: "Thus when we close one eye, and look through the lid of the other half-shut, we see only the general effect of objects."[14] To understand the significance of such a substitution, we must recall that the black mirror is a historically ambiguous instrument, for it belongs to both of the periods defined by Jonathan Crary. Indeed, if in the seventeenth and eighteenth centuries the black mirror was considered a tool, at the beginning of the nineteenth century the mirror was envisaged as an instrument. The status of the black mirror thus shifts from metaphoric to instrumental. If the mirror seems to effect this conjunction among nature, the image, and the eye — each element rendered transparent to the others in this procession of signs, according to Michel Foucault — metaphor is the figure used to define this metaphoric status itself, for the mirror is always a metaphor for something (the painting, for example): it is ekphrasis.[15] However, when the relation between the eye and the mirror is instrumental, the figure used is metonymy. Both the eye and the mirror can then be considered "contiguous instruments, on the same plane of operation, with varying capabilities and features. The limits and deficiencies of one will be complemented by the capacities of the other and vice versa."[16] Metonymy makes this instrument into a prosthesis by virtue of an internal structural link that binds the instrument to a lack and to internal deficiencies of the eye. Now, we have seen that this lack is constitutive of the very unity of this instrument, for without this lack the eye would not need a prosthesis. In fact, to be more precise, the prosthesis replaces nothing. Certainly, the eye lacks "vision," but the prosthesis does not replace the eye; it compensates for deficiencies. It is therefore a question of a metonymic relation between the eye and the black mirror (see above). Metonymy leads us to make a double observation. On the one hand, if the black mirror provokes a blindness, it is because the eye contains its own power of blindness

through the eye blink and its capacity to blind itself in an originary way through the blind spot. On the other hand, this optical prosthesis leads to a second crisis of the gaze, that described by Crary, for while this instrument serves the eye, the eye also begins to serve this instrument. The risk of servitude felt by Gilpin is that of an observer, grafted onto the apparatus and becoming an entirely separate element of this new observer/black mirror machine. This is also the danger that Eugène Delacroix perceived when he wrote that "the artist, in a word, becomes a machine harnessed to another machine."[17] But paradoxically, it was in his desire to give the eye its independence that Gilpin fell into this logic of servitude.

This, in my view, is why Horace Lecoq de Boisbaudran totally eliminated the use of the black mirror in order to place his trust in the eye alone:

> One must not claim to reproduce from the beginning all the nuances that can be seen in the model; one must on the contrary seek, by blinking one's eyes, the result of several tints. Then, over this local tone, one will place new touches in order to modify and complete the color.
>
> If one executes this work energetically and before the colors have dried, it is called painting straightaway; more generally, one begins by sketch, that is, by groping after the form and the tone.[18]

Thus, squinting leads to groping, which is indeed what the blind are prone to do. But this renowned professor went still further into blindness in the first half of the nineteenth century, since he advocated the widest possible use of memory. Memory induces a delay between the instant the eye sees and the moment the hand executes. And in this suspension, this eye blink, the creative act is located: "The meaning I attach to the word 'memory' is that of 'preserved observation,' memory that retains during the instant

when the draftsman shifts his gaze from his model to the paper and thus preserves impressions for his whole life."[19] Memory constitutes an act of resistance to all the forms of instrumentalization to which the gaze is subjected in the first half of the nineteenth century. It allows one to reaffirm the individuality of the artist at a moment when this individuality is being threatened by the industrial age. That is why Cavé and Delacroix emphasize memory when they recommend the use of optical instruments; memory allows the artist to avoid becoming "a machine harnessed to another machine."

In Charles Baudelaire, memory and its reductive properties take on a sacrificial meaning. "Since art is only an abstraction and a sacrifice of the detail for the sake of the whole, it is important to be especially careful with masses," writes the poet, arguing in another essay that "the best way to know whether a painting is melodious is to look at it from far enough away so that neither the subject nor the lines are comprehensible. If it is melodious, it already has a meaning, and it has already taken its place within the repertory of our memories."[20] Baudelaire takes an even greater step back than Richardson, then; at the limit, he goes completely beyond it, since the painter's judgment is located less in sight than in memory, that is, in the eye blink and in blindness. Memory has become a black mirror.

Blindness

What one finds in Richter, Boltanski, Müller, Perrodin, and Matisse, but also in a certain way in Gilpin, Gray, Coleridge, and Walpole, and going as far back as Seneca and Plato, if not further, is the fascination exerted by the mirror.[21] Now, this fascination is rarely spoken of explicitly but, rather, almost always implied — and we may well suspect that the essential remains unsaid. This fascination exerted by the black mirror comes from this black

hole's attracting and absorbing the gaze, which ends by being lost and engulfed in it.[22] To use Eliphas Lévi's expression, Du Potet's mirror is a "negative space": in it, space is defined by its withdrawal.[23] The black mirror is a surface, but this surface is also a depth. This specular catastrophe, prefigured by the myth of Narcissus, is inseparable from a process that renders the gaze opaque. Fascination quickly becomes malaise.

The malaise provoked in the gaze by the black mirror originates in its hallucinatory effects: the reflection is presented in the form of an interrogative apparition; it is thus located in a kind of transcendence in the Sartrean sense.[24] But the gaze interrogates the mirror because the gaze itself is always being interrogated. This interrogation shows that the gaze is always separated from itself, from its reflection, for it loses itself in the nothingness of this gap opened by the reductive effect of the mirror. This dislocation, this noncoincidence with itself, "nihilates" the gaze. This specular dispossession renders the gaze "vitreous."[25] If the gaze were able to close this gap, reflection would disappear, as would all knowledge of the visible. The blackish and glassy reflection renders the gaze opaque, and yet this rendering opaque makes the gaze possible. The black mirror both kills and constitutes the gaze. Thus, when the gaze wants to rejoin itself in a Platonic specular movement, it is engulfed in the gap, in this black hole that the black reflection is.[26] The mirror is like the Grand Canal for Sartre, a "false hyphen [that] pretends to bring together only the better to separate."[27] There is no gaze that is not from a distance. The gaze is situated in the darkness of the gap inasmuch as every reflection escapes it. Thus the gaze is always in the process of being lost, dispersed, dislocated, for it is always other, multiplied by its reflection in the black mirror. The gaze is the perpetual project of founding itself as a gaze and the perpetual failure of this project. In this sense, the black mirror marks the disaster and the blindness of the gaze.

Melancholy

Although this failure of the gaze remained in the shadows at the end of the eighteenth century, it took place in broad daylight at the end of the twentieth century. And it did so beyond any split between modernism and postmodernism — especially if we think of modernism as giving rise to works that play on the interactive relation between painting as object and painting as representation, and of postmodernism as giving rise to hybrid works, sometimes more or less reminiscent of the black mirror — for the question of the tain remains central. Between reflection and monochrome, these works offer a visual effect very close to that of the Claude mirror, submerging the gaze in darkness and indeterminacy. These works are thus all openly influenced by that most reflective humor, melancholy. In addition to the works of Gerhard Richter, those of François Perrodin make us particularly aware of this.

Is it not characteristic of the melancholic to enjoy this paradox, this failure of the gaze? Only the atrabilious disposition has the capacity to enjoy what one knows one has lost or will never attain. Perrodin confirms this; the "failure of the gaze," he says, is "melancholic" par excellence: "The black tain is perhaps the ultimate site of an exchange with the real; and unlike the silver tain, it could only recall and describe the status of representation, that is, of a relation that tends absolutely toward the real but can never reach it."[28]

The mirror is constantly associated with melancholy. Already for Flaubert, who, like so many of his time, experienced boredom as a fundamental condition, Claude glasses no longer idealize; on the contrary, they cast a bitter tint over the world: "You have seen those colored glasses that decorate kiosks and hosiery shops in the middle of nowhere. One sees the countryside in red, blue, yellow. That's how boredom is. The most beautiful things seen through it take on its tint and reflect its sadness."[29] Flaubert's image for

his imagination is a tinted glass that transfigures everything it observes. That is how a yellow pane makes "everything reflect on [his] soul, as though on the paving stones of a sanctuary that is beautified, transfigured, and yet melancholic."[30] The field of melancholy gradually widens: *Black Mirror*, a collection of poems by Roger Gilbert-Lecomte, attests to this melancholy separation and to a desperate tearing apart not only of the gaze but of the entire individual.[31]

The occultist Paul Sédir established this comparison most explicitly: the "black disks and instruments" are "saturnine mirrors," for the simple reason that black is a "saturnine color," not in the physical sense, of course, but in the astral sense.[32] In fact, onychomancy requires certain astrological conditions: "The moon must be fully aligned with Saturn, or at least well positioned."[33] A lunatic mirror: also a melancholic mirror.

It is therefore not by chance that a number of melancholics — Walpole and Coleridge among them — were interested in the black mirror.[34] A beautiful emblem of melancholic separation, it is almost as if this object were made of solidified black bile.[35] As the poet said, or almost: the tain of the mirror is made of the black cast of desire.[36] This mirror seems suffused with different fluids and humors — beginning with those associated with hunting. And when Colonel Fraser's sheik remarks that "the substance contained in the vases [used in catoptromancy] ... is charged with passion," it is implied that this passion harbors something primitive, since this substance originates from "volcanic chasms" (a reminiscence of classicism and Romanticism) and it will be recalled that many mirrors are made from solidified lava, such as the obsidian mirror.[37] The black humor is frozen. This solidification "vitrifies" the gaze in return, and the gaze frozen on the mirror petrifies and paralyzes the one who looks, as we see on the engraving of an immobilized woman leaning over the infinite void of

Figure 16.1. *Du Potet's Mirror — Allegory*, in Charles Lancelin, *L'Au-delà et ses problèmes: Thème magique et clavicules* (Paris: Librairie du Magnétisme, 1907), p. 196.

her black mirror, her chin resting on her hand, in an attitude characteristic of representations of melancholy (figure 16.1).[38] And Arnold Böcklin's Melancholia, who holds up a black mirror into whose depths she stares, certainly constitutes the finest illustration of this atrabilious contamination.[39] This chain of effects set off by a contamination of the gaze is the inheritance of a long tradition of which the figure of the Medusa is the paragon.[40] If the black mirror is charged with passion, it is charged above all with poison — as were mirrors made with mercury. Thus, although this mirror does not necessarily provoke melancholy, it is quite apt to maintain it, if not actually to darken our minds, just like this black exhalation.[41]

Notes

CHAPTER ONE: DEFINITIONS

1. Michael Kitson, *The Art of Claude Lorrain* (London: Arts Council of Great Britain, Northern Arts Association, Hayward Gallery, 1969), p. 77, no. 185: "A Claude Glass."

2. Leslie Parris, *Landscape in Britain, c. 1750–1850* (London: Tate Gallery, 1973), pp. 124–25.

3. Pierre-Henri de Valenciennes, *Elémens de perspective pratique à l'usage des artistes, suivis de réflexions et conseils à un élève sur la peinture et particulièrement sur le genre du paysage* (1800; Geneva: Minkoff Reprint, 1973), p. 296 (in reference to a mirror to be used for a camera obscura).

4. *Ibid.*, p. 297.

5. Yves Rifaux's mirror can be seen in his museum, L'Art de l'Enfance, in Marcellaz Albanais (74150 France) near Annecy, in the Haute-Savoie region; Pliny the Elder, *Natural History* 36.67.196 (Cambridge, MA: Harvard University Press, 1962), vol. 10, trans. D.E. Eichholz, p. 155; Hugh Tait, "'The Devil's Looking-Glass': The Magical Speculum of Dr. John Dee," in Warren Hunting Smith (ed.), *Horace Walpole, Writer, Politician, and Connoisseur: Essays on the 250th Anniversary of Walpole's Birth* (New Haven, CT: Yale University Press, 1967), pp. 203–204; Francesco Colonna, *Hypnerotomachia Poliphili: The Strife of Love in a Dream*, trans. Joscelyn Godwin (London: Thames and Hudson, 1999), p. 59.

6. These notions of sharpness and depth will be debated, however, by Pliny and William Gilpin, among others.

7. "Vision is not exactly the same thing as the gaze, because the models of scientific explanation applied to vision do not reveal everything involved, within a given cultural context, in the mysteries or the presence of the gaze," Carl Havelange, *De l'oeil et du monde: Une Histoire du regard au seuil de la modernité* (Paris: Fayard, 1998), pp. 18ff.

8. Valenciennes, *Elémens de perspective*, p. 297.

9. Identification number 1980-1747.

10. Thomas West, *A Guide to the Lakes: Dedicated to the Lovers of Landscape Studies* (London, 1778), in *A Guide to the Lakes in Cumberland, Westmorland, and Lancashire*, 3rd ed. (London: J. Robson and W. Pennington, 1784; facs. ed., Oxford: Woodstock Books, 1989), p. 12.

11. Roger de Piles, *Cours de peinture par principes* (1708; Paris: Gallimard, 1989), p. 68; published in England as *The Principles of Painting* (London: J. Osborn, 1743), p. 67.

12. West, *Guide to the Lakes*, p. 12.

13. This mirror was offered for sale in the fall of 1996 at the Librairie Alain Brieux, 48, rue Jacob, 75006, Paris. My thanks to Jean Clair for pointing this out to me. This mirror does not therefore "condense" the image but produces two different, "divergent" images, so to speak. As a Claude mirror, it is thus rather paradoxical.

14. West, *Guide to the Lakes*, p. 12.

15. Reproduced in Martin Kemp, *The Science of Art: Optical Themes in Western Art from Brunelleschi to Seurat* (1990; New Haven, CT: Yale University Press, 1992), p. 199. Martin Kemp has drawn my attention to the fact that the 1992 edition of this book, cited here, includes a number of supplementary points concerning the Claude mirror.

16. William Mason, *The Poems of Mr. Gray, to Which Are Prefixed Memoirs of His Life and Writings*, 2nd ed. (London: H. Hughs, 1775), p. 352n.

17. West, *Guide to the Lakes*, p. 12.

18. Mason, *Poems of Mr. Gray*, p. 352n.

19. *Ibid.*, p. 352n.

20. Truman Capote, "Music for Chameleons," in *Music for Chameleons* (New

York: Random House, 1980), p. 7. I thank Anne Baldassari for introducing me to this beautiful text.

21. Gérard de Lairesse, *Groot schilderboek: Waar in de schilderkonst in al haar deelen grondig werd onderweezen, ook door redeneeringen en prentverbeeldingen verklaard, met voorbeelden uit de beste konststukken der oude en nieuwe puikschilderen bevestigd: En derzelver wel-en missand aangeweezen*, 2 vols. (Haarlem: Johannes Marshoorn, 1740), vol. 2, p. 155; published in English as Gérard de Lairesse, *The Art of Painting in All Its Branches, Methodically Demonstrated by Discourses and Plates, and Exemplified by Remarks on the Paintings of the Best Masters; and Their Perfections and Oversights Laid Open*, trans. John Frederick Fritsch (London, 1778), bk. 9, ch. 9, p. 464.

22. Jean-Antoine Nollet, *Leçons de physique expérimentale*, 6 vols. (Paris: Les Frères Guérin, 1743–1748), vol. 5, pp. 208–11.

23. This drawing is in the British Museum; see John Hayes, *The Drawings of Thomas Gainsborough* (London: Zwemmer, 1970), vol. 1, p. 112, no. 10. A copy attributed to Thomas Baker was exhibited in 1968; another copy, with a slightly different pose, is in the Morgan Library, New York; and a third is in the possession of John Bryson.

24. West, *Guide to the Lakes*, p. 12.

25. For arguments in favor of this hypothesis, see the exhibition catalog by Timothy Clifford, Anthony Griffiths, and Martin Royalton-Kisch, *Gainsborough and Reynolds in the British Museum: The Drawings of Gainsborough and Reynolds with a Survey of Mezzotints After Their Paintings and a Study of Reynolds' Collection of Old Master Drawings* (London: British Museum Publications, 1978), p. 11, drawing no. 14. For arguments against it, see Hayes, *Drawings of Thomas Gainsborough*, vol. 1, p. 112, no. 10; and the exhibition catalog by Michael Clarke and Nicholas Penny, *The Arrogant Connoisseur: Richard Payne Knight, 1751–1824* (Manchester: Manchester University Press, 1982), p. 112, no. 10.

26. Information provided by Elise Picard, who is responsible for the instruments held in the CNAM at Saint-Denis.

27. See especially inventory numbers 1735, 1736 (metal mirrors on a stand,

used on both the concave and the convex sides), 1739 (a convex glass mirror on a stand), 1862, 1863 (no stand).

28. Valenciennes, *Elémens de perspective*, p. 299. West, *Guide to the Lakes*, p. 12: "It should be suspended by the upper part of the case."

29. On the 1996 sale, see above, n.13. In the Science Museum of London, there is a circular black mirror from the eighteenth century made from clear glass that was smoothed and polished on one side only. This mirror coated with tar is peculiar in that there is an oak handle attached with wax and plaster to its back side. This device makes it possible either to hold it in one's hand or to set it up on a flat surface. Nothing prevents us from thinking that this mirror was used as a Claude mirror, thus freeing the artist from the trouble of having to hold it. Cataloged as no. E166 and reproduced in Alan Q. Morton and Jane A. Wess, *Public and Private Science: The King George III Collection* (Oxford: Oxford University Press in association with the Science Museum, 1993), p. 491.

CHAPTER TWO: PROBLEMS OF NAMING

1. P. Berville, 25, rue de la Chaussée d'Antin (Science Museum, mirror no. 1980–1750); the engineer Chevalier, 15, place du Pont Neuf (mirror offered for sale by the Librairie Alain Brieux).

2. Lars Kiel Bertelsen, in researching his doctoral thesis on the beginnings of photography (which will hopefully soon be published), has done intensive work on the Claude mirror. He is the author of an excellent article written in Danish, "Det grå glas [The gray glass]: Observations on the Claude Glass, Relative Chiefly to Picturesque Beauty, etc.," *Passage, tidsskrift for literatur og kritik* 31/32 (1999), pp. 142–54. This text has since been translated into English by Stacey M. Cozart, "The Claude Glass : A Modern Metaphor between Word and Image," *Word & Image* 20, no. 3 (July–Sept. 2004), pp. 182–90. I am grateful to Mr. Bertelsen for kindly sending me the English version as well as other documents he has located, and to Neil Brown for having put us in contact during our nearly simultaneous visit to the Science Museum in 1997.

3. *Schwarzspiegel-Specchio nero e convesso, Installation von Rainer Müller,* Kunst im Turm (K.I.T.) II, Sept. 1997, Waldemarturm, 29446 Dannenberg/ Elbe.

4. What are we to make of Heinrich Schwarz's assertion "In the 1830s — the decade which brought forth photography — the Austrian realist painter Waldmüller painted his landscapes with the help of a black mirror which is still preserved" ("The Mirror in Art," *Art Quarterly* 15, no. 2 [summer 1952], p. 116)? I have unfortunately been unable to locate this mirror, assuming it still exists. Schwarz again mentions Ferdinand Waldmüller's possible use of the black mirror in *Salzburg und das Salzkammergut* (Salzburg: Galerie Welz, 1977), p. 38. He bases his claims on the testimony of Count Athanasius Raczynski, *Geschichte der neuen deutschen Kunst* (Berlin, 1740), pp. 620–30: certain landscape paintings evoke the effect of this instrument. Professor Rupert Feuchtmüller, the author of a very fine and exhaustive study of this Austrian painter, *Ferdinand Georg Waldmüller, 1793–1865* (Vienna: Christian Brandstätter, 1996), informed me that he is unaware of a single black mirror — including Waldmüller's — held in any Austrian museum.

5. Georg Hieronimus Bestelmeier, *Magazin von verschiedenen Kunst und anderen nützlichen Sachen, zur lehrreichen und angenehmen Unterhaltung der Jugend, als auch für Liebhaber der Künste und Wissenschaften, welche Stücke meistens vorräthig zu finden* (Nuremberg, 1803; repr. Zurich: Olms Zürich, 1979), no. 414. I am grateful to Yves Rifaux for this reference.

6. Neil Brown of London's Science Museum expressed his surprise that there are so few Claude mirrors in France. Although they are not very common in England, it is not difficult to find some of them. The Science Museum has not always had very many; most of them came from the large and very diverse Wellcome Collection, which entered the Science Museum as a loan about twenty years ago. The largest part of this collection is made up of medical instruments, but there are numerous other objects as well. As of January 7, 1997, the Science Museum had twenty-eight. The inventory numbers are as follows: 1951-298, 1954-272 and 273, 1980-1740 to 1742, 1980-1745, 1980-1746/1 to 11 (Wellcome Collection series), 1980-1747, 1980-1750, 1980-1751/1 and 2, 1980-1752, 1981-106, and 1993-1222 to 1224. The last, A127914, is a Claude mirror in a sharkskin-covered box that was believed for a time to be the famous mirror of Dr. John Dee (see below).

7. The claim made above that there are no Claude glasses in French collections is an overly hasty statement that requires more precise specification: Some do exist, but not with this designation. Indeed, in the CNAM I happened upon some black mirrors used in analyzing and producing the polarization of light (see below). The curators had obviously not made the connection, since these mirrors had been designed and utilized for scientific experiments (or so they believe, naively), a point I will return to. There are therefore at least two black circular mirrors similar to the one belonging to Yves Rifaux, but flat (no. 1750, registered at the CNAM in 1814, and no. 8451). Their scientific vocation and their flatness surely led to their being forgotten by the curators at the time of my consultations.

8. Olivier Meslay, "Murillo and 'Smocking Mirrors,'" *Burlington Magazine*, Feb. 2001, pp. 73–79; Erik Gonthier, Françoy Gendron, and Olivier Meslay, "Deux tableaux de Murillo au Musée du Louvre, une étonnante découverte artistique et archéologique," *Revue de gemmologie AFG (Association Française de Gemmologie)*, Jan./Feb. 2001, pp. 59–64.

9. Nicholas J. Saunders, *Obsidian Mirrors and Tezcatlipoca in Conquest and Post-conquest México: Report submitted to FAMSI*, Jan. 2, 2001, http://www.famsi. org/reports/98056/index.html.

10. I am grateful to Marie-Christine Pouchelle for relating this information to me. Beyond these magical or demoniac considerations — whether they are expressed in an ironic French mode or a tragic American mode — she admitted that she regarded this mirror quite seriously since, magic or not, it can become dangerous, if only from the point of view of the imagination and the mind of the viewer. It must be recognized that our rationalism is quite incapable of dealing with such an object and the phenomena that accompany it, for, as the poet has written, "There are more things in heaven and earth, Horatio, / Than are dreamt of in your philosophy" (Shakespeare, *Hamlet* 1.5).

11. Marie-Madeleine Martinet, *Le Miroir de l'esprit dans le théâtre élisabéthain* (Paris: Didier Erudition, 1981), pp. 13ff.

12. Marie-Madeleine Martinet, *Art et nature en Grande-Bretagne* (Paris: Aubier-Montaigne, 1980) pp. 23–28; see also Jurgis Baltrušaitis, *Aberrations: An*

Essay on the Legend of Forms, trans. Richard Miller (Cambridge, MA: MIT Press, 1989), p. 157.

13. Deborah Jean Warner, "The Landscape Mirror and Glass," *Magazine of Antiques*, Jan. 1974, pp. 158–59, can be credited with having clearly indicated the difference between these two instruments.

14. Accordingly, I have maintained this distinction by translating *verre de Claude* as "Claude glass" and *miroir de Claude* as "Claude mirror." — TRANS.

15. On reducing glasses, see Rutherford J. Gettens and George Leslie Stout, *Painting Materials: A Short Encyclopedia* (1942; New York: D. Van Nostrand, 1946), p. 308. On convex glasses, see Gérard de Lairesse, *The Art of Painting in All Its Branches, Methodically Demonstrated by Discourses and Plates, and Exemplified by Remarks on the Paintings of the Best Masters; and Their Perfections and Oversights Laid Open*, trans. John Frederick Fritsch (London, 1778), bk. 5, ch. 22, p. 254. Lairesse's work (*Groot schilderboek*) was first published in Amsterdam in 1707 and was translated at the time into English and German (and even partially into Japanese). Gérard de Lairesse describes concave and convex glasses through which one can look at the landscape, but he warns against the images that these instruments present, for they diverge somewhat, because of an accentuated effect, from the pictorial model.

16. Sir Walter Scott, *Redgauntlet* (1824; New York: Columbia University Press, 1997), letter 5, p. 33.

17. Samuel Taylor Coleridge, *The Notebooks*, ed. Kathleen Coburn (London: Routledge and Kegan Paul, 1957), vol. 1 (1794–1804), entry no. 1412. I believe it is a question of Claude glasses, for in entry no. 452 Coleridge notes, "Mem — A Claude Lorrain & the coloured glasses for Greenough."

18. Gustave Flaubert, *Correspondance* (Paris: Gallimard, 1980), vol. 2, p. 89. This page is without doubt the description of Emma's looking successively through the differently colored panes of a window; but Flaubert did not include this description in the final text. It can be found in *Madame Bovary, nouvelle version précédée des scénarios inédits*, ed. Jean Pommier and Gabrielle Leleu (Paris: Librairie José Corti, 1949), p. 216.

19. Cuming Museum, inventory no. C2618. I thank Marie-Madeleine Martinet for pointing this out.

20. See Peter Bicknell, *The Picturesque Scenery of the Lake District, 1752–1855: A Bibliographic Study* (Winchester, UK: St. Paul Bibliographies, 1990), p. 194.

21. William Gilpin, *Observations, Relative Chiefly to Picturesque Beauty, Made in the Year 1776, on Several Parts of Great Britain; Particularly the Highlands of Scotland*, 2 vols. (London: Blamire, 1789), vol. 1, p. 124. Although Gilpin did not show an unconditional admiration for Lorrain, he was aware of the latter's originality, his capacity to simplify his landscapes, notably in his drawings; see Malcolm Andrews, *The Search for the Picturesque: Landscape Aesthetics and Tourism in Britain, 1760–1800* (Stanford, CA: Stanford University Press, 1989), p. 31.

22. Adam Walker, *Remarks Made in a Tour from London to the Lakes of Westmoreland and Cumberland, in the Summer of 1791, Originally Published in the Whitehall Evening Post, and Now Reprinted with Additions and Corrections, to Which Is Annexed, a Sketch of the Police, Religion, Arts, and Agriculture of France, Made in an Excursion to Paris in 1785* (London: G. Nicol and C. Dilly, 1792), p. 3.

23. Johann Wolfgang von Goethe, *Italian Journey*, ed. Thomas P. Saine and Jeffrey L. Sammons, trans. Robert R. Heitner (New York: Suhrkamp, 1989), p. 142.

24. Gettens and Stout, *Painting Materials*, p. 286; or, more recently, "Claude Glass," in Ian Chilvers, Harold Osborne, and Dennis Farr (eds.), *The Oxford Dictionary of Art* (Oxford: Oxford University Press, 1990), p. 109.

25. Marcel Röthlisberger, *Critical Catalogue*, vol. 1 of *Claude Lorrain: The Paintings*, 2 vols. (New Haven, CT: Yale University Press, 1961), p. 41, n.60.

26. George Adams, *A Treatise Describing the Construction and Explaining the Use of New Celestial and Terrestrial Globes* (London, 1787), cited in Warner, "Landscape Mirror and Glass," p. 158. A story found on the internet provides a strange but intriguing version of the possible origin of the Claude glass: in Italy in 1635, Lorrain was meditating at his window (rather like Aretino in his famous letter addressed to Titian in May 1544), and as evening approached, he emptied his wine glass and placed it next to a lit candle which covered it with a

layer of soot. As he yawned, the painter turned his glass toward the landscape in such a way as to see the landscape reflected and reduced in its colors. Realizing that this was not an effect of the alcohol, the artist thus discovered the virtues of tonal values. This fiction comes from the British painter and writer John Coombes (blog, dated April 8, 2003, "Great moments in history, No. 6: The Claude Glass"), who could equally have presented Lorrain in his last glass while it was still full in order to obtain this reflection, as in the mannerist paintings in which the carafe or the glass is filled with wine: the idea is more or less the same, that is, to explain a rich and obvious beauty in a fantastical manner (see below).

27. Peter Crosthwaite, *A Series of Accurate Maps of the Principal Lakes of Cumberland, Westmorland & Lancashire...*, *First Surveyed and Planned Between 1783 and 1794* (1792; Newcastle on Tyne: Frank Graham, 1968); Bicknell, *Picturesque Scenery*, p. 194, and in Warner, "Landscape Mirror and Glass," p. 158.

CHAPTER THREE: PROBLEMS OF HISTORICAL SOURCES

1. Bernard Teyssedre, *Roger de Piles et les débats sur le coloris au siècle de Louis XIV* (Paris: Bibliothèque des Arts, 1957), pp. 109–12.

2. Gustav Friedrich Hartlaub, *Zauber des Spiegels; Geschichte und Bedeutung des Spiegels in der Kunst* (Munich: R. Piper, 1951); Jurgis Baltrušaitis, *Le Miroir: Essai sur une légende scientifique: Révélations, science-fiction, et fallacies* (Paris: Elmayan, 1978).

3. Roger de Piles, *The Principles of Painting* (London: J. Osborn, 1743), p. 68.

4. Father Jean Dubreuil, *La Perspective pratique nécessaire à tout peintres, graveurs, sculpteurs, architectes, orfèvres, brodeurs, tapissiers, et autres se servans du dessin* (Paris: Melchior Tavernier, François L'Anglois, dit Chartres, 1642), n.p.

5. "Miroir," in Denis Diderot and Jean Le Rond D'Alembert (eds.), *Encyclopédie; ou, Dictionnaire raisonné des sciences, des arts, et des métiers*, 35 vols. (Paris: Briasson, David, Le Breton, Durand, 1750–1770; repr. Stuttgart-Bad Cannstatt: Friedrich Frommann, Günther Holzboog GmbH & Co., 1988), vol. 10, p. 566. In fact, as Vasco Ronchi recalls, Johannes Kepler had caused a veritable revolution in

the understanding of how images are formed in spherical mirrors, which were considered no longer in their totality but only partially. The reflected rays passed through only one point on such a mirror. Thus, when one places a curved mirror before the moon, each point of the moon has a corresponding point in its image. Kepler thus gave birth to the optical image and to optics itself, but no one understood anything about it at the time and even long afterward. See *Le Soleil à la Renaissance: Sciences et mythes* (Brussels: Presses Universitaires de Bruxelles, 1965), pp. 155–57.

6. Jean Torlais, "La Physique expérimentale," in René Taton (ed.), *Enseignement et diffusion des sciences en France au XVIIIe siècle* (Paris: Hermann, 1964), pp. 619–45.

7. These drawings are at the Bibliothèque d'Art et d'Archéologie Jacques Doucet in Paris. They are reproduced in two articles on this famous cabinet: C.R. Hill, "The Cabinet of Bonnier de la Mosson (1702–1744)," *Annals of Science* 43 (1986), pp. 147–74; and Franck Bourdier, "L'Extravagant cabinet Bonnier," *Connaissance des arts*, Aug. 1959, pp. 52–59. See also a brief mention in an anonymous article on the amateurs' cabinets: "Le Cabinet du curieux," *Connaissance des arts*, Dec. 1953, pp. 61–65.

8. Edme François Gersaint, *Catalogue raisonné d'une collection considérable de diverses curiosités en tous genres, contenuës dans les cabinets de feu Monsieur Bonnier de la Mosson, bailly & capitaine des chasses de la Varenne des Thuilleries & ancien colonel du régiment dauphin* (Nevers: Jacques Barois; Paris: Pierre-Guillaume Simon, 1744). A copy in the Bibliothèque Nationale de France ([V. 32663) was annotated by hand in the margin with the names of those who acquired the various objects upon the sale of the collection.

9. Didier d'Arclais de Montamy, *Traité des couleurs pour la peinture en émail et sur la porcelaine; précédé de l'art de peindre sur l'émail, et suivi de plusieurs mémoires sur différents sujets intéressants, tels que le travail de la porcelaine, l'art du stuccateur, la maniere d'exécuter les camées & les autres pierres figurées, le moyen de perfectionner la composition du verre blanc & le travail des glaces, &c.* (Paris: G. Cavelier, 1765), p. 258.

10. *Ibid.*, pp. 253–54.

11. *Ibid.*, pp. 256–57.

12. De Rancy, *Essai de physique en forme de lettres; à l'usage des jeunes person-nes de l'un et l'autre sexes, augmenté d'une lettre sur l'aimant, de réflexions sur l'electricité, & d'un petit traité sur le planétaire* (Paris: Hérissant, 1768), p. 7.

13. "Miroitier," in *Encyclopédie*, vol. 10, p. 572.

14. Antoine Furetière, "Miroir," in *Dictionnaire universel, contenant géné-ralement tous les mots françois, tant vieux que modernes et les termes de toutes les sciences et des arts* (The Hague: Arnout and Reinier Leers, 1690), vol. 2, n.p.: "A burning mirror is a concave mirror. It is applied also to magnifying glasses, although they burn only by refraction."

15. Marc Mitouflet Thomin, *Traité d'optique méchanique, dans lequel on donne les règles et les proportions qu'il faut observer pour faire toutes sortes de lunettes d'approche, microscopes simples et composés, et autres ouvrages qui dépendent de l'art, avec une instruction sur l'usage des lunettes ou conserves pour toutes sortes de vûes* (Paris: Jean-Baptiste Coignard and Antoine Boudet, 1749), p. 345.

16. "Miroitier," p. 568.

17. William Mason, *The Poems of Mr. Gray, to Which Are Prefixed Memoirs of His Life and Writings*, 2nd ed. (London: H. Hughs, 1775), p. 352.

CHAPTER FOUR: DEMONIAC MIRRORS

1. "The mirror is the real ass of the devil." This is an old proverb reported by Jurgis Baltrušaitis in *Le Miroir: Essai sur une légende scientifique: Révélations, science-fiction, et fallacies* (Paris: Elmayan, 1978), p. 193.

2. As Baltrušaitis recalls, the "witch" is an "embossed mirror." The image is thus multiplied by the number of bumps that make up so many small convex mirrors, as it were, juxtaposed on a large mirror. But the witch referred to here is made from a single piece and therefore requires a special mold. See *ibid.*, pp. 36–37.

3. *Ibid.*, p. 248. The tale of the tigress recounted by Pliny (*Natural History* 7.25) does not include a mirror, which was added in later versions.

4. Sabine Melchior-Bonnet, "Figures de miroirs dans la culture médiévale,"

in *Miroirs: Jeux et reflets depuis l'antiquité* (Paris: Somogy Editions d'Art, 2000), pp. 108–109. On the monkey as symbol, see Horst Woldemar Janson, *Apes and Ape Lore in the Middle Ages and the Renaissance* (London: Warburg Institute, University of London, 1952).

5. The great satanic principle so well understood by witches consists in inverting, reverting, overturning everything invested by the sacred world. For the sake of clarity, I will take an example not from optics but from "medicine against nature": for Satan, contrary to the Church, which believes it can cure the body through spiritual means, the remedy lies in the use of "material means for acting even on the soul." Thus, for example, Jules Michelet tells us that whereas the sacred man has a holy horror of poison, Satan uses it as a remedy. By treating the ill with the ill, this "bold homeopathy" is equivalent to seeking a cure in the ill itself. Jules Michelet, *Satanism and Witchcraft: A Study in Medieval Superstition* (1862), trans. A.R. Allinson (New York: Citadel Press, 1939), ch. 9, esp. p. 82. We will have occasion to return to this thought that goes against nature.

6. *Bullarum privilegiorum ac diplomatum Romanorum pontificum* (Rome: Hieronimus Mainardi, 1741), vol. 3, pt. 2, pp. 194–95. For John XXII's letter of February 27, 1318, see Joseph Hansen, *Quellen und Untersuchungen zur Geschichte des Hexenwahns und der Hexenverfolgung im Mittelalter* (Bonn: C. Georgi, 1901), pp. 3 and 43ff. Two and a half centuries later, the prohibition, far from being lifted, is affirmed by Jean Bodin, *De la démonomanie des sorciers* (Paris: Du Puys, 1580), p. 56: "the law of God, which forbids us to adore the stone of imagination: where it seems that it was a stone exactly polished in the form of a mirror, in order to imagine, and to divine."

7. Jean-Baptiste Thiers, *Traité des superstitions selon l'Ecriture Sainte, les décrets des conciles, et les sentimens des saints pères et des théologiens*, 3rd ed. (Paris: Antoine Dezallier, 1712), vol. 1, p. 126.

8. This hypothesis was suggested to me by Yves Rifaux. Jacques Goimard has also stated that he supports it.

9. Paul Jay, *Les Conserves de Nicéphore: Essai sur la nécessité d'inventer la photographie* (Chalon-sur-Saône: Société des Amis du Musée Nicéphore Niépce,

1992), p. 98. I am grateful to Yves Rifaux for this reference. I might note with amusement that the perfectly circular black mirror with no handle owned by Yves Rifaux has a label on the back inscribed with the date 1842!

10. Jean Ray, "Le Miroir noir," in *Le Grand Nocturne: Les Cercles de l'épouvante* (Brussels: Actes Sud/Editions Labor, 1984), p. 316. I have unfortunately been unable to find the source of this excerpt that Jean Ray says he copied "from an old Warren Almanac from 1857" (p. 316). This text, however, seems to me to be a trustworthy testimony, inasmuch as the citation from Elias Ashmole is authentic: "*By the* Magicall *or* Prospective Stone *it is possible to discover a* Person *in what part of the* World *soever, although never so secretly concealed or hid; in* Chambers, Closets, *or* Cavernes *of the* Earth: *Fore there it makes a strict* Inquisition. *In a word, it fairely presents to your view even the* whole World *wherein to behold, heare, or see your* Desire. *Nay more, It enables Man to* understand *The Language of the* Creatures, *as the* Chirping *of* Birds, Lowing *of* Beasts &c. *To* Convey *a* Spirit *into an* Image, *which by observing the* Influence *of* Heavenly Bodies, *shall become a true* Oracle, *And yet this as E.A.* [Elias Ashmole] *assures you, is not any wayes* Necromanticall, *or* Devilish; *but easy, wonderous easy, Naturall and Honest.*" In Elias Ashmole, *Theatrum Chemicum Britannicum: Containing Severall Poeticall Pieces of Our Famous English Philosophers, Who Have Written the Hermetique Mysteries in Their Owne Ancient Language: Faithfully Collected into One Volume, with Annotations Thereon* (London: Brooke, 1652), n.p. We will return later to the opposition between diabolical and natural magic.

11. Jean Starobinski, "From Light Frivolities to Macabre Delights," *The Invention of Liberty, 1700–1789*, trans. Bernard C. Swift (Geneva: Skira, 1964), pp. 72–75.

12. Antoine-Joseph Dezallier d'Argenville, *L'Histoire naturelle éclaircie dans deux de ses parties principales, la lithologie et la conchyliologie* (Paris: De Bure, 1742), p. 199.

13. Christian Duverger, *La Méso-Amérique: L'Art préhispanique du Mexique et de l'Amérique centrale* (Paris: Flammarion, 1999), p. 437. Nevertheless, as Olivier Meslay pointed out to me, it seems difficult to believe that these mirrors appear

ex nihilo beginning with the Spanish Conquest. Indeed, nothing comes from nothing, and until there is proof to the contrary, there is no spontaneous generation. In an article cited above, Meslay claims that "the first monolithic mirrors made of obsidian did not appear until [Epoch IV] (800– 1300 AD)," but that the use of obsidian goes back much farther in this part of the globe: GONTHIER, GENDRON, MESLAY, "Deux tableaux de Murillo au Musée du Louvre, une étonnante découverte artistique et archéologique," pp. 62–63.

14. See Christian F. Feest, *Vienna's Mexican Treasures* (Vienna: Museum für Völkerkunde, 1990).

15. On this imbroglio and the controversy around Tezcatlipoca and his mirror before and after the Spanish conquest, see Olivier Guilhem, *Moqueries et métamorphoses d'un dieu aztèque: Tezcatlipoca, le "Seigneur au miroir fumant"* (Paris: Institut d'Ethnologie, 1997); Mary Miller and Karl Taube, *An Illustrated Dictionary of the Gods and Symbols of Ancient Mexico and the Maya* (London: Thames and Hudson, 1993); François Gendron, Erik Gonthier, and Olivier Meslay, "Quand Murillo peignait sur des miroirs préhispaniques," *Archéologia*, Sept. 2000, pp. 6–7; Nicholas J. Saunders, *Obsidian Mirrors and Tezcatlipoca in Conquest and Post-conquest México: Report Submitted to FAMSI*, Jan. 2, 2001, http://www.famsi.org/reports/98056/index.html.

16. For everything, or almost everything, there is to know about Dr. Dee's mirror, see Hugh Tait, "'The Devil's Looking-Glass': The Magical Speculum of Dr. John Dee," in Warren Hunting Smith (ed.), *Horace Walpole, Writer, Politician, and Connoisseur: Essays on the 250th Anniversary of Walpole's Birth* (New Haven, CT: Yale University Press, 1967), pp. 195–212 and 337–338. Also see Marie-Madeleine Martinet, *Le Miroir de l'esprit dans le théâtre élisabéthain* (Paris: Didier Erudition, 1981), p. 324, n.23.

17. Sir Walter Scott, *Letters on Demonology and Witchcraft* (New York: Bell Publishing Co., 1970), letter 10, p. 339. Scott elsewhere evokes the "looking-glass" of Cornelius Agrippa that allowed one to see at a distance: *The Lay of the Last Minstrel: A Poem in Six Cantos*, in *The Poetical Works of Sir Walter Scott* (London: H.G. Bonn, 1848), pp. 84–85n.

18. Eliphas Lévi, *Histoire de la magie*, in *Secrets de la magie: Dogme et rituel de*

la haute magie: Histoire de la magie; La Clef des grands mystères, ed. Francis
Lacassin (Paris: Robert Laffont, 2000), p. 640.

CHAPTER FIVE: CATOPTROMANCY

1. Johann Hartlieb, *Das Buch aller verbotenen Künste, des Aberglaubens und
der Zauberei* (Ahlerstedt: Param, 1989), ch. 84. French trans. by Armand Delatte
in *La Catoptromancie grecque et ses dérivés* (Liège: H. Vaillant-Carmanne, Paris: E.
Droz, 1932), pp. 50–51. This very fine study is an inexhaustible source and a
necessary starting point. The present work owes a great deal to it, as well as to
that of Baltrušaitis and those who came after him.

2. Delatte, *Catoptromancie*, pp. 60ff.

3. Léon de Laborde, "Magie orientale," *Revue des deux mondes* 3 (1833), pp.
332–43.

4. Edward William Lane, *An Account of the Manners and Customs of the Mod-
ern Egyptians, Written in Egypt During the Years 1833–1835* (1837; Glasgow:
Grand Colosseum Warehouse Co., [1900]), pp. 246–54.

5. *Mémoires de L.A. Bellanger de Lespinay, vendômois, sur son voyage aux Indes
Orientales (1670–1675)* (Vendôme: Charles Huet, 1895), p. 207.

6. Stephen Fraser, *Twelve Years in India*, cited by Paul Sédir, *Les Miroirs ma-
giques: Divination, clairvoyance, royaumes de l'astral, évocations, consécrations,
l'Urim & le Thummim, miroir des Bhattahs, des arabes, de Nostradamus, de Sweden-
borg, de Cagliostro, etc.*, 3rd ed. (Paris: Librairie Générale des Sciences Occultes,
Bibliothèque Chacornac, 1907), p. 60.

7. During a long journey to the Orient begun in 1826, the Comte de
Laborde explored Petra in particular in 1828, then he was a diplomat, a senator,
a curator of Antiquities for the Louvre from 1845 to 1848, and later became the
Directeur Général of Archives in 1857.

8. Kaspar Peucer, *Commentarius de praecipuis divinationum generibus* (Wit-
terberg, 1553), cited by Delatte, *Catoptromancie*, pp. 72–73.

9. Jean-Baptiste Thiers, *Traité des superstitions selon l'Ecriture Sainte, les
decrets des conciles, et les sentimens des saints pères et des théologiens*, 3rd ed. (Paris:
Antoine Dezallier, 1712), vol. 1, p. 188.

10. *L'Almanach du magiste, première année mars 1894–mars 1895* (published in Paris by a group of occultists under the direction of Papus), p. 165.

11. Louis-Alphonse Cahagnet, *Magie magnétique; ou, Traité historique et pratique de fascinations, miroirs cabalistiques, apports, suspensions, pactes, talismans, charme des vents, convulsions, possessions, envoûtements, sortilèges, magie de la parole, correspondance sympathique, nécromancie, etc.* (Paris: Baillière, 1854), p. 81. Du Potet's mirror no longer even uses reflective materials: a circle of about 10 centimeters in diameter is drawn on the ground with charcoal. Staring at the center of the circle, one then sees visions appear in it.

12. Delatte, *Catoptromancie*, p. 60. *Art Magic; or, Mundane, Sub-mundane, and Super-mundane Spiritism: A Treatise*, ed. Emma Hardinge Britten (New York, 1876), p. 420.

13. Benjamin Goldberg, *The Mirror and Man* (Charlottesville: University Press of Virginia, 1985), p. 4.

14. *A True & Faithful Relation of What Passed for Many Yeers Between Dr. John Dee (Mathematician of Great Fame in Q. Eliz. and King James, Their Reignes) and Some Spirits: Tending (Had It Succeeded) to a General Alteration of Most STATES and KINGDOMES in the World . . . with a Preface Confirming the Reality (as to the Point of Spirits) of This Relation: and Shewing the Several Good Uses That a Sober Christian May Make of All* by Meric. Casaubon (London: D. Maxwell, 1659).

15. Delatte, *Catoptromancie*, pp. 69ff.; Jurgis Baltrušaitis, *Le Miroir: Essai sur une légende scientifique: Révélations, science-fiction, et fallacies* (Paris: Elmayan, 1978), p. 194.

Chapter Six: Magnetism, Hypnotism

1. Pierre Massé, *De l'imposture et tromperie des diables, devins, enchanteurs, sorciers, noueurs d'esguillettes, chevilleurs, necromanciens, chiromanciens, & autres qui par telle invocation diabolique, ars magique, & superstitions abusent le peuple* (Paris: Jean Poupy, 1579), p. 10. There is much reason to believe that such a distinction was introduced as part of a strategy that divides what is not understood into opposing orders. Magic resists all forms of order, classification, or system, such as Christianity, the law, or the philosophy derived from the Platonic tradi-

tion; it is a grain of sand in their gears. Much like contradiction, such a division is a form of cheating designed to better recuperate what has heretofore resisted the grand dialectical recuperation of powerful systems.

2. Louis-Alphonse Cahagnet, *Magie magnétique; ou, Traité historique et pratique de fascinations, miroirs cabalistiques, apports, suspensions, pactes, talismans, charme des vents, convulsions, possessions, envoûtements, sortilèges, magie de la parole, correspondance sympathique, nécromancie, etc.* (Paris: Baillière, 1854), p. 75.

3. Sir John Davies, "Orchestra; or, A Poem Expressing the Antiquity and Excellency of Dancing. In a Dialogue Between Penelope and One of Her Wooers (Not Finished)," in Robert Anderson (ed.), *A Complete Edition of the Poets of Great Britain* (London: John and Arthur Arch, Bell and Bradfute, I. Mundell, 1795), vol. 2, st. 126, p. 721:

> This was the picture of wondrous thought
> But who can wonder that her thought was so
> Sith Vulcan king of fire that mirror wrought,
> (Who things to come, present, and past, doth know)
> And there did represent in lovely show
> Our glorious English court's divine image,
> As it should be in this golden age.

4. Jean Starobinski, *L'Oeil vivant II: La Relation critique, essai* (Paris: Gallimard, 1970), pp. 204ff.

5. Georges Bell [Joachim Hounau, pseud.], *Le Miroir de Cagliostro (hypnotisme)* (Paris: Librairie Nouvelle, A. Bourdillat et Cie, 1860), p. 89. Also see pp. 52–53 and 87.

6. This is also how Cahagnet interprets it; see *Magie magnétique*, p. 75.

7. Léon de Laborde, "Magie orientale," *Revue des deux mondes* 3 (1833), p. 338.

8. Robert Muchembled, *Une Histoire du diable, XIIe–XXe siècles* (Paris: Seuil, 2000), p. 279.

9. Jurgis Baltrušaitis, *Le miroir: Essai sur une légende scientifique: Révélations,*

science-fiction, et fallacies (Paris: Elmayan, 1978), pp. 193, 177–212, 147ff.; Sabine Melchior-Bonnet, *The Mirror: A History* (New York: Routledge, 2001), pp. 187–221; Jean Bodin, *De la démonomanie des sorciers* (Paris: Du Puys, 1580), p. 56 (see quotation above in ch. 4, n.6).

10. Truman Capote, "Music for Chameleons," in *Music for Chameleons* (New York: Random House, 1980), p. 7.

11. *Ibid.*, p. 11.

12. *Ibid.*, p. 12.

13. *Ibid.*, p. 7.

CHAPTER SEVEN: DISQUIET

1. Pliny the Elder, *Natural History* 36.67.196 (Cambridge, MA: Harvard University Press, 1962), vol. 10, trans. D.E. Eichholz, p. 155.

2. Gérard Simon, "Science de la vision et représentation du visible: Le Regard de l'optique antique," *Cahiers du Musée National d'Art Moderne* (Autumn 1991), p. 6.

3. James Mellaart, *Çatal Hüyük: A Neolithic Town in Anatolia* (New York: McGraw-Hill, 1967), p. 79.

4. Pliny the Elder, *Natural History* 35.5, vol. 9, trans. H. Rackham, p. 271: "The question as to the origin of art is uncertain …, but all agree that it began with tracing an outline round a man's shadow and consequently that pictures were originally done in this way."

5. *Ibid.* 35.43.151, p. 373.

6. *Ibid.* 33.46.131, p. 99. Personally, I find the text somewhat ambiguous, but Delatte also interprets it thus. There are in fact other mirrors in Pliny that can be interpreted as black mirrors, such as the mirrors of Syros (36.26, vol. 10, p. 105); see Johann Beckmann, *A History of Inventions and Discoveries* (London: J. Bell, 1797), vol. 3, pp. 192–93 and 195. And Theophrastus, as Pliny also relates (*Natural History* 37.25.97, vol. 10, p. 243), says that the carbuncles of Orchomenus in Arcadia, darker than the rocks of Chios, were made into mirrors; see Theophrastus, *De lapidibus* 6.33, ed. and trans. D.E. Eichholz (Oxford: Clarendon Press, 1965), p. 69. Finally, there is the *Lapidaire orphique*, a "round stone,

quite rough, compact, black, and dense," given as a gift by Apollo to the prophet Helenus (Fernand de Mély and Charles-Emile Ruelle, *Les Lapidaires de l'anti-quité et du moyen âge* [Paris: Leroux, 1896], vol. 2, p. 147, ll. 357ff. Also see "L'Epitomé du lapidaire orphique," in *ibid.*, pp. 163ff.; and Armand Delatte, *La Catoptromancie grecque et ses dérivés* [Liège: H. Vaillant-Carmanne; Paris: E. Droz, 1932], p. 144, for the translation). This last-mentioned mirror did not bring forth demoniac apparitions but allowed one to hear miraculous sounds. The use of the black mirror in Antiquity was therefore not an isolated case; these objects were found in various places and times and were used in different ways.

7. Pausanias, *Description of Greece*, trans. W.H.S. Jones (Cambridge, MA: Harvard University Press, 1935), bk. 8, *Arcadia* 37.6, p. 89.

8. Jean-Pierre Vernant, *L'Individu, la mort, l'amour: Soi-même et l'autre en Grèce ancienne* (Paris: Gallimard, 1989), pp. 117–18.

9. *The New Oxford Annotated Bible* (New Revised Standard Version), ed. Bruce M. Metzger and Roland Murphy (New York: Oxford University Press, 1989), p. 243 NT.

10. Marie-Madeleine Martinet, *Le Miroir de l'esprit dans le théâtre élisabé-thain* (Paris: Didier Erudition, 1981), pp. 30–34. In fact, the translation cited above reads "...in a mirror, dimly," with a footnote inserted at "dimly": "Gr *in a riddle.*" —TRANS.

11. Jurgis Baltrušaitis, *Le Miroir: Essai sur une légende scientifique: Révéla-tions, science-fiction, et fallacies* (Paris: Elmayan, 1978), p. 75.

12. Jules Barbey d'Aurevilly, "The Greatest Love of Don Juan," in *The Dia-boliques (The She-Devils)* (1874), trans. Ernest Boyd (London: Dedalus, 1986), p. 69 (translation slightly modified).

13. Pierre Larousse, *Grand Dictionnaire universel du XIXe siècle français, historique, géographique, biographique, mythologique, bibliographique, littéraire, artistique, scientifique, etc.* (Paris: Administration du Grand Dictionnaire Uni-versel, 1865–1888), vol. 11, p. 325. Larousse is no doubt referring to the mirrors of Hostius Quadra, but Seneca does not say exactly what sort of mirrors are involved. "He had mirrors made of the type I described (the ones that reflect

images far larger) in which a finger exceeded the size and thickness of an arm. These, moreover, he so arranged that when he was offering himself to a man he might see in a mirror all the movements of his stallion behind him and then take delight in the false size of his partner's very member just as though it were really so big." Seneca continues the description of these turpitudes for the next two pages, emphasizing the number of mirrors that "faced him on all sides in order that he might be a spectator of his own shame" so that it was possible to enjoy the spectacle that the debauched knows only through reflections. But above all he perfectly captures the psychology of Hostius Quadra. Thus he has him say: "All my organs are occupied in the lechery. Let my eyes, too, come into their share of the debauchery and be the witnesses and supervisors of it [...] so that no one may think I do not know what I do." This is "a way to deceive my sick wants and satisfy them. To what purpose my depravity if I sin only to the limit of nature? I will surround myself with mirrors, the type which renders the size of objects incredible. If it were possible, I would make those sizes real; because it is not possible, I will feast myself on the illusion. Let my lust see more than it consumes and marvel at what it undergoes." Seneca, beside himself but also filled with the delights of his own descriptions — Roman modesty allowed for the narration but not the exhibition of horrors — ends by saying "he ought to have been immolated in front of a mirror of his own" (which, for us, may well evoke Michael Powell's film *Peeping Tom* [1960]). In Seneca, *Natural Questions*, trans. Thomas H. Corcoran (London: William Heinemann LTD; Cambridge, MA: Harvard University Press, Loeb Classical Library, 1971), 1.15.2, pp. 83ff.

14. Seneca, *Natural Questions* 1.16.3, p. 85. See also 1.17. To show just how far the mirror has been turned away from its original vocation, the author states that "when luxury had already become supremely powerful, full-length mirrors were carved of gold and silver, then adorned with jewels" (1.17.8, p. 50).

15. Apuleius, *Apologia* 13–14, in *The Apologia and Florida of Apuleius of Madaura*, trans. H.E. Butler (Oxford: Clarendon Press, 1909; repr., Westport, CT: Greenwood Press, 1970), pp. 36–41. As part of his defense, he recalled that Plato recommended the noble and philosophical use of the mirror. On this question in general, I refer the reader once again to the study by Armand Delatte.

16. Larousse, *Grand Dictionnaire*, vol. 11, p. 325. Neither I nor Anne Baldassari has been able to find the passage referred to.

17. Jacques van Lennep, *Alchimie: Contribution à l'histoire de l'art alchimique*, 2nd ed. (n.p.: Crédit Communal de Belgique/Diffusion Dervy-Livres, 1985), p. 285. Also see John Gage, *Colour and Culture: Practice and Meaning from Antiquity to Abstraction* (1993; London: Thames and Hudson, 1995), pp. 149ff.

18. Henry Carrington Bolton, "A Modern Oracle and Its Prototypes: A Study in Catoptromancy," *Journal of American Folk-Lore*, Jan.–March 1893, pp. 25–37, esp. p. 26.

19. The Conservatoire National des Arts et Métiers in Paris possesses several of these, including, notably, nos. 1750 and 8451. These mirrors "prove that light vibrations are transversal, that is, perpendicular to the direction of their propagation." These black mirrors are called polarizers. "When light rays vibrating in all directions fall on a polarizer, it transforms them into polarized rectilinear light." See A.C.S. van Heel and C.H.F. Velzel, *What Is Light?* trans. J.L.J. Rosenfeld (New York: McGraw-Hill, 1968), p. 131. (Translation modified to approximate author's French more closely. — TRANS.)

20. This exhibition of work by Rainer Müller (*Schwarzspiegel-Specchio nero e convesso*) included both an indoor and an outdoor installation. The alarm clocks were installed in a tower used as an exhibition space, and the large roadside mirrors were hung outside.

21. I am thinking in particular of mirror no. E166 in London's Science Museum.

22. Louis-Alphonse Cahagnet, *Magie magnétique; ou, Traité historique et pratique de fascinations, miroirs cabalistiques, apports, suspensions, pactes, talismans, charme des vents, convulsions, possessions, envoûtements, sortilèges, magie de la parole, correspondance sympathique, nécromancie, etc.* (Paris: Baillière, 1854), p. 81. Of course, the magnetizer is right there as well (p. 84).

23. But it is the idea of such transgression that is stimulating, for what one finds there is very dull in relation to the power of the imagination or to what one could and ought to be able to find: thus, for example, the "butt-paintings," described as "m'ass'terpieces" (!), found on one of these sites. All this offers

very little interest. Falling far short of what the Viennese Actionists were able to do — one wonders if there are even any terms of comparison — it is simply a question here of hip forms of business where the so-called provocation and the whiffs of subversion that would arise from all these sites no longer have anything truly scandalous about them. These latter are sanitized, and they all come down to one single argument: the sale. In the age of the general bourgeoisification of the West, if these things still shock certain people, it would be interesting to know who they could be.

24. Subcomandante Marcos, "The Devils of the New Century (Zapatista Children in the Year 2001, Seventh of the War Against Forgetting)," Mexico City, Feb. 2001, http://flag.blackened.net/revolt/mexico/ezln/2001/marcos/devils_feb.html. I have already mentioned the importance of the obsidian mirror in Mesoamerican and Mexican culture. Even today, this object remains a fundamental element in Central American folklore.

25. Francesco Colonna, *Hypnerotomachie; ou, Discours du songe de Poliphile* (1546; facs. ed., Paris: Club des Libraires de France, 1963), f° 18v, p. 32.

26. Sabine Melchior-Bonnet, "Miroir et identité à la Renaissance," in *Miroirs: Jeux et reflets depuis l'antiquité* (Paris: Somogy Editions d'Art, 2000), p. 138.

27. Jean Ray, "Le Miroir noir," in *Le Grand Nocturne: Les Cercles de l'épouvante* (Brussels: Actes Sud/Editions Labor, 1984); Jorge Luis Borges, "The Mirror of Ink," in *Borges: A Reader*, ed. Emir Rodriguez Monegal and Alastair Reid (New York: E.P. Dutton, 1981), pp. 55–56.

CHAPTER EIGHT: FASCINATION

1. Jean Ray, "Le Miroir noir," in *Le Grand Nocturne: Les Cercles de l'épouvante* (Brussels: Actes Sud-Editions Labor, 1984), pp. 320–21; *L'Almanach du magiste, première année mars 1894–mars 1895* (published in Paris by a group of occultists under the direction of Papus), p. 165.

2. Papus [Gérard Encausse], *Traité élémentaire de magie pratique*, 2nd ed. (Paris: Chamuel, 1893), p. 178.

3. Philippe de La Hire, "Dissertation sur les différens accidens de la Vüe," in *Mémoires de mathématiques et de physique* (Paris: L'Imprimerie Royale, 1694),

ch. 1, sect. 5, p. 236; Gérard de Lairesse, *The Art of Painting in All Its Branches, Methodically Demonstrated by Discourses and Plates, and Exemplified by Remarks on the Paintings of the Best Masters; and Their Perfections and Oversights Laid Open,* trans. John Frederick Fritsch (London, 1778), bk. 5, ch. 18, p. 239.

4. Jorge Luis Borges, "Blindness," in *Seven Nights*, trans. Eliot Weinberger (New York: New Directions, 1984), p. 107 (translation modified).

5. To say that "this color becomes that of the blind" is to invoke an image, a manner of speaking, for, as various medical and scientific studies have shown, colors are not located in the eye; the eye is only a photoreceptor sensitive to light waves. The stimuli, which vary according to wavelength, are converted into colors by the occipital lobe of the brain. It is therefore quite possible to become blind without thereby ceasing to "see" — that is, to "imagine" or to "visualize" — colors: this is the nature of cortical blindness. Some sensations of color are clearly perceived by certain blind people when pressure is placed on an eyeball. In the case of a gradual loss of sight (which is what happened to Borges), many people with poor eyesight no longer perceive anything in the end but a vague bluish color sometimes tending to mauve. But it is impossible for ophthalmologists to make this observation into a rule, for there are so many medical causes of blindness, as diverse as they are complex — ocular, histological, neurological, ischemic, and so on — that the very term "blindness" no longer has any precise meaning. A deconstruction of its definition is thus inevitable and necessary but remains entirely to be carried out. (I am grateful to Dr. Mario Ciolek for drawing my attention to these problems.)

6. Paul Sédir, *Les Miroirs magiques: Divination, clairvoyance, royaumes de l'astral, évocations, consécrations, l'Urim & le Thummim, miroir des Bhattahs, des arabes, de Nostradamus, de Swedenborg, de Cagliostro, etc.,* 3rd ed. (Paris: Librairie Générale des Sciences Occultes, Bibliothèque Chacornac, 1907), pp. 14ff.

7. *Ibid.*, p. 20.

8. *Ibid.*, p. ix.

9. Papus, *Traité élémentaire*, pp. 176–77; Papus, *La Magie et l'hypnose: Recueil de faits et d'expériences justifiant et prouvant les enseignements de l'occultisme* (Paris: Chamuel, 1897), p. 373. For occultists and theosophists, the

astral body is that subtle envelope surrounding the physical body, binding the latter to the mental body, each interpenetrating the other the way the oxygen of the air is found in water and in ether. It is, moreover, made of desire. See the works of Papus, Charles W. Leadbeater, and Annie Besant, among others.

10. Armand Delatte, *La Catoptromancie grecque et ses dérivés* (Liège: H. Vaillant-Carmanne; Paris: E. Droz, 1932), p. 117.

11. Victor Hugo, "Le Mendiant," in *Les Contemplations* (Paris: Nelson, 1956), bk. 5, "En marche," poem 9, Dec. 1834 (the manuscript shows the date Oct. 20, 1854), ll. 18–26; George Sand, *Histoire de ma vie* (Paris: Calmann-Lévy, 1863–1926, vol. 2, p. 274.

12. Paul Martial Joseph Joire, "De la méthode d'expérimentation des phénomènes psychiques," *Annales des sciences psychiques* 11 (1901), pp. 328ff.

13. Strictly speaking, hypnosis may have nothing to do with the black mirror, for it can very well take place without it. The mirror is only a tool; that is why this mirror can be made out of almost anything. The hypnotist can even do without the gaze. It is merely a question of method.

CHAPTER NINE: REGARDING THE EYE AND THE VISUAL FIELD

1. Roger de Piles, *The Principles of Painting* (London: J. Osborn, 1743), p. 2.

2. *Ibid.*, pp. 8–9.

3. Claude Lévi-Strauss, *The Savage Mind* (Chicago: University of Chicago Press, 1966), p. 23.

4. De Piles, *Principles of Painting*, p. 76.

5. *Ibid.*, p. 64. De Piles was not the only one to think this way; it was a point of view shared by his entire age. For example, Father Chérubin tried to channel both eyes with his *oculaire royal* (royal eyepiece) — a double or binocular eyepiece — which is also not without political undertones; see Father Chérubin d'Orléans, *La Vision parfaite; ou, Le Concours des deux axes de la vision en un seul point de l'objet* (Paris: Sébastien Mabre, 1677), and *La Vision parfaite: ou, La Veue distincte par le concours des deux axes en un seul point d'objet* (Paris: Edme Couterot, 1681).

6. De Piles, *Principles of Painting*, p. 65.

7. *Ibid.*, p. 66.

8. *Ibid.*, pp. 66–67.

9. Less than a century later, in August Wilhelm Schlegel the focalization of the gaze is brought about through an excess, beginning at the frame and increasing in intensity gradually toward the center: "The painter, by setting his foreground, by throwing the whole of his light into the center, and by other means of fixing the point of view, will learn that he must neither wander beyond the composition, nor omit anything within it." August Wilhelm Schlegel, *Course of Lectures on Dramatic Art and Literature*, trans. A.J.W. Morrison (London: H.G. Bohn, 1846; repr., New York: AMS Press, 1973), lecture 22, p. 343. See also the text by Carl Gustav Carus cited in Roland Recht, *La Lettre de Humboldt: Du jardin paysager au daguerréotype* (Paris: Christian Bourgois, 1989), pp. 20–21. We can see the distance that separates de Piles from Schlegel: rays, an old inheritance from ancient geometric optics, are placed in opposition to the intensity of contrasts, which Goethe defined through the opposition of a light figure to a dark ground, a notion belonging to physiological optics.

10. De Piles, *Principles of Painting*, p. 67 (my emphasis) (translation slightly modified).

11. *Ibid.*, p. 67.

12. The convex mirror was a symbol not always of union but of the dissipation of the soul. In religious sermons, the concave mirror is seen as concentrating the rays of the sun, whereas the convex mirror disperses them: "The first designates the humble, who receive the rays of divine grace and inflame their neighbor; the second represents the worldly, incapable of inciting others to the good." Hervé Martin, *Le Métier de prédicateur en France septentrionale à la fin du moyen âge, 1350–1520* (Paris: Cerf, 1988), p. 50.

13. De Piles, "Observations," in *The Art of Painting by C.A. Du Fresnoy, with Remarks: Translated into English with an Original Preface, Containing a Parallel Between Painting and Poetry: by Mr. Dryden*, trans. John Dryden (London: Bernard Lintott, 1716), p. 80.

14. Gérard de Lairesse, *The Art of Painting in All Its Branches, Methodically Demonstrated by Discourses and Plates, and Exemplified by Remarks on the Paintings*

of the Best Masters; and Their Perfections and Oversights Laid Open, trans. John Frederick Fritsch (London, 1778), bk. 6, ch. 1, p. 267 (translation modified).

15. *Ibid.*, bk. 9, ch. 9, pp. 464–65.

16. This forward movement is a fundamental aspect of cropping: one finds it especially in photography. Man Ray, for example, almost always cropped his photographs from their original width, initially either with a pencil or by folding the print, as was visible in the recent exhibition of his work at the Grand Palais in Paris.

17. Granting a certain freedom to the spectator is nothing new, however: at the end of the fifteenth century, unlike the geometric optics that subjects the spectator to a fixed and unique point of view, the *artificialis* perspective tolerates some movement on the part of the spectator, who guarantees the coherence of the perspectival constructions. See Hubert Damisch, *The Origin of Perspective*, trans. John Goodman (Cambridge, MA: MIT Press, 1994), pp. 122ff.

18. Lairesse, *Art of Painting in All Its Branches*, bk. 9, ch. 9, p. 465 (translation modified).

19. The French debates on perspective, between the geometer's eye (the "perspector" must paint according to rules; measurement serves as a guarantee) and the gaze of the painter (the artist must paint as the eye sees; the eye is the sole judge), are in fact only a consequence of this theoretical debate.

20. Philippe Hamou (ed.), *La Vision perspective (1435–1740): L'Art et la science du regard de la Renaissance à l'âge classique* (Paris: Payot et Rivages, 1995), pp. 284–85, n.3. For a clear and simple exposition of this problem, see Philippe Comar, *La Perspective en jeu: Les Dessous de l'image* (Paris: Gallimard, 1992), pp. 67–70.

21. William Gilpin, *Remarks on Forest Scenery and Other Woodland Views (Relative Chiefly to Picturesque Beauty), Illustrated by the Scenes of New-Forest in Hampshire*, 2 vols. (London: Blamire, 1791; repr., Richmond: Richmond Publishing Co., 1973), vol. 2, p. 227.

22. *Ibid.*, pp. 224 and 225. Two of Gilpin's notes cite passages from Thomas Gray's *Memoirs* relating to the use of the convex mirror.

23. Gilpin, *Remarks on Forest Scenery*, vol. 2, p. 199.

24. William Gilpin, *Three Essays: On Picturesque Beauty; On Picturesque Travel; and On Sketching Landscape: With a Poem, on Landscape Painting. To These Are Now Added Two Essays, Giving an Account of the Principles and Mode in Which the Author Executed His Own Drawings*, 3rd ed. (London: T. Cadell and W. Davies, 1808), p. 69.

25. René-Louis de Girardin, *An Essay on Landscape*, trans. Daniel Malthus (London: J. Dodsley, 1783; repr., New York: Garland, 1982), p. 42 (translation slightly modified).

26. The ha-ha, or *saut-de-loup*, would perhaps benefit from this perspective. For an analysis of the classic ha-ha, see Ann Grieve, "La Limite invisible dans le jardin anglais au XVIIIe siècle: Le Saut-de-loup ou le ha-ha," *Cahiers Charles V, Littérature britannique: Marches, bordures, limites, confins* ... 4 (March 1983), pp. 39–45.

27. In fact, paintings were often removed from their frames and placed in differently shaped ones, such as Hyacinthe Rigaud's *Double Portrait of the Artist's Mother* (1695), on which one can still see the creases caused by its having been in an oval frame for a time, and Jean-Auguste-Dominique Ingres's *Turkish Bath* (1862), presented after the fact in the form of a tondo (both of these are exhibited in the Louvre). The problem of the shape of the frame could not have any real importance as long as paintings were not conceived and executed according to their borders: the use of circular and oval frames is almost exclusively decorative (see *Eloge de l'ovale: Peintures et pastels du XVIIIe siècle français: Du 18 novembre au 20 décembre 1975, Galerie Cailleux* [Paris, 1975], p. 7). One could object, as Pierre-Henri de Valenciennes does, that "the most natural ... and most geometrically true" shape for a frame is "the circular figure," because "all the points of the circle that form both the diameter and the circumference are equally distant from the eye; and in this case, this circular figure becomes the base of an ideal cone formed by the visual rays, the apex of which is in the eye of the spectator" (*Elémens de perspective pratique à l'usage des artistes, suivis de réflexions et conseils à un élève sur la peinture et particulièrement sur le genre du paysage* [1800; Geneva: Minkoff Reprint, 1973], pp. 154–55). The idea of a visual cone is not new; however, if a circular frame enables the painter to make the

science of optics coincide with the art of the painter, Valenciennes complains of the disadvantages of this form, which, in larger dimensions, truncates the two sides of "a composition's foreground," that is, its very basis (p. 155). And a master will recommend that his students paint within frames of every possible shape in order to teach them "to mask their actual defects" and to comprehend the basis of large compositions (p. 156). Nevertheless, Valenciennes sees some value in circular or at least oval frames for small paintings, "especially for the genre of the portrait, which has more grace than if it is in a square" (p. 155): the curve of the frame underscores the curve of a face. The frame accentuates and decorates but does not yet provide a foundation for the work it serves. Later we will see that the entire neoclassical theory works against framing (*cadrage*) (certain elements are used, but it is not a question of delineating a section of a continuum).

28. Gilpin, *Remarks on Forest Scenery*, vol. 2, pp. 224–25.

29. *Ibid.*, p. 226.

30. *Ibid.*, pp. 224 and 226.

31. *Ibid.*, p. 227.

32. Rupert Feuchtmüller, *Ferdinand Georg Waldmüller, 1793–1865* (Vienna: Christian Brandstätter, 1996), p. 116.

33. *Ibid.*, p. 83.

34. These details were provided by Rupert Feuchtmüller.

35. See Louis Joly, *La Vision et l'optique géométrique, ondulatoire, physiologique* (Paris: Albert Blanchard, 1975), pp. 108–10; Jean Clair, "Les Aventures du nerf optique," in *Bonnard* (Paris: Centre Georges Pompidou, 1984), pp. 16–37, esp. pp. 20–22; Jean-Pierre Mourey, *Philosophies et pratiques du détail: Hegel, Ingres, Sade, et quelques autres* (Seyssel: Champ Vallon, 1996), p. 154.

36. The idea that the brain, not the eye, "sees" is hardly new. In a report presented in 1666 to the Académie des Sciences, *Observations sur l'origine de la vision*, the amateur physicist Edme Mariotte demonstrates the existence of the blind spot, a hole in the visual field. The blind spot constitutes "a scientific proof of 'fixing' or 'cheating' reality, since we are not conscious of a hole in the visual field, of a lack of adequation between what we see and what we think we see.... The proof, in sum, of a correction of vision by the brain." In Philippe

Meyer, *L'Oeil et le cerveau: Biophilosophie de la perception visuelle* (Paris: Odile Jacob, 1997), p. 92.

37. Yves Legrand, *L'Espace visuel,* vol. 3 of *Optique physiologique,* 3 vols. (Paris: Masson, 1967).

38. I am grateful to Dr. Mario Ciolek for opening these perspectives for me.

39. Pointed out by Marie-Madeleine Martinet. Unfortunately, there is no mention of this video in the exhibition catalog by Susan Foister, Rica Jones, and Olivier Meslay, *Young Gainsborough* (London: Apollo Magazine in association with National Gallery, 1997).

40. Gilpin, *Remarks on Forest Scenery,* vol. 2, p. 226.

41. Louis Marin compares the Claude mirror to *ekphrasis,* in the sense that both enable one to make an image from a landscape. *Des pouvoirs de l'image: Gloses* (Paris: Seuil, 1993), p. 90.

42. Jacques Derrida, *Of Grammatology,* corr. ed., trans. Gayatri Chakravorty Spivak (Baltimore: Johns Hopkins University Press, 1998), pp. 141–64, esp. pp. 144–45 for the difference that Derrida establishes between surplus and substitute, which will be discussed below.

43. On the notion of the prosthesis, see Jacques Derrida, *Memoirs of the Blind: The Self-Portrait and Other Ruins,* trans. Pascale-Anne Brault and Michael Naas (Chicago: University of Chicago Press, 1993), p. 70; Jacques Derrida, *The Truth in Painting,* trans. Geoff Bennington and Ian McLeod (Chicago: University of Chicago Press, 1987), pp. 78–79; Jacques Derrida, *Glas,* trans. John P. Leavey Jr. and Richard Rand (Lincoln: University of Nebraska Press, 1986), pp. 138ff.

CHAPTER TEN: A REDUCTIVE MIRROR

1. Leonardo da Vinci, *Notebooks,* ed. Jean Paul Richter (London: Sampson, Low, Marston, Searle, and Rivington, 1838; repr. New York: Dover Books, 1970), vol. 1, pp. 264–65.

2. See Michel Foucault, *The Order of Things: An Archaeology of the Human Sciences* (New York: Random House, 1970), pp. 17–45.

3. Leonardo da Vinci, *Notebooks,* vol. 1, p. 265.

4. Hubert Damisch, *The Origin of Perspective*, trans. John Goodman (Cambridge, MA: MIT Press, 1994), p. 117, n.3.

5. *Les Livres de Hierome Cardanus, medecin milanois, intitulés De la subtilité, & subtiles inventions, ensemble les causes occultes, & raisons d'icelles*, trans. Richard Le Blanc (Paris: Guillaume le Noir, 1556), p. 92.

6. *Ibid.*, p. 92.

7. Black and white are not colors for Alberti but aids in modifying colors: "The admixture of white, therefore, does not alter the basic genera of colors, but creates species." In Leon Battista Alberti, *On Painting* (1435), trans. Cecil Grayson (London: Penguin, 1991), bk. 1, sec. 10, p. 45.

8. *Ibid.*, bk. 2, sec. 46, p. 83 (translation slightly modified).

9. Samuel Y. Edgerton Jr. notes that in his frequent remarks on white and black, Alberti showed an interest in the modulation of values, which was revolutionary at the time. But Alberti did not yet understand how the tint, tone, and intensity of colors are separate qualities, or how pure tints possess different values without its being necessary to add white or black. See "Alberti's Colour Theory: A Medieval Bottle Without Renaissance Wine," *Journal of the Warburg and Courtauld Institutes* 32 (1969), pp. 109–34, esp. pp. 114–15 and 123.

10. André Chastel, *Art et humanisme à Florence au temps de Laurent le Magnifique: Etude sur la Renaissance et l'humanisme platonicien* (1959; Paris: PUF, 1982), p. 321.

11. Edgerton, "Alberti's Colour Theory," p. 133.

12. Edme-Gilles Guyot, *Nouvelles Récréations physiques et mathématiques, contenant ce qui a été imaginé de plus curieux dans ce genre et qui se découvre journellement; auxquelles on a joint les causes, leurs effets, la manière de les construire, et l'amusement qu'on peut tirer pour étonner et surprendre agréablement*, 2 vols., new ed. (Paris, 1799), vol. 2; see pp. 129–30 for the construction of the *galerie perpétuelle*, and p. 131 for a description of the effect produced.

13. An example of this catoptric box can be seen at the Musée de l'Art de l'Enfance.

14. Leonardo da Vinci, *Notebooks*, vol. 1, p. 264; Chastel, *Art et humanisme*, p. 321.

15. Didier d'Arclais de Montamy, *Traité des couleurs pour la peinture en émail et sur la porcelaine; précédé de l'art de peindre sur l'émail, et suivi de plusieurs mémoires sur différents sujets intéressants, tels que le travail de la porcelaine, l'art du stuccateur, la maniere d'exécuter les camées & les autres pierres figurées, le moyen de perfectionner la composition du verre blanc & le travail des glaces, &c.* (Paris: G. Cavelier, 1765), p. 258.

16. I am thinking here of that magnetizer who inserted cabalistic signs into the magic mirror stored away in the Musée National des Arts et Traditions Populaires de Paris.

17. "On the back" (*sur le dos*) is meant here to evoke the weight of a burden or the exertion of a force that joins with and changes its object; hence the following note. — TRANS. How is it possible to write on the mirror and its tain without speculatively altering the mirror? The coincidence of the study with its object was a necessity, if not a fatality.

18. Here I refer the reader once again to Jacques Derrida, particularly *Dissemination* (1972), trans. Barbara Johnson (Chicago: University of Chicago Press, 1981), as well as to Rodolphe Gasché, *The Tain of the Mirror: Derrida and the Philosophy of Reflection* (Cambridge, MA: Harvard University Press, 1986), and the preface by Marc Froment-Meurice to the French edition of this work, *Le Tain du miroir: Derrida et la philosophie de la réflexion* (Paris: Galilée, 1995).

19. Charles-Alphonse Du Fresnoy, *L'Art de peinture (De arte graphica), traduit en françois, enrichy de remarques, & augmenté d'un "Dialogue sur le coloris" par Roger de Piles*, 2nd ed. (Paris: Nicolas Langlois, 1673), ll. 286–90 and 387–88; and in the same volume, Roger de Piles, "Remarques," pp. 199–200 and 219–20.

This work, including de Piles's "Remarques," was translated into English by John Dryden: *The Art of Painting by C.A. Du Fresnoy, with Remarks: Translated into English with an Original Preface, Containing a Parallel Between Painting and Poetry: by Mr. Dryden* (London: Bernard Lintott, 1716), ll. 286–90, p. 41, and ll. 387–88, p. 55; de Piles's commentary on these lines is on pp. 172 and 189–90. This commentary is printed (without being credited to de Piles) under the title "Observations on *The Art of Painting* of Charles Alphonse Du Fresnoy" and will be referred to hereafter as "Observations."

20. De Piles, "Remarques," p. 192; "Observations," p. 166. He thus opposes himself to Leonardo da Vinci and to the Académie Royale; see Bernard Teyssedre, *Roger de Piles et les débats sur le coloris au siècle de Louis XIV* (Paris: Bibliothèque des Arts, 1957), p. 114.

21. Henri Testelin, "Le Clair et l'obscur," Nov. 5, 1678, in Henry Jouin, *Conférences de l'Académie Royale de Peinture et de Sculpture* (Paris: A. Quantin, 1883), pp. 180–86.

22. Roger de Piles, *The Principles of Painting*, trans. a Painter (London: J. Osborn, 1743), pp. 219–20.

23. *Ibid.*, p. 221.

24. *Ibid.*, pp. 224–28 (translation modified).

25. *Ibid.*, p. 224 (translation modified).

26. De Piles, "Remarques," p. 195; "Observations," p. 168.

27. De Piles, "Remarques," p. 197; "Observations," p. 170.

28. Note that Dryden's translation of "clair-obscur" is "Lights and Shadows." — TRANS.

29. De Piles, "Remarques," pp. 198 and 199; "Observations," pp. 171 and 172.

30. De Piles, "Remarques," pp. 197 and 219–20; "Observations," pp. 170 and 189.

31. Du Fresnoy, *Art de peinture (De arte graphica)*, ll. 387–88, pp. 60–62; *Art of Painting*, p. 55.

32. De Piles, "Remarques," pp. 219–20; "Observations," pp. 189–90.

33. De Piles, "Remarques," pp. 219–20; "Observations," p. 189.

34. Sébastien Bourdon, *La Lumière*, Feb. 9, 1669, in Jouin, *Conférences*, p. 134. The manuscript, which seems to be lost, was published by Claude-Henri Watelet and Pierre-Charles Levesque, *Dictionnaire des arts de peinture, sculpture, et gravure*, 5 vols. (Paris: L.-F. Prault, 1792; repr., Geneva: Minkoff, 1972), vol. 1, pp. 398–415; its full title was apparently not *La Lumière* (Light), but *La Lumière selon les heures du jour* (Light according to the time of day) (see Teyssedre, *Roger de Piles et le débat sur le coloris*, pp. 133 and 568).

35. De Piles, "Remarques," p. 220; "Observations," p. 190.

36. Mary Philadelphia Merrifield, *Original Treatises, Dating from the XIIth to*

the XVIIIth Centuries on the Arts of Painting, in Oil, Miniature, Mosaic, and Glass; of Gilding, Dyeing, and Preparation of Colours and Artificial Gems (London: John Murray, 1849), p. cxxv.

37. However, Merrifield says of Signor A. that he is "an artist who had practised many years at Milan, and is esteemed as a skillful restorer of pictures," and that he "has an accurate and most extensive knowledge of all the writers on painting, and seems to know every thing, in these authors that bears on technical points. He quoted passages from Vasari, Ridolfi, Bellori, Zanetti, Guarienti's 'Abecedario,' etc." (*ibid.*, pp. cxvii and cxxiv).

38. "Sentiments de Charles-Alphonse Du Fresnoy sur les ouvrages des principaux et meilleurs peintres des derniers siècles," in Du Fresnoy, *Art de peinture (De arte graphica)*, p. 270; translated by Dryden as "The Judgment of Charles Alphonse Du Fresnoy on the Works of the Principal and Best Painters of the Two Last Ages," in *Art of Painting*, p. 232.

39. William Gilpin, *Two Essays: One on the Author's Mode of Executing Rough Sketches; the Other on the Principles on Which They Are Composed* (London: T. Cadell and W. Davies, 1804), p. 14.

40. Watelet and Levesque, *Dictionnaire des arts de peinture*, vol. 2, p. 153.

41. William Gilpin, *Three Essays: On Picturesque Beauty; On Picturesque Travel; and On Sketching Landscape: With a Poem, on Landscape Painting. To These Are Now Added Two Essays, Giving an Account of the Principles and Mode in Which the Author Executed His Own Drawings*, 3rd ed. (London: T. Cadell and W. Davies, 1808), pp. 72–73.

42. *Ibid.*, inserted between pp. 74 and 75.

43. William Gilpin, *Three Essays*, p. 75.

44. Uvedale Price, *A Dialogue on the Distinct Characters of the Picturesque and the Beautiful. In Answer to the Objections of Mr. Knight* (London: Printed by D. Walker for J. Robson, 1801), pp. 171–72.

45. Just after this, Price specifies that if the black mirror allows one to smoke the raw colors of reality, it also allows one to attenuate the crudeness of repulsive details through the reduction of the size of the carcass reflected by the mirror, as if it were seen from a distance.

46. M. Kirby Talley Jr., "'Tous les bons tableaux se craquellent': La Technique picturale et l'atelier de Sir Joshua Reynolds," in *Sir Joshua Reynolds, 1723–1792* (Paris: Réunion des Musées Nationaux, 1985), p. 102.

47. Jonathan Richardson, *An Essay on the Theory of Painting*, 2nd ed., enl. and corr. (London: A.C., 1725), p. 118.

48. Pierre-Henri de Valenciennes, *Elémens de perspective pratique à l'usage des artistes, suivis de réflexions et conseils à un élève sur la peinture et particulièrement sur le genre du paysage* (1800; Geneva: Minkoff Reprint, 1973), p. 295.

49. François-Xavier de Burtin, *Traité théorique et pratique des connoissances qui sont nécessaires à tout amateur de tableaux, et à tous ceux qui veulent apprendre à juger, apprécier, et conserver les productions de la peinture; suivi d'observations sur les collections publiques et particulières, et de la description des tableaux que possède en ce moment l'auteur*, 2 vols. (Brussels: Weissenbruch, 1808), vol. 1, pp. 80–81.

50. Hermann von Helmholtz, "The Relation of Optics to Painting" (1871), in David Cahan (ed.), *Science and Culture: Popular and Philosophical Essays* (Chicago: University of Chicago Press, 1995), p. 291.

51. *Ibid.*, p. 293; see also E.H. Gombrich, *Art and Illusion: A Study in the Psychology of Pictorial Representation* (Princeton, NJ: Princeton University Press, 2000), p. 38.

52. Helmholtz, "Relation of Optics to Painting," pp. 293 (translation modified) and 292.

53. *Ibid.*, p. 294 (translation of the first quotation has been modified).

54. Valenciennes, *Elémens de perspective pratique*, p. 297.

55. Du Fresnoy, *L'Art de peinture (De arte graphica)*, ll. 365–70, p. 59; *Art of Painting*, p. 51.

56. Abraham Bosse, *Traité des pratiques géométrales et perspectives, enseignées dans l'Académie Royale de la Peinture et Sculpture. Très utiles pour exceller en ces arts, et autres, où il faut employer la règle et le compas* (Paris, 1665), p. 23.

57. Helmholtz, "Relation of Optics to Painting," p. 293 (translation slightly modified).

58. Paul Jay, *Les Conserves de Nicéphore: Essai sur la nécessité d'inventer la photographie* (Chalon-sur-Saône: Société des Amis du Musée Nicéphore Niépce,

1992), p. 98; Jean-François Chevrier, "La Photographie dans la culture du paysage, première partie: Le XIXe Siècle et ses antécédents," in Mission Photographique de la DATAR, *Paysages/photographies: Travaux en cours 1984/ 1985* (Paris: Hazan, 1985), pp. 362–63; see also Jean-François Chevrier, "Le Modèle photographique dans l'art moderne: Le Regard comme appropriation esthétique," in *Conférences du Musée d'Orsay, 1848–1914* (Paris: Réunion des Musées Nationaux, 1991), no. 3, pp. 82–86; Anne Baldassari, *Le Miroir noir: Picasso, sources photographiques, 1900–1928* (Paris: Réunion des Musées Nationaux, 1997), p. 17.

59. Gombrich, *Art and Illusion*, pp. 36 and 46.

60. Antonin Proust, *Edouard Manet/Souvenirs* (Caen: L'Echoppe, 1988), cited in *Manet, 1832–1883* (New York: Metropolitan Museum of Art, Abrams Publishers, 1983), p. 28.

61. *Ibid.*, p. 64.

62. Daniel Halévy, *My Friend Degas*, trans. Mina Curtiss (Middletown, CT: Wesleyan University Press, 1964), entry dated Tuesday, Feb. 23, 1897, p. 94. This passage was pointed out to me by Jean-Claude Lebensztejn.

63. Proust, *Edouard Manet/Souvenirs*, p. 22.

64. Aaron Scharf, *Art and Photography* (1968; New York: Penguin, 1986), pp. 58–61.

65. *Ibid.*, pp. 61–66 and 334, n.18.

66. From this perspective, there is still the case of Camille Corot, of whom it has often been said that he used the Claude mirror; see, for example, "Claude Glass" in Ian Chilvers, Harold Osborne, and Dennis Farr (eds.), *The Oxford Dictionary of Art* (Oxford: Oxford University Press, 1990), p. 109. I have yet to find the origin of this assertion. However, there are many signs indicating that Corot may have used the Claude mirror. One anecdote is particularly germane in this sense: "Corot, questioned by Alfred Robaut concerning the approximate date of this study, recalled that he had painted it one day when there was a solar eclipse; the fact had struck him" (Alfred Robaut, *L'Oeuvre de Corot: Catalogue raisonné et illustré précédé de l'histoire de Corot et de ses oeuvres par Etienne Moreau-Nélaton*, 4 vols. [Paris: H. Floury, 1905], vol. 2, p. 148, no. 410 — 1840–1850 — *Le Lac de*

Genève en face de Villeneuve, canvas from 3 to 4). It is not difficult to associate the light of an eclipse with the effect of the Claude mirror. In volume 1 of this work, Etienne Moreau-Nélaton reports some statements made by Corot and insists that what the painter sought was "the form, the ensemble of the tones. For me, color comes after" (p. 286; see also pp. 170 and 206). Corot even elaborates "a conventional notation" for the synthetic brightness of his sketches, enabling him to render the "relations of forms and values." This "picturesque stenography" is obtained in the following way: "A circle indicates a light, and a square indicates a dark. The dimensions of these signs are proportionate to the progression of the values" (p. 209). Later, a color was even invented that was "baptized 'Corot-gray,'" and this flattered the painter (p. 308). But this tonality led the critic E. de B. de Lépinois to say that Corot's palette was restricted to "a shade of caca d'oie" (pp. 198–201; see also p. 167). All these indications seem to suggest that Corot's use of the mirror was quite probable.

67. Matisse's use of the black mirror was pointed out to me by John Gage.

68. Pierre Schneider, *Matisse*, trans. Michael Taylor and Bridget Stevens Romer (New York: Rizzoli, 1984), pp. 353 and 382–83, n.43.

69. The first document cited by Schneider is taken from an interview with Pierre Courthion, conducted when Matisse was still recovering from his operation in Lyon. The text was to appear under the title "Bavardage" (Chatter). But later Matisse distanced himself from the statements he made there, judging them too chatty. The typescript of this interview is at the Getty Center, Los Angeles; I thank Tracy Schuster of the Getty Research Library for sending the text to me. The other document is found in an unpublished notebook from 1946, "Cahier 6," in preparation for the text titled "Jazz," held in the Matisse Archives, Paris. This information was furnished by Pierre Schneider.

70. Henri Matisse, "Cahier 6," cited in Schneider, *Matisse*, p. 382, n.43.

71. Henri Matisse, "Interview with Charles Estienne, 1909," in Jack Flam (ed.), *Matisse on Art*, rev. ed. (Berkeley: University of California Press, 1995), p. 54.

72. Henri Matisse, "On Modernism and Tradition, 1935," in *ibid.*, p. 121; and Henri Matisse, "Notes of a Painter on His Drawing, 1939," in *ibid.*, p. 130.

73. Henri Matisse, "Statements to Tériade: Matisse Speaks, 1951," in *ibid.*, p. 202; and Matisse, "On Modernism and Tradition," p. 121.

74. Matisse, "Cahier 6," cited in Schneider, *Matisse*, pp. 382–83.

75. Alberti, *On Painting*, bk. 2, sec. 31, pp. 65–67. For Alberti, the intersection was used not for framing but to circumscribe figures, to inscribe their contours, "circumscription" being "simply the recording of outlines" (p. 65). For Girolamo Cardano, the "trellis" brings out mistakes, for "in a small space a mistake, even a very small one, cannot be hidden, and leads the hand of the painter with rectitude" (*De la subtilité*, p. 92).

It is said that Gerard Dou, the son of an artisanal mirror maker, also developed a system combining a convex mirror with Alberti's intersection. This installation was placed between the model and the painter, allowing the latter to use both of these aids simultaneously. See Heinrich Schwarz, "The Mirror in Art," *Art Quarterly* (Summer 1952), p. 115. I have been unable to discover the source on which the author bases this supposition.

76. Henri Matisse, *Ecrits et propos sur l'art*, ed. Dominique Fourcade (Paris: Hermann, 1972), p. 198: "It was necessary to knock against the wall [of impressionism] in order to pass through," Matisse declared on August 30, 1945. [This statement is in "De la couleur [On color]," no translation of which is included in *Matisse on Art*. — TRANS.]

77. Courthion, "Bavardage," p. 133, cited in Schneider, *Matisse*, p. 353.

78. Matisse, "Cahier 6," cited in Schneider, *Matisse*, p. 383.

79. Courthion, "Bavardage," p. 133.

80. Henri Matisse, *Anemones with a Black Mirror*, winter 1918–1919, oil on canvas, 68 x 52 cm, David Juda Collection; *Still Life with a Vase of Flowers, Lemons, and Mortar*, end of 1918–spring 1919, oil on canvas, 46 x 38 cm, Alsdorf Collection. See *Henri Matisse: The Early Years in Nice, 1916–1939* (Washington, DC: National Gallery of Art, 1986); John Elderfield, *Henri Matisse: A Retrospective* (New York: Museum of Modern Art, 1992), esp. p. 310. In 1908, Matisse writes against "the fleeting sensations of a moment that can never define me entirely, and that I would hardly recognize[recall] the next day," and he adds: "I want to reach that state of condensation of sensations that makes the painting,"

preferring thus to retouch the work right away "in order to be able to recognize it later as a representation of my mind."

81. Schneider, *Matisse*, pp. 513–14.

82. Matisse, "Matisse parle," in *Ecrits et propos sur l'art*, p. 117, n.73; Henri Matisse, "Black Is a Color, 1946," in *Matisse on Art*, p. 166; John Gage, *Colour and Meaning: Art, Science, and Symbolism* (London: Thames and Hudson, 2001), pp. 228–40.

83. Graham Sutherland, "Thoughts on Painting," *Listener*, Sept. 6, 1951, p. 378. For a more precise idea of these conditions, see Marcus Whiffen, "Graham Sutherland's *Crucifixion*," *Architectural Review*, March 1947, pp. 105–106.

84. John Hayes, *The Art of Graham Sutherland* (London: Phaidon, 1980), p. 50.

85. *Ibid.*, p. 25.

86. *Ibid.*, pp. 25–26.

87. In June of 2005 I happened to see Jean-Marie Straub wearing a glass filter with a frame made of gold on a string around his neck, which had been presented to him by the Kodak company as a token of their thanks and acknowledgment.

88. An anecdote related by chief cameraman William Lubtchansky, who also often uses his glass in this way.

89. The polarization of light was discovered in 1690 by Huygens, who carried out experiments on a piece of calcite. In 1801, Etienne-Louis Malus, a French officer and physician, saw a reflection of the Luxembourg Palace windows in a piece of calcite crystal. He then noticed that the reflections became brighter, then dimmer, as he rotated the crystal. He understood that the glass pane of the window must have changed the light. He then did the experiment using two black mirrors. He noted that by placing the two surfaces of the mirrors approximately at a 56°40′ in relation to the light rays, the brightness or absence of brightness of the light alternated as one of the two mirrors was rotated. Thus he discovered that light can be polarized by reflection in a mirror or glass surface. This experiment proves that the light waves are indeed transversal, that is, perpendicular to the direction of their propagation.

I thank Jean-Louis Constanza for his patient attempts to explain to me the secrets of polarization.

90. Valenciennes, *Elémens de perspective pratique*, p. 209.

CHAPTER ELEVEN: AN IDEALIZING MIRROR

1. Jurgis Baltrušaitis, *Aberrations: An Essay on the Legend of Forms*, trans. Richard Miller (Cambridge, MA: MIT Press, 1989), pp. 139ff.

2. *Ibid.*, p. 157.

3. Marie-Madeleine Martinet, *Art et nature en Grande-Bretagne* (Paris: Aubier-Montaigne, 1980), p. 56, no. 16; Malcolm Andrews, *The Search for the Picturesque: Landscape Aesthetics and Tourism in Britain, 1760–1800* (Stanford, CA: Stanford University Press, 1989), p. 26.

4. Sir Joshua Reynolds, *Discourses on Art*, ed. Robert R. Wark (New Haven, CT: Yale University Press, 1997), p. 44.

5. *Ibid.*, pp. 69–70.

6. It is interesting to read in Roger de Piles about the "implements" that painters carried with them to do their studies after nature; see *The Principles of Painting*, trans. a Painter (London: J. Osborn, 1743), p. 150. On the beginnings of open-air painting, see Philip Conisbee, "Pre-Romantic Plain-Air Painting," *Art History* 214 (1979), pp. 413–28; Peter Galassi, *Corot in Italy: Open-Air Painting and the Classical Landscape Tradition* (New Haven, CT: Yale University Press, 1991), pp. 11ff. On Claude Lorrain's technique of mixing his pigments in the open air, then applying them to the canvas in his studio, see Lawrence Gowing, "Nature and Ideal in the Art of Claude Lorrain," *Art Quarterly* 37.1 (Spring 1974), pp. 91–96.

7. Claude-Henri Watelet and Pierre-Charles Levesque, *Dictionnaire des arts de peinture, sculpture, et gravure*, 5 vols. (Paris: L.-F. Prault, 1792; repr., Geneva: Minkoff, 1972), vol. 5, p. 832.

8. The origin of the word "picturesque" is unclear. While at the beginning of the eighteenth century it is found neither in English dictionaries nor in that of the Académie Française, the term *pittoresco* was commonly used in Italy at that time. This term designated compositions or pictorial objects and characterized

the manner in which Giorgione, and especially Titian, "reproduced the effects of light and shadow to render the total impression of a landscape rather than to juxtapose all its details," thus opening the way to the Venetian and Lombard schools. See the postface to the French edition of William Gilpin's *Three Essays*: Michel Conan, "Le Pittoresque: Une Culture Poétique," in *Trois essais: Sur le beau pittoresque; Sur les voyages pittoresques; et Sur l'art d'esquisser le paysage, suivis d'un poème sur la peinture du paysage* (1792; Breslau: Guillaume Théophile Korn, 1799; repr., Paris: Moniteur, 1982), p. 120.

9. William Gilpin, *Three Essays: On Picturesque Beauty; On Picturesque Travel; and On Sketching Landscape: With a Poem, on Landscape Painting. To These Are Now Added Two Essays, Giving an Account of the Principles and Mode in Which the Author Executed His Own Drawings*, 3rd ed. (London: T. Cadell and W. Davies, 1808), p. 3.

10. Gilpin proves this through his practice of sketching in "perfect liberty": "I take up a tree here, and plant it there. I pare a knoll, or make an addition to it. I remove a piece of paling — a cottage — a wall — or any removable object, which I dislike. In short, I do not so much mean to exact a liberty of introducing what does not exist; as of making a few of those simple variations, of which all ground is easily susceptible, and which time itself indeed is continually making" (*ibid.*, p. 68). He reworks the landscape, and the one rule he observes in this reworking carried out in the free practice of sketching is to be "restrained only by the analogy of the country" (*ibid.*, p. 68).

11. Martinet, *Art et nature*, pp. 10–11. In this regard, the ideal figure of the gardener-painter, Hubert Robert, obliges us to introduce some nuance, for the situation at the end of the eighteenth century was changing. Consider, for example, the specific case of the garden at Ermenonville belonging to the Marquis de Girardin, on which Robert worked. His recourse to painting in the elaboration of the garden, in reaction with Humphry Repton against the Anglomania of the pictorial reference, served to draw up a plan for the arrangement of the future site: the art of gardens "is to poetry and painting, what reality is to description, and the original is to the copy." See René-Louis de Girardin, *An Essay on Landscape* and *A Tour to Ermenonville*, trans. Daniel Malthus (London: J. Dodsley, 1783; repr., New York: Garland, 1982), pp. 5 and 18–29, and in *A Tour*

to *Ermenonville*, pp. v–vii; see also the postface by Michel Conan to the French edition, *De la composition des paysages; ou, Des Moyens d'embellir la nature autour des habitations, en joignant l'agréable à l'utile* (1777; repr., Seyssel: Champ Vallon, 1992), pp. 239–40.

12. Joseph Spence, *Observations, Anecdotes, and Characters of Books and Men Collected from the Conversation of Mr. Pope and Other Eminent Persons of His Time*, ed. J.M. Osborn (Oxford: Clarendon Press, 1966), vol. 1, p. 252.

13. E.H. Gombrich, *Art and Illusion: A Study in the Psychology of Pictorial Representation* (Princeton, NJ: Princeton University Press, 2000), pp. 44–46.

14. Anne-Claude-Philippe de Pestels de Lévis de Tubières-Grimoard, Comte de Caylus, *Vies d'artistes du XVIIIe siècle; Discours sur la peinture et la sculpture; Salons de 1751 et de 1753; Lettre à Lagrenée*, ed. André-Jean-Charles Fontaine (Paris: H. Laurens, 1910), p. 141.

15. Marc Mitouflet Thomin, *Traité d'optique méchanique, dans lequel on donne les règles et les proportions qu'il faut observer pour faire toutes sortes de lunettes d'approche, microscopes simples et composés, et autres ouvrages qui dépendent de l'art, avec une instruction sur l'usage des lunettes ou conserves pour toutes sortes de vûes* (Paris: Jean-Baptiste Coignard and Antoine Boudet, 1749), p. 295. The author has a low opinion of colored glass, because, he says, if such glasses are bad, they can "alter the coloring or cause some illusion in it"; he thus recommends them only for medical use (as "shields"). Some colors are more appropriate than others for shielding vision, like celadon green, light blue, or yellow, depending on the user, when the daylight is too strong for fragile eyes. Darker glasses are proscribed because they tend to be poorly finished. See Jonathan Crary, "Aveuglante lumière," in *Aux origines de l'abstraction: 1800–1914* (Paris: Musée d'Orsay, 2003), pp. 104–109, esp. p. 107.

16. Baltrušaitis, *Aberrations*, p. 157.

17. Adam Walker, *Remarks Made in a Tour from London to the Lakes of Westmoreland and Cumberland, in the Summer of 1791, Originally Published in the Whitehall Evening Post, and Now Reprinted with Additions and Corrections, to Which Is Annexed, a Sketch of the Police, Religion, Arts, and Agriculture of France, Made in an Excursion to Paris in 1785* (London: G. Nicol and C. Dilly, 1792), p.

63. The analogy between the dark lakes and the black mirror recurs often; see, for example, William Gilpin, *Observations, Relative chiefly to Picturesque Beauty, Made in the Year 1776, on Several Parts of Great Britain; Particularly the Highlands of Scotland*, 2 vols. (London: Blamire, 1789), vol. 2, pp. 19–20: "The waters... were dark, like a black transparent mirror."

18. Pierre-Henri de Valenciennes, *Elémens de perspective pratique à l'usage des artistes, suivis de réflexions et conseils à un élève sur la peinture et particulière-ment sur le genre du paysage* (1800; Geneva: Minkoff Reprint, 1973), p. 627. See also, for example, Walker, *Remarks*, p. A, where he paraphrases a sentence from *Emile*: "I think with Rousseau, that there is but one way of Travelling more pleasant than riding on horseback, and that is on foot." Rousseau goes on to remark that "when one wants only to arrive, one can hurry in a post-chaise. But when one wants to travel, one has to go on foot." See *Emile, or On Education*, trans. Allan Bloom (New York: Basic Books, 1979), pp. 411–12.

19. See Jean Starobinski, *The Invention of Liberty, 1700–1789*, trans. Bernard C. Swift (Geneva: Skira, 1964), p. 160.

20. Jean-Jacques Rousseau, *The Reveries of a Solitary Walker*, trans. Peter France (London: Penguin, 1979), p. 84.

21. Jean Starobinski, *Jean-Jacques Rousseau: Transparency and Obstruction*, trans. Arthur Goldhammer (Chicago: University of Chicago Press, 1988), pp. 271–332.

22. See Andrews, *Search for the Picturesque*, pp. 85ff.

23. Conan, "Le Pittoresque," p. 121.

24. Ann Bermingham, *Landscape and Ideology: The English Rustic Tradition, 1740–1860* (London: Thames and Hudson, 1987), pp. 83–85.

25. Timothy F. Mitchell, *Art and Science in German Painting, 1770–1840* (Oxford: Clarendon Press, 1993), p. 47.

26. Johann Wolfgang von Goethe, *Italian Journey*, ed. Thomas P. Saine and Jeffrey L. Sammons, trans. Robert R. Heitner (New York: Suhrkamp, 1989), p. 188.

27. In many cases, nature produces effects comparable to those observable in our instrument. As the sculptor Pierre-Jean David d'Angers wrote, for ex-ample, "At seven o'clock in the morning, there was a very thick fog that almost

confounded sky and earth.... Through the fog one saw a few darker lines: it was the earth.... One also saw, on the horizon of this desert of fog, a small white line" (*Carnets*, 2 vols. [Paris: Plon, 1958], vol. 1, pp. 339–40). The reductive effect of the fog makes lines appear like the ones visible in the Claude mirror.

28. Thomas Dudley Fosbroke, *The Wye Tour; or, Gilpin on the Wye, with Historical and Archaeological Additions* (Ross, UK: W. Farror, 1822), p. 83.

29. Jurgis Baltrušaitis, *Le Miroir: Essai sur une légende scientifique: Révélations, science-fiction, et fallacies* (Paris: Elmayan, 1978), pp. 252–54.

30. Samuel Taylor Coleridge to George Dyer, March 10, 1795, *Collected Letters of Samuel Taylor Coleridge*, ed. Earl Leslie Griggs (Oxford: Clarendon Press, 1956), vol. 1, p. 154. In another letter, Coleridge is even more emphatic about this idealization of the landscape: "We drank tea the night before I left Grasmere on the Island in that lovely lake, our kettle swung over the fire hanging from the branch of the Fir Tree, and I lay & saw the woods, & mountains, & lake all trembling, & as it were *idealized* thro' the subtle smoke which rose up from the clear red embers of the fir-apples which we had collected" (letter to Humphry Davy, July 25, 1800, vol. 1, p. 612). The experience must have made a strong impression on Coleridge, for he recorded it again in his *Notebooks*, ed. Kathleen Coburn (London: Routledge and Kegan Paul, 1957), vol. 1, entry 758. This idealized vision of the landscape seen through smoke obviously recalls the effect of the Claude mirror.

31. Christopher Wordsworth, *Memoirs of William Wordsworth*, ed. Henry Reed (Boston: Ticknor, Reed, and Fields, 1851; repr., New York: AMS Press, 1966), vol. 2, p. 487.

32. René Wellek, *The Romantic Age*, vol. 2 of *A History of Modern Criticism, 1750–1950* (London: Jonathan Cape, 1955), pp. 145ff.

33. William Wordsworth and Samuel Taylor Coleridge, *Lyrical Ballads*, ed. R.L. Brett and A.R. Jones (London: Methuen, 1986), p. 244.

34. Samuel Taylor Coleridge, *Biographia Literaria; or, Biographical Sketches of My Literary Life and Opinions*, ed. James Engell and Walter Jackson Bate (Princeton, NJ: Princeton University Press, 1983), vol. 2, ch. 14, p. 5.

35. Andrews, *Search for the Picturesque*, p. 71.

36. Coleridge, *Notebooks*; see entries 2394 (in vol. 2) and 1412 and 1668 (in vol. 1).

37. See Pierre Pachet, "Phosphorescence," preface to the French edition of Coleridge's notebooks: *Carnets*, trans. Pierre Leyris (Paris: Belin, 1987), p. 30.

38. Max Milner, *La Fantasmagorie: Essai sur l'optique fantastique* (Paris: PUF, 1982), pp. 95ff.

39. Wellek, *Romantic Age*, p. 174.

Chapter Twelve: Limits on the Use of the Claude Mirror

1. John Ruskin, *The Elements of Drawing, The Element of Perspective, and The Laws of Fésole*, in *The Works of John Ruskin*, 39 vols., ed. E.T. Cook and Alexander Wedderburn (London: George Allen, 1904), vol. 15, p. 27.

2. *Ibid.*, p. 28.

3. *Ibid.*, p. 28.

4. *Ibid.*, pp. 200–203.

5. *Ibid.*, pp. 201–202.

6. *Ibid.*, p. 101 and 100.

7. Ruskin, *Elements of Drawing*, p. 203. Note that Ruskin does not refer to the mirror as the "Claude mirror," although *The Elements of Drawing* was published in 1857 and, as I pointed out above, this designation already existed at that time.

8. Charles Robert Leslie, *Memoirs of the Life of John Constable*, ed. Jonathan Mayne (London: Phaidon, 1951), p. 114.

9. E.H. Gombrich, *Art and Illusion: A Study in the Psychology of Pictorial Representation* (Princeton, NJ: Princeton University Press, 2000), p. 48.

10. I am grateful to Jonathan Crary for pointing this out to me.

11. John Ruskin, *The Guild and Museum of St. George*, in *Works* (1907), vol. 30, p. 346, letter to Rose Queen, Monday, mid-May 1889: "I send you one for yourself, such as every girl should keep in her — waistcoat pocket! always handy." See also John Ruskin, *Academy Notes: Notes on Prout and Hunt and Other Art Criticisms, 1855–1888*, in *Works* (1904), vol. 14, p. 408n.

12. Robert Hewison, *The Argument of the Eye* (London: Thames and Hudson, 1976), p. 35.

13. Lindsay Smith, "The Elusive Depth of Field: Stereoscopy and the Pre-Raphaelites," in Marcia Pointon (ed.), *Pre-Raphaelites Re-viewed* (Manchester: Manchester University Press, 1990), pp. 83–89, esp. p. 86; see also Lindsay Smith, *Victorian Photography, Painting, and Poetry: The Enigma of Visibility in Ruskin, Morris, and the Pre-Raphaelites* (Cambridge, UK: Cambridge University Press, 1995), pp. 8, 25–26, 36, 130, 136, 224.

14. Jonathan Crary, *Techniques of the Observer: On Vision and Modernity in the Nineteenth Century* (Cambridge, MA: MIT Press, 1990), p. 16.

15. This is also Lars Kiel Bertelsen's argument in his article "Det grå glas [The gray glass]: Observations on the Claude Glass, Relative Chiefly to Picturesque Beauty, etc.," *Passage, tidsskrift for literatur og kritik* 31/32 (1999). This gray mirror becomes for him the emblem of a transition period, which he qualifies as gray, a mixture of two periods: the preceding, which he calls white, and ours, referred to as black. See also Crary, *Techniques of the Observer.*

16. William Gilpin, *Remarks on Forest Scenery and Other Woodland Views (Relative Chiefly to Picturesque Beauty), Illustrated by the Scenes of New-Forest in Hampshire,* 2 vols. (London: Blamire, 1791; repr., Richmond: Richmond Publishing Co., 1973), vol. 2, pp. 224–25 and 226.

17. Pierre-Henri de Valenciennes, *Elémens de perspective pratique à l'usage des artistes, suivis de réflexions et conseils à un élève sur la peinture et particulièrement sur le genre du paysage* (1800; Geneva: Minkoff Reprint, 1973), p. 297.

18. Hermann von Helmholtz, "The Relation of Optics to Painting" (1871), in David Cahan (ed.), *Science and Culture: Popular and Philosophical Essays* (Chicago: University of Chicago Press, 1995), p. 291.

19. I thank Jonathan Crary for confirming my intuition regarding this interpretation.

20. Samuel Taylor Coleridge, *Notebooks,* ed. Kathleen Coburn (London: Routledge and Kegan Paul, 1957), vol. 1, entry 760.

21. James Plumptre, *The Lakers: A Comic Opera in Three Acts* (London: W. Clarke, 1798; facs. ed., Oxford: Woodstock Books, 1990), p. 19. This Veronica Beccabunga is a *Lady,* a botanist, who writes gothic novels.

22. William Darby Templeman, *The Life and Work of William Gilpin (1724–*

1804), Master of the Picturesque and Vicar of Boldre (Urbana: University of Illinois Press, 1939), p. 295; Peter Bicknell, *The Picturesque Scenery of the Lake District, 1752–1855: A Bibliographical Study* (Winchester, UK: Saint Paul Bibliographies, 1990), p. 65.

23. Plumptre, *Lakers*, p. 58.

24. This idea is proposed by Norman Nicholson in *The Lakers: The Adventures of the First Tourists* (London: Hale, 1955), p. 53.

25. William Gilpin, *Observations, Relative Chiefly to Picturesque Beauty, Made in the Year 1776, on Several Parts of Great Britain; Particularly the Highlands of Scotland,* 2 vols. (London: Blamire, 1789), vol. 1, p. 124.

26. Jean Baudrillard, *The Consumer Society: Myths and Structures*, trans. Chris Turner (Thousand Oaks, CA: Sage Publications, 1998), p. 113: "The gadget is defined in fact by the way we act with it, which is not utilitarian or symbolic in character, but *ludic.*"

27. Gilpin, *Observations, Relative Chiefly to Picturesque Beauty*, vol. 1, pp. 123–24.

28. Gilpin, *Remarks on Forest Scenery*, vol. 2, p. 226.

29. Charles Baudelaire, "Morale du joujou," *Œuvres complètes*, éd. Claude Pichois, 2 vols. (Paris: Gallimard, 1975–1976), vol. I, pp. 581–87

30. Michel Conan, postface to William Gilpin, *Trois essais: Sur le beau pittoresque; Sur les voyages pittoresques; et Sur l'art d'esquisser le paysage, suivis d'un poème sur la peinture du paysage* (1792; Breslau: Guillaume Théophile Korn, 1799; repr., Paris: Moniteur, 1982), p. 133.

31. Gilpin, *Remarks on Forest Scenery*, vol. 2, pp. 226–27.

32. "I do not myself thoroughly understand the process of working in aquatinta, but the great inconvenience of it seems to arise from its not being sufficiently under the artist's command. It is not always able to give that just gradation of light and shade, which he desires. Harsh edges will sometimes appear." But this defect is quite minimal in comparison with the advantage it offers as a "mode of multiplying drawings"; and this process "comes the nearest of any mode we know, to the softness of the pencil"; this makes it like a drawing, and, Gilpin declares, that is what it can indeed be called. See the letter to

the Reverend William Mason, in William Gilpin, *Observations on the River Wye, and Several Parts of South Wales, &c. Relative Chiefly to Picturesque Beauty: Made in the Summer of the Year 1770*, 2nd ed. (London: Blamire, 1789), p. viii.

33. Antoine-Chrysostome Quatremère de Quincy, *Essai sur la nature, le but, et les moyens de l'imitation dans les beaux-arts* (1823; repr., Brussels: Archives d'Architecture Moderne, 1980), p. 95.

34. Jacques Derrida, *Of Grammatology*, corr. ed., trans. Gayatri Chakravorty Spivak (Baltimore: Johns Hopkins University Press, 1998), p. 197; see also pp. 195–216.

35. On the neoclassical theory of imitation, see Jean-Claude Lebensztejn, *L'Art de la tache: Introduction à la "Nouvelle méthode" d'Alexander Cozens* (Montélimar: Limon, 1990), esp. pp. 308–17. See also, by the same author, "De l'imitation dans les beaux-arts," in *De l'imitation dans les beaux-arts* (Paris: Carré, 1996), pp. 7–31. A summary of this theory is in Pierre Wat, *Naissance de l'art romantique: Peinture et théorie de l'imitation en Allemagne et en Angleterre* (Paris: Flammarion, 1998), p. 128, n.29, and an interview in Jean-Pierre Criqui and Gilles A. Tiberghien, "A propos de l'art de la tache: Entretien avec Jean-Claude Lebensztejn," in *Les Cahiers du Musée National d'Art Moderne* 36 (Summer 1991), pp. 125–34.

36. Sir Joshua Reynolds, *Discourses on Art*, ed. Robert R. Wark (New Haven, CT: Yale University Press, 1997), p. 44.

37. Charles-Alphonse A. Du Fresnoy, *The Art of Painting by C.A. Du Fresnoy, with Remarks: Translated into English with an Original Preface, containing a Parallel Between Painting and Poetry: by Mr. Dryden*, trans. John Dryden (London: Bernard Lintott, 1716), p. 220.

38. Reynolds, *Discourses on Art*, p. 44 and p. 45.

39. Reproduced in Martin Kemp, *The Science of Art: Optical Themes in Western Art from Brunelleschi to Seurat* (1990; New Haven, CT: Yale University Press, 1992), p. 198.

40. Reynolds, *Discourses on Art*, p. 237.

41. Criqui and Tiberghien, "A propos de l'art de la tache," pp. 130–31.

42. Claude Lévi-Strauss, *Totemism*, trans. Rodney Needham (Boston: Beacon Press, 1963), p. 77.

43. Jean-Jacques Rousseau, *Essay on the Origin of Languages and Writings Related to Music*, trans. John T. Scott, vol. 7 of *Collected Writings of Rousseau* (Hanover, NH: University Press of New England, 1998), p. 305.

44. This was brought to my attention by Jean-Claude Lebensztejn, who saw this drawing hanging in the artist's studio; it has not yet been publicly exhibited.

45. From statements that Malcolm Morley was kind enough to share with me in a telephone conversation in 1998. He also said that he was familiar with the Claude mirror but had never used one.

46. Rousseau, *Essay on the Origin of Languages and Writings Related to Music*, p. 321: "It is imitation alone that elevates them [colors and sounds] to that rank [that of fine art]. Now, what makes painting an imitative art? Drawing." See also Derrida, *Of Grammatology*, pp. 208–209; and Lebensztejn, *Art de la tache*, pp. 277ff.

47. Giuliano Briganti, *The View Painters of Europe*, trans. Pamela Waley (London: Phaidon, 1970), p. 15.

48. *Ibid.*, p. 24.

49. Valenciennes, *Elémens de perspective pratique*, p. 209.

50. Eugène Delacroix, *Ecrits sur l'art*, ed. Françoise-Marie Deyrolle and Christophe Denissel (Paris: Librairie Séguier, 1988), p. 56. See also pp. 316–20.

51. Marie-Elisabeth Cavé, *La Couleur: Ouvrage approuvé par M. Delacroix pour apprendre la peinture à l'huile et l'aquarelle*, 3rd ed. (Paris: Plon, 1863), pp. 27–28.

52. Marie-Elisabeth Cavé, *Le Dessin sans maître, méthode pour apprendre à dessiner de mémoire, ouvrage approuvé par les premiers artistes*, 2nd ed. (Paris: Susse Frères, 1850), p. 13.

53. *Ibid.*, p. 46.

54. *Ibid.*, p. 68.

55. *Ibid.*, p. 27.

56. *Ibid.*, p. 67.

57. Hubert Damisch, "L'Oeil juste," in *Les Multiples Inventions de la photographie: Cerisy-la-Salle, 29 septembre–1 octobre 1988* (Paris: Ministère de la

Culture, de la Communication, des Grands Travaux, et du Bicentennaire, Association Française pour la Diffusion du Patrimoine Photographique, 1989), p. 170.

58. Eugène Delacroix, *The Journal of Eugène Delacroix*, trans. Walter Pach (New York: Covici, Friede, 1937), p. 645.

59. Kemp, *Science of Art*, p. 199.

60. William Mason, *The Poems of Mr. Gray, to Which Are Prefixed Memoirs of His Life and Writings*, 2nd ed. (London: H. Hughs, 1775), p. 352: "A glass of this sort is perhaps the best and most convenient substitute for a Camera Obscura, of any thing that has hitherto been invented." But we would need to know what type of camera obscura Mason is referring to. Indeed, during the same period, Valenciennes began to mistrust the rendering of colors in the camera obscura (*Elémens de perspective pratique*, pp. 295–96). For him, this instrument becomes less useful for "tracing lines" than for "studying colors and its effects" (p. 209). Everything seems to depend on the quality of the tinsmithing performed on the mirror. Let us note also — since we are now in a position to understand this — that in 1783 Mason published a translation of Du Fresnoy, *The Art of Painting*. Mason was therefore very familiar with the black mirror, as was Reynolds, whom Mason asked to write a commentary on the poem. On the other hand, unlike de Piles, Reynolds in his notes says nothing at all about the mirror, and in his very free translation he sanitizes the poem and the mirror a great deal (we will see the importance of this below).

61. Thomas Gray, *The Selected Letters of Thomas Gray*, ed. Joseph Wood Krutch (New York: Farrar, Straus, and Young, 1952), pp. 152–53.

62. *Ibid.*, p. 148.

63. Plato, *Theaetetus* 174b in *The Collected Dialogues of Plato*, eds. Edith Hamilton and Huntington Cairns (Princeton, NJ: Princeton University Press, 1961), p. 879.

64. Charles des Guerrois, ed., *Oeuvres posthumes: Etudes anglaises: Correspondance de Thomas Gray* (Paris: Alphonse Lemerre, 1931), vol. 3, p. 162.

65. Mason, *Poems of Mr. Gray*, p. 355.

66. William Combe, *The Tour of Doctor Syntax, in Search of the Picturesque,*

a Poem (London: Diggins. 1812); translated into French as *Le Don Quichotte romantique; ou, Voyage du docteur Syntaxe, à la recherche du pittoresque et du romantique* (Paris, 1821); the poem was inspired by a series of color drawings by the great English caricaturist Thomas Rowlandson, which are reproduced in this work in the form of colored engravings. For Dr. Syntax's fall, see canto 9, pp. 80–88, plate 11 (between pp. 86 and 87). In canto 13, Dr. Syntax falls into the water again as he practices the art of sketching while riding on the back of his mare named Grizzle, which, driven by hunger, slips down a bank, taking her good master with her into the lake. On the genesis of Dr. Syntax, see Joseph Grego, *Rowlandson the Caricaturist: A Selection from His Works: with Anecdotal Descriptions of His Famous Caricatures and a Sketch of His Life, Times, and Contemporaries*, 2 vols. (London: Chatto and Windus, 1880), vol. 2, pp. 247–52. Rowlandson also did a series of drawings on "a tour in a post chaise": *Rowlandson's Drawings for a "Tour in a Post Chaise"* (Robert R. Wark), Huntington Library, San Marino, CA, 1963.

Chapter Thirteen: Toward Deception and Beyond

1. Malcolm Andrews, *The Search for the Picturesque: Landscape Aesthetics and Tourism in Britain, 1760–1800* (Stanford, CA: Stanford University Press), p. 67.

2. *Chasseur d'images* literally means "hunter of images"; the expression is used idiomatically to mean something like "shutterbug" or "roving photographer." — Trans.

3. William Gilpin, *Three Essays: On Picturesque Beauty; On Picturesque Travel; and On Sketching Landscape: With a Poem, on Landscape Painting. To These Are Now Added Two Essays, Giving an Account of the Principles and Mode in Which the Author Executed His Own Drawings*, 3rd ed. (London: T. Cadell and W. Davies, 1808), p. 47–48.

4. Originally "sport" was defined as follows: "An English word used to designate all outdoor exercise, such as horse racing, boating, hunting with hounds, fishing, archery, gymnastics, fencing." Emile Littré, "Sport," in *Dictionnaire de la langue française* (Chicago: Encyclopaedia Britannica, 1987), vol. 6, p. 6041.

5. "His name appears to have been Charles Gough. Several things were found in his pockets; fishing tackle, memorandums, a gold watch, a silver pencil, Claude Lorrain glasses, &c." Charles Luff of Patterdale to his wife, July 23, 1805, in *The Prose Works of William Wordsworth — Aesthetical and Literary*, ed. Alexander B. Grosart (London: E. Moxon, 1876), p. 172. I am very grateful to Dr. Robert Woof for locating this quotation for me. It provides evidence that these "Claude Lorrain glasses" were indeed glasses and not mirrors, contrary to what has been argued previously; see William Wordsworth, *A Guide Through the District of the Lakes* (1835), reprint in Peter Bicknell (ed.), *The Illustrated Wordsworth's Guide to the Lakes* (Exeter: Webb and Bower, 1984), pp. 13 and 61; Elizabeth Wheeler Manwaring, *Italian Landscape in Eighteenth Century England: A Study Chiefly of the Influence of Claude Lorrain and Salvator Rosa on English Taste, 1700–1800* (1925; London: F. Cass, 1965), pp. 186 and 194. Manwaring suggests that the "Claude Lorrain glasses" were the two mirrors — one with a black and one with a silver tain — recommended by Thomas West. But this is certainly incorrect.

6. The "sport of hunting" reference is in Andrews, *Search for the Picturesque*, p. 67.

7. William Gilpin, *Remarks on Forest Scenery and Other Woodland Views (Relative Chiefly to Picturesque Beauty), Illustrated by the Scenes of New-Forest In Hampshire*, 2 vols. (London: Blamire, 1791; repr., Richmond: Richmond Publishing Co., 1973), vol. 2, p. 225.

8. Marcel Proust, *Within a Budding Grove*, vol. 2 of *In Search of Lost Time*, trans. C.K. Scott-Moncrieff and Terence Kilmartin, revised by D.J. Enright (London: Chatto and Windus, 1992), p. 268. On the way in which this description becomes the emblem of a cinematographic vision, see Gilles Deleuze and Félix Guattari, *Anti-Oedipus*, trans. Robert Hurley, Mark Seem, and Helen R. Lane (New York: Viking, 1977), p. 43. This is a somewhat forced interpretation of Proust, since he did not particularly recognize the cinematographer here.

9. Bertrand Hell, *Le Sang noir: Chasse et mythes du sauvage en Europe* (Paris: Flammarion, 1994), esp. pp. 25–26. "Etymology confirms the ancientness of this mode of hunting; the German term *Pirsch* comes down from the twelfth century and from the Old French *berser*, itself derived from the Latin *bersare*,

meaning 'to hunt with an arrow.' The *bersarii* who practice their art in the forest should not be confused with other hunters who use dogs or set traps" (p. 25).

10. *Ibid.*, p. 20: "Hunting as a collecting of trophies? No hunter doubts this."

11. Gilpin, *Three Essays*, p. 51.

12. Gilpin, *Remarks on Forest Scenery*, vol. 2, p. 224. A hundred and twenty years later, Ambrose Bierce will give the following definition of a "looking glass": "A vitreous plane upon which to display a fleeting show for man's disillusion given." See *The Devil's Dictionary* (1911) (Oxford and New York: Oxford University Press, 1999), p. 114.

13. Gilpin, *Remarks on Forest Scenery*, vol. 2, p. 225. Gilpin then cites "*Gray's memoirs*, page 360."

14. *Ibid.*, p. 226. See also James Plumptre, *The Lakers: A Comic Opera in Three Acts* (London: W. Clarke, 1798); facs. ed., Oxford: Woodstock Books, 1990), p. 19: "My Claude-Lorrain [glass]! It is a *deceptio visus*, an artifice to give the various tints of the changes of weather and season to the landscape."

15. Claude Lévi-Strauss, *The Savage Mind* (Chicago: University of Chicago Press, 1966), p. 50.

16. *Travail* (trave) derives from the vulgar Latin *trepalium*, a variation of *tripalium*, "instrument of torture," from the classical Latin *tripalis*, "with three posts": *Le Grand Robert de la langue française*, 2nd ed. (Paris: Dictionnaires Le Robert-VUEF, 2001), vol. 6, p. 1463.

17. Henri Matisse, "Interview with Charles Estienne, 1909," in Jack Flam (ed.), *Matisse on Art*, rev. ed. (Berkeley: University of California Press, 1995), p. 54.

18. Henri Matisse, "Interview with Léon Degand, 1945," in *ibid.*, p. 161: "I know where I want it to end up. The photos taken during the execution of the work permit me to know if the last conception conforms more to the ideal than the preceding ones; whether I am advancing or regressing."

19. *Déception* (disappointment) comes from the Latin verb *decipio*, whose root derives from *capio*, that is, "I take," but also *capere*, "to grasp," "to take hold of," "to contain," "to enclose," "to embrace." *Decipio* (*decipire*) means "to take," "to surprise," "to capture," "to deceive," "to abuse." See Félix Gaffiot, *Dictionnaire latin-français* (Paris: Hachette, 1934).

20. Pierre-Henri de Valenciennes, *Elémens de perspective pratique à l'usage des artistes, suivis de réflexions et conseils à un élève sur la peinture et particulièrement sur le genre du paysage* (1800; Geneva: Minkoff Reprint, 1973), pp. 254ff. That the moon is the mirror of the sun, whose reflected rays it attenuates, is an idea "deeply rooted . . . in the human mind,"of which Aristophanes is one of the first witnesses as in Nubes. See Jurgis Baltrušaitis, *Le Miroir: Essai sur une légende scientifique: Révélations, science-fiction, et fallacies* (Paris: Elmayan, 1978), pp. 45 and 255. What is interesting here is that a painter describes this principle and that, several pages later, he again uses this reductive principle in reference to the black mirror.

21. Moreover, the moon is a curved mirror. The lunar globe, like the convex mirror, shrinks the image of the sun, from which it reflects a silvery light during the night. It is a sun in reduction, a contracted image of the sun; see Baltrušaitis, *Miroir*, pp. 45ff. and 155ff.

22. *James Plumptre's Britain: The Journals of a Tourist in the 1790s*, ed. Ian Ousby (London: Hutchinson, 1992), p. 150.

23. William Gilpin, *Observations on the River Wye, and Several Parts of South Wales, &c. Relative Chiefly to Picturesque Beauty: Made in the Summer of the Year 1770*, 2nd ed. (London: Blamire, 1789), p. 39. Further on, the "clear and splendid" river becomes "ouzy [sic] and discoloured." And, Gilpin adds, "sludgy shores appeared, on each side; and other symptoms discover the influence of a tide" (p. 53). We recognize the sublime here in the movement of repulsion from the sea and its occult effects.

24. Jean-Claude Lebensztejn, *L'Art de la tache: Introduction à la "Nouvelle méthode" d'Alexander Cozens* (Montélimar: Limon, 1990), p. 129.

25. For a very long time, people slept in a sitting position rather than lying down, for the prone position was associated with the dead.

26. *Rejeté* (divided by a hyphen here) means literally "thrown back" but also "rejected," a sense that clearly evokes the idea of repression. — TRANS.

27. Lebensztejn, *L'Art de la tache*, p. 126.

28. Jacques Derrida, *Of Grammatology*, corr. ed., trans. Gayatri Chakravorty Spivak (Baltimore: Johns Hopkins University Press, 1998), pp. 150ff. I note in

passing that the long list of maladies caused by this dangerous supplement includes blindness. It would seem that Robert James was the first to make this connection in his Medicinal Dictionary, published in London in 1743–45, and translated into French by Diderot: "'Mastupratio or Manu Stupratio,' a vice that modesty does not allow one to name, and that results in terrible maladies, ordinary incurable. We have given in the Article Amaurosis a lengthy history of the fatal consequences of this abominable and unnatural practice." Amaurosis is "a malady of the eye. It is commonly called 'goute sereine.'" Robert James, *Dictionnaire universel de médecine, de chirurgie, de chymie, de botanique, d'anatomie, de pharmacie, d'histoire naturelle, &c.*, trans. Diderot, *Eidous et Toussaint*, ed. M. Julien Busson, Briasson, David l'aîné, 6 vols. (Paris: Durand,1746–48), vol. 4, p. 1186, vol. 1 p. 935.

29. As J.-C. Lebensztejn pointed out, the definition of the sublime formulated by Kant — who was however resolutely opposed to masturbation — is not after all without a certain homology with "la petite mort": the feeling of the sublime "is a pleasure that arises only indirectly: it is produced by the feeling of a momentary inhibition of the vital forces followed immediately by an outpouring of them that is all the stronger." Kant, *Critique of Judgment*, trans. Werner S. Pluhar (Indianapolis: Hackett, 1987), section 23, p. 98; Lebensztejn, *L'art de la tache*, p. 126.

30. Mason explains that Gray's descriptions were written in the form of letters addressed to a close friend, Dr. Thomas Wharton, who, following a violent attack of asthma, had to turn back and was unable to follow the poet on his visit to the Lake District. To console and amuse his bedridden friend, Gray decided to write these descriptions for him, which he sent in the form of a journal, so that their recipient could travel along with him and enjoy the same spectacles. See William Mason, *The Poems of Mr. Gray, to Which are Prefixed Memoirs of His Life and Writings*, 2nd ed. (London: H. Hughs, 1775), letter 4, Oct. 18, 1769, p. 350n.

31. John Dixon Hunt, "Picturesque Mirrors and the Ruins of the Past," *Art History*, Sept. 1981, pp. 254–70. The author evokes the exquisite solitude and the intimacy of the convex mirror that only Gray's eyes could contemplate, amplified by the gesture of turning his back to the landscape in order to see it in

the mirror (p. 258), but unfortunately he says no more about it. On the other hand, in a masterful study *Solitary Sex: A Cultural History of Masturbation* (New York: Zone Books, 2004), Thomas Laqueur gives three reasons for the disapproval of solitary sex as an unnatural act in the eighteenth century (which became an undeniable social fact around 1712, following the appearance in England of *Onania* by Dr. John Marten). First, fantasy sullies the imagination. Second, masturbation is perceived as excessive and addictive. Finally, onanism takes on a transgressive character that is of some interest to us here: this solitary and secret vice, a dark and perverse double of intimacy, constitutes a dangerous supplement for the private space that was then in the process of emerging: "Masturbation represented socially inappropriate and uncontrolled privacy," a subversion of the "realm of the private [which] was the basis for civil society in which individual interests negotiated and contained each other," (p. 226). In the same register of disturbing concomitants, Laqueur notes that it was also in 1712 that Joseph Addison, for whom "The Pleasures of the Imagination or Fancy" ought to be democratic, published in the Spectator his important essay with this title, the same year in which *Onania* denounced the negative counterpart of the imagination.

32. Cited in Mason, *Poems of Mr. Gray*, p. 360. Also cited by Gilpin, *Remarks on Forest Scenery*, vol. 2, p. 225.

33. Gilles Deleuze, *Difference and Repetition* (1968), trans. Paul Patton (New York: Columbia University Press, 1994), p. 227.

34. Pierre Klossowski, *Diana at Her Bath*, trans. Stephen Sartarelli (Boston: Eridanos, 1990), p. 52.

35. Ovid, *Metamorphoses*, trans. Frank Justus Miller (Cambridge, MA: Harvard University Press, 1956), bk. 3, ll. 138–252, pp. 134–43, esp. l. 193.

36. Jonathan Crary, *Techniques of the Observer: On Vision and Modernity in the Nineteenth Century* (Cambridge, MA: MIT Press, 1990), p. 131.

37. Derrida, *Of Grammatology*, p. 226.

38. Charles Chevalier, *Notice sur l'usage des chambres obscures et des chambres claires, contenant la description et l'emploi des meilleurs appareils de ce genre, des modifications dont ils ont été l'objet, ainsi que les mémoires publiés à ce sujet par le*

docteur Wollaston et le professeur Amici: documens utiles à toutes les personnes qui s'occupent du dessin d'après nature, recueillis et publiés par C. Chevalier avec quatre planches (Paris: V. et C. Chevalier, 1829), p. 86. See also Arnaud Maillet, "Le Mystère de la chambre claire: L'Oeil instrumentalisé de Jules-Romain Joyant," in *Sur la route de Venise: Jules-Romain Joyant, 1803–1854: Les Voyages en Italie du "Canaletto français"* (Paris: Somogy, 2003), esp. p. 107.

39. Jean H. Hagstrum, *The Sister Arts: The Tradition of Literary Pictorialism and English Poetry from Dryden to Gray* (Chicago: University of Chicago Press, 1958), p. 141.

40. Jean Starobinski, *The Invention of Liberty, 1700–1789*, trans. Bernard C. Swift (Geneva: Skira, 1964), pp. 117–18.

41. Both of these terms can be translated as "framing," but in French they have somewhat different meanings. *Cadrage* refers to the framing of an image as a process of selection and composition (in photography and film, where the term is most often used now, it is often translated as "shot"); *encadrement* refers both to the placement of a physical frame around a painting or photograph and, more generally, to the fact of containing a space or an image within a border (and thus turning it into a picture). I have included these terms in parentheses in the following section. — TRANS.

42. Sir John Robison, "Our Weekly Gossip," *Athenaeum: Journal of English and Foreign Literature, Science, and the Fine Arts*, June 8, 1839, p. 435.

43. Geoffrey Batchen, *Burning with Desire: The Conception of Photography* (Cambridge, MA: MIT Press, 1997), p. 74.

44. Crary, *Techniques of the Observer*, p. 16.

45. Thomas West, *A Guide to the Lakes: Dedicated to the Lovers of Landscape Studies* (London, 1778), in *A Guide to the Lakes in Cumberland, Westmorland, and Lancashire*, 3rd ed. (London: J. Robson and W. Pennington, 1784; facs. ed., Oxford: Woodstock Books, 1989), p. 12.

46. Ewa Lajer-Burcharth, *Necklines: The Art of Jacques-Louis David After the Terror* (New Haven, CT: Yale University Press, 1999), esp. p. 137. See also the critical review of this work that Jean-Claude Lebensztejn published in *Les Cahiers du Musée d'Art Moderne* 75 (Spring 2001), pp. 112–17.

47. He does not see it in the manner of those ancient Greeks who did not see sunspots, because they were incapable of explaining them, and finally refused to see them because, at bottom, these spots disturbed their conception of the world. And yet this phenomenon is a fundamental, even a banal given in Arab folklore and is easily observable in the desert under favorable conditions. Scientific thought is full of such prior decisions, as Jean Pelseneer argues; and Vasco Ronchi puts it plainly: "One sees what one wants." Such blinkers and blindness not only apply to scientists but seem quite simply human. Much as Pelseneer demanded a negative history of the sciences in this sense, it is interesting to see, with reference to artists, how men of genius affirmed their genius by creating things that were truly new. And yet at certain moments they recoiled; they did not go as far as one might expect them to. See *Le Soleil à la Renaissance: Sciences et mythes* (Brussels: Presses Universitaires de Bruxelles, 1965), pp. 161ff.

48. Jean-Claude Lebensztejn, *Zigzag* (Paris: Flammarion, 1981), pp. 340–41. For Valenciennes, nature is "framed [*encadrée*] on a flat surface" provided by the optical apparatus of the camera obscura; *Elémens de perspective pratique*, p. 295.

49. William Chambers, *An Explanatory Discourse by Tan Chet-Qua of Quang-Chew-Fu, Gent.* (1773; Los Angeles: Augustan Reprint Society, 1978), pp. 130–31.

50. Théophile Gautier, "Vues de Savoie et de Suisse de MM. Bisson frères," *Revue photographique* (1862), pp. 134–40. Reproduced, with no mention of this first publication, in the *Bulletin de la Société Française de Photographie*, June 1982, pp. 10–13.

51. Karl Gotthard Grass, *Fragment von Wanderungen in der Schweiz* (Zurich, 1797), p. 85, cited in Stephan Oettermann, *The Panorama: History of a Mass Medium* (New York: Zone Books, 1997), p. 33; *James Plumptre's Britain*, pp. 79 and 150.

52. Bicknell, *Illustrated Wordsworth's Guide to the Lakes*, pp. 13 and 61.

53. A mask is a piece of paper used for cropping photographs or film images. — TRANS.

54. Jean-Claude Lebensztejn, "A partir du cadre (vignettes)," *Annexes — de l'oeuvre d'art* (Brussels: La Part de l'Oeil, 1999), p. 198.

55. Charles-Alphonse Du Fresnoy, *L'Art de la peinture (De arte graphica)*, *traduit en françois, enrichy de remarques, & augmenté d'un "Dialogue sur le coloris"* par Roger de Piles, 2nd ed. (Paris: Nicolas Langlois, 1673), ll. 286–90, p. 47; *The Art of Painting by C.A. Du Fresnoy, with Remarks: Translated into English with an Original Preface, Containing a Parallel Between Painting and Poetry: by Mr. Dryden*, trans. John Dryden (London: Bernard Lintott, 1716), p. 41 (translation modified).

56. Francesco Colonna, *Hypnerotomachie*, f° 6v.

57. Pliny the Elder, *Natural History* 33.45.128–29 (Cambridge, MA: Harvard University Press, 1962), vol. 9, trans. H. Rackham, p. 97. The center of a convex mirror is "projecting," he adds.

58. The notion of surging forth (*surgissement*) is inseparable from the black mirror. It will be recalled that the magnetized or hypnotized person saw things "surge forth" from the instrument. For Jean Ray, it is at first "a beautiful blue clarity that surges forth from the depths of the mirror," but before long it is time for a creature to emerge from this mirror. (See "Le Miroir noir," in *Le Grand Nocturne: Les Cercles de l'épouvante* (Brussels: Actes Sud/Editions Labor, 1984), pp. 319ff

59. Quoted in Louis Marin, *To Destroy Painting*, trans. Mette Hjort (Chicago: University of Chicago Press, 1995), p. 130.

60. Abraham Bosse, *Traité des pratiques géométrales et perspectives, enseignées dans l'Académie Royale de la Peinture et Sculpture. Très utiles pour exceller en ces arts, et autres, où il faut employer la règle et le compas* (Paris, 1665), pp. 13, 16, 21. Certainly, the distinction made by Marin (in *To Destroy Painting*, esp. p. 160), taken up here, between the Arcadian space of the window and the arcanian space of the camera obscura is tempting, but it reduces the opposition between Bosse and Du Fresnoy in a way that is too Manichaean; as I have suggested in relation to the problem of the reduction of colors in small-format paintings, if the two theorists were often opposed, they also have an *aisthésis* in common, which, within the unity of their age, ensures a certain artistic coherence. It is in the articulation of a thought like this that the black mirror can be situated.

Chapter Fourteen: Devaluation

1. Witold Gombrowicz, *Cours de philosophie en six heures un quart* (Paris: Payot and Rivages, 1995), esp. p. 145. It might be interesting to link the Claude mirror with Kant's thought in other ways. Indeed, it was during the age of this great philosopher that this mirror was most in fashion. When Kant announced his Copernican revolution in the preface to the second edition of the *Critique of Pure Reason*, he did away with the harmony between the subject and the object, together with the theological principle that guaranteed this finality, replacing it with the principle of the object's necessary submission to the subject (see Gilles Deleuze, *Kant's Critical Philosophy*, trans. Hugh Tomlinson and Barbara Habberjam [London: Athlone, 1984], pp. 13–14 and 20). Kant calls this principle "transcendental," a term that could be seen as a portmanteau word: a transcendence that is horizontal. Thus, with Kant one no longer looks up, as it were; to know something, one looks directly at the object, for it is located on the same horizontal plane as the spectator. In this sense, the Claude mirror has something Kantian, something transcendental about it, in that it is an instrument that enables one to experience the distance between the subject and the object.

Moreover, the black mirror, which is like "day for night," recalls Kant's description of "the starry heavens above me," which, however, are not simply above me, since "I them see before me," as Kant hastens to add (*Critique of Practical Reason*, trans. Lewis White Beck [Indianapolis: Bobbs-Merrill, 1956], p. 166). The black mirror is this little starry sky, portable and exhibited before me, like the overcoat "pricked with a thousand holes" worn by Victor Hugo's beggar, who, in front of the fire, "seemed to be a black sky" ("*Le Mendiant*," in *Les Contemplations* [Paris: Nelson, 1956], ll. 18–21), or the "old screen with worn-out green taffeta decorating its feet" in George Sand, which, when one looked through, "produced little stars whose glow I increased by half-closing my eyes" (*Histoire de ma vie* [Paris: Calmann-Lévy, 1863–1926], vol. 2, p. 274). This comparison between night and the black mirror is a constant; it will be fully realized, for example, by Jean Ray: "The thin dark oval shone like a shred of nocturnal sky without moon or stars" ("Le Miroir noir," in *Le Grand Nocturne: Les Cercles*

de l'épouvante [Brussels: Actes Sud/Editions Labor, 1984], p. 319). Or more recently by Subcomandante Marcos: "The night is a black mirror in that way" ("The Devils of the New Century [Zapatista Children in the Year 2001, Seventh of the War Against Forgetting]," Mexico City, Feb. 2001, http://flag. blackened.net/revolt/ mexico/ezln/2001/marcos/devils_feb.html).

On the other hand, with this Copernican revolution Kant shows that there is a legislative aspect in the faculty of knowing. The subject, as a rational being, discovers his power as a legislator and commands nature. And as Eric Rohmer wrote, "Although Kant did not really foresee this, our conception of the relation between art and nature will, by the same token, be overturned. Nature will be no longer the guarantor of art but the inverse. And one can say, reversing Boileau's precept: 'Nothing is true but the Beautiful: that is, Art.' The objectivity of the model will be substituted, beginning at the dawn of Romanticism, with the subjectivity of the artist. It is henceforth the painter who makes the beauty of the world: this beauty exists only as thought by him, in him, and for him." Eric Rohmer, *De Mozart en Beethoven: Essai sur la notion de profondeur en musique* (Arles: Actes Sud, 1996), p. 22. From this perspective, as we have seen, the Claude mirror creates a painting from a landscape, and it is in this sense that we must think of it as a Kantian instrument. Thanks to this instrument, one can henceforth — after Kant — rethink the landscape.

Of course, Kant never said any of this literally. However, beginning with Kant, one can think this instrument in such a way. And when I say "beginning with," I am not referring to a temporal scale: those who used the mirror in this way in the eighteenth century, and perhaps even earlier, were Kantians in a sense. But rather than confront the vexed problem of chronology, I will simply recall Goethe's words to Johann Peter Eckermann on this question: "He [Kant] has influenced even you, although you have never read him; now you need him no longer, for what he could give you you possess already." Johann Wolfgang von Goethe, *Conversations with Eckermann*, trans. John Oxenford (1850; repr., San Francisco: North Point Press, 1984), p. 155. In other words, to be Kantian means simply to be modern.

2. Gombrowicz, *Cours de philosophie*, p. 146.

3. *Gerhard Richter*, 3 vols. (Bonn: Kunst- und Ausstellungshalle der Bundes-republik Deutschland; distributed by Paris Musées, 1993), vol. 1, pp. 156–57 and 190, no. 735-1: 280 x 165 cm, 1991. This mirror painted in gray is darker than the others.

4. Gerhard Richter, *The Daily Practice of Painting: Writings, 1962–1993*, ed. Hans-Ulrich Obrist, trans. David Britt (Cambridge, MA: MIT Press, 1995), pp. 225–26.

5. *Ibid.*, p. 226.

6. *Ibid.*, p. 99. This remark undoubtedly refers to a crystal mirror of 100 x 100 cm (no. 485-1 of *Gerhard Richter*).

7. On three occasions, Jacques-Louis David installed three of his major works by placing a psyche between the painting and the spectator, as we have already seen. This large mirror somehow "froze" (*glaçait*) the spectator, who then saw himself in a certain way reduced and inscribed into the painting and, by implication, enlisted in a process of citizen formation, particularly in the case of the *Sabines*. But if this "frozen image of a certain psychosexual coherence," provoked among other things by the nude — and the obligatory reference to Antiquity — participated in the production of a "social and political cohesive-ness," this did not happen without a repression provoked by this frozen aspect. See Ewa Lajer-Burcharth, "*Les Sabines*; ou, La Révolution glacée," in *David con-tre David*, 2 vols. (Paris: La Documentation Française, 1993), vol. 1, pp. 471–91.

8. Richter, *Daily Practice of Painting*, p. 108 (translation slightly modified).

9. *Ibid.*, p. 140. Jean-Philippe Antoine related to me an anecdote that is very much in line with this point of view. Philippe Thomas had told him, refer-ring to an exhibition he had organized with the group Les Ready-Made Appar-tiennent à Tout le Monde (Readymades belong to everyone), from December 7, 1990, to March 3, 1991, at the CAPC Musée d'Art Contemporain de Bordeaux, titled *Feux pâles* (Pale fires), that for the occasion Richter did not send a mirror but gave specifications for having one made. This mirror (1990) does not appear in his *catalogue raisonné*.

10. In 1987, the cultural center of Saint-Etienne proposed to John Knight and Louise Lawler that they share its exhibition space. Knight covered the entire

surface of the wall available to him, about 30 meters long, with seventeen "equal mirror panels, creating an almost seamless reflective curtain wall facing Lawler's installation." At the bottom of each panel was inscribed "UVC," which stands for "une vue culturelle (a cultural view)." This site-specific practice was designed "to avoid the formation of an aesthetic surplus." These mirrors are therefore situated at the " zero-degree of representation." See Claude Glintz, "From Site Specificity to Reflexiveness," in *John Knight: Une Vue culturelle: Exposition, 12.11.1987–16.1.1988* (Saint-Etienne: Maison de la Culture et de la Communication, 1987–1988), pp. 5–16.

11. Michelangelo Pistoletto exhibited a set of reflective metallic plates. These mirrors fix the attention by means of soft undulations on the metallic plates, which slightly deform the reflection. But Pistoletto also included trompe l'oeil objects or more often human figures on the front of his mirrors; these were painted on a paper support that was then applied to the mirror. The spectator is thus lost between his reflected image and that of the spectator painted in trompe l'oeil; he becomes his own looked-at reflection, while he also has the feeling of being looked at by the illusory reality of the spectator painted in trompe l'oeil. See, for example, *I visitatori* (1968), in Germano Celant (ed.), *Pistoletto* (Milan: Electa Firenze, 1984), pp. 49 and 190.

12. Gilles Deleuze and Félix Guattari, *A Thousand Plateaus: Capitalism and Schizophrenia* (1980; Minneapolis: University of Minnesota Press, 1987), esp. pp. 24–25 and 293–98.

13. 1 Corinthians 13.12, in *The New Oxford Annotated Bible* (New Revised Standard Version), ed. Bruce M. Metzger and Roland Murphy (New York: Oxford University Press, 1989), pp. 243 NT–244 NT.

14. See Richard Cork, "Through a Glass, Darkly: Reflections on Richter," in *Gerhard Richter: Mirrors* (London: Anthony d'Offay Gallery, 1991), p. 20.

15. Richter, *Daily Practice of Painting*, p. 171.

16. Jean-Luc Nancy, *Le Sens du monde* (Paris: Galilée, 1993), pp. 130–31.

17. Richter, *Daily Practice of Painting*, p. 225.

18. Nancy, *Sens du monde*, p. 131.

19. In this exhibition, Müller demonstrated how the proliferation of black

mirrors is inseparable from the multiple objects that were variously altered in order to produce them — inseparable, that is, from their plural aspect.

20. Personal letter, Jan. 15, 1999.

21. *François Perrodin* (Nice: Villa Arson, 1986), n.p.

22. Personal letter, Jan. 15, 1999.

23. *Ibid.*

24. Christian Boltanski exhibited *Les Images noires* for the first time in 1996 at the De Pont Foundation for Contemporary Art in Tilburg, Netherlands, then in 1997 at the Galleria d'Arte Moderna in Bologna, more recently in London at the Anthony d'Offay Gallery for the exhibition *Nightfall* (Jan. 30–March 7, 1998), and finally at the Musée d'Art Moderne in Paris, for the exhibition *Dernières Années* (May 15–Oct. 4, 1998).

25. In *Menschlich* (1994), fifteen hundred photographs provide a sort of last testament for people who have been completely forgotten, including even their names. Boltanski has stated that "being means having a name of one's own" (Christian Boltanski, *Dernières Années* [Paris: Musée National d'Art Moderne, 1998], n.p., from the section "Les Registres du Grand Hornu"). Nothing remains of them except their respective photographs. "The only thing one can say is that they were human, that is, different and unique" (from the section "Menschlich").

26. Similar perspectives are suggested by Eliane Burnet, "Dépouilles et reliques: Les Réserves de Christian Boltanski," in *Cahiers du Musée National d'Art Moderne* 62 (Winter 1997), pp. 57–61.

27. Christian Boltanski, *Dernières Années*, from the section "Tout ce qui reste de mon enfance."

28. This irremediable loss appears in other pieces: the artist had already "made photographs that were not fixed and that faded away as one looked at them, or objects in modeling clay called *Reconstitutions*, which crumble as soon as they are touched" (*ibid.*, from the section "Perdus").

29. *Ibid.*, from the section "Une Célébration en l'honneur des Suisses morts."

30. *Ibid.*, from the section "Les Portants et les lits."

31. *Ibid.*, from the section "La Paix des cimetières."

32. Adrianne Tooke, *Flaubert and the Pictorial Arts: From Image to Text* (Oxford: Oxford University Press, 2000), p. 20.

CHAPTER FIFTEEN: ABSTRACTION(S)

1. *Dictionnaire philosophique; ou, Introduction à la connoissance de l'homme*, new ed. (Paris: Durand, Guillyn, 1764), p. 1.

2. Piet Mondrian, "Toward the True Vision of Reality" (1941), in *The New Art — The New Life: The Collected Writings of Piet Mondrian*, ed. and trans. Harry Holtzman and Martin S. James (London: Thames and Hudson, 1987), p. 338.

3. Saint Augustine, *La Trinité* 2, "Les Images," 15.23.44–25.44 (Paris: Etude Augustiniennes, 1991), pp. 540–43. We might note that this distinction does not concern the visible. If "seeing through a mirror," as the Apostle says, is the only way to know that which is beyond the reach of the simple physical gaze, "seeing a mirror" refers not to this physical gaze but to a faulty and vain form of divine knowledge.

4. Bernard Marcadé, "La Peinture et son ombre," *Artstudio: Spécial Roy Lichtenstein* 20 (Spring 1991), pp. 122–31, esp. p. 130.

5. *Henri Matisse: The Early Years in Nice, 1916–1939* (Washington, DC: National Gallery of Art, 1986); John Elderfield, *Henri Matisse: A Retrospective* (New York: Museum of Modern Art, 1992), pp. 289ff.

6. Yve-Alain Bois, "L'Aveuglement," in *Henri Matisse, 1904–1917* (Paris: Centre Georges Pompidou, 1993), p. 26.

7. *Ibid.*, pp. 50 and 55.

8. Matisse to André Rouveyre, Dec. 16, 1943, in Pierre Schneider, *Matisse*, trans. Michael Taylor and Bridget Strevens Romer (New York: Rizzoli, 1984), p. 279.

9. Henri Matisse, *Ecrits et propos sur l'art*, ed. Dominique Fourcade, new ed. (Paris: Hermann, 1978), p. 105, n.60. The note this quote is from is not included with the English translation. — TRANS.

10. Bois, "Aveuglement," pp. 12–56; John Gage, *Colour and Meaning: Art, Science, and Symbolism* (London: Thames and Hudson, 2001), pp. 228–40.

11. Gage, *Colour and Meaning*, pp. 239–40.

12. Jean-Luc Nancy, *Le Regard du portrait* (Paris: Galilée, 2000), p. 77; see also pp. 71–83.

CHAPTER SIXTEEN: AN IRREMEDIABLE LOSS

1. Papus [Gérard Encausse], *Traité élémentaire de magie pratique*, 2nd ed. (Paris: Chamuel, 1893), pp. 177–78.

2. Edmund Burke, *A Philosophical Enquiry into the Origin of Our Ideas of the Sublime and the Beautiful* (1757; Oxford: Oxford University Press, 1990), p. 132.

3. Eliphas Lévi, *Histoire de la magie*, in *Secrets de la magie: Dogme et rituel de la haute magie; Histoire de la magie; La Clef des grands mystères*, ed. Francis Lacassin (Paris: Robert Laffont, 2000), p. 640.

4. Truman Capote, "Music for Chameleons," in *Music for Chameleons* (New York: Random House, 1980), pp. 7–8.

5. I do not know where Capote might have gotten this idea. I assume it is a literary fiction, a notion with which Françoise Cachin says she is inclined to agree.

6. Jean Renoir, *Renoir, My Father*, trans. Randolph Weaver and Dorothy Weaver (Boston, Toronto: Little, Brown and Co., 1962), pp. 318–19.

7. Jacques Derrida, *Memoirs of the Blind: The Self-Portrait and Other Ruins*, trans. Pascale-Anne Brault and Michael Naas (Chicago: University of Chicago Press, 1993), p. 32.

8. *Ibid.*, pp. 52–53. The blind spot is the very image of vision, of vision seeing itself see, for it is at the very moment when vision sees itself looking that it is blinded.

9. *Louche* means "dubious" or "suspect," as in earlier chapters, and is occasionally used in English in this sense; but its literal meaning is "cross-eyed." — TRANS.

10. Etienne-Jean Delécluze, *Précis d'un traité de peinture, contenant les principes du dessin, du modelé, et du coloris, et leur application à l'imitation des objets et à la composition; précédé d'une introduction historique, et suivi d'une biographie des plus célèbres peintres, d'une bibliographie, et d'un vocabulaire analytique des termes techniques* (Paris: Bureau de l'Encyclopédie Portative, 1828), p. 138.

11. Benjamin Pike, Jr., *Illustrated Descriptive Catalogue of Optical, Mathemat-*

ical, and Philosophical Instruments (New York, 1856), vol. 2, p. 193. See also Deborah Jean Warner, "The Landscape Mirror and Glass," *Magazine of Antiques*, Jan. 1974, p. 158.

12. Jean-Claude Lebensztejn, *Le Journal de Jacopo da Pontormo* (Paris: Aldines, 1992), p. 133.

13. Maurice de Gandillac recalls that if a lack of confidence in the eye was associated with an instrument that shows fallacious images, the distrust of optical instruments was even greater. *Le Soleil à la Renaissance: Sciences et mythes* (Brussels: Presses Universitaires de Bruxelles, 1965), p. 157.

14. William Gilpin, *Remarks on Forest Scenery and Other Woodland Views (Relative Chiefly to Picturesque Beauty); Illustrated by the Scenes of New-Forest in Hampshire*, 2 vols. (London: Blamire, 1791; repr., Richmond: Richmond Publishing Co., 1973), vol. 2, p. 226.

15. Michel Foucault, *The Order of Things: An Archaeology of the Human Sciences* (New York: Random House, 1970), p. 65.

16. Jonathan Crary, *Techniques of the Observer: On Vision and Modernity in the Nineteenth Century* (Cambridge, MA: MIT Press, 1990), p. 129.

17. Eugène Delacroix, *Ecrits sur l'art*, ed. Françoise-Marie Deyrolle and Christophe Denissel (Paris: Librairie Séguier, 1988), p. 59.

18. Horace Lecoq de Boisbaudran, *L'Education de la mémoire pittoresque et la formation de l'artiste. Précédé d'une notice sur la vie de l'auteur L.-D. Luard et d'une lettre de M. Auguste Rodin* (Paris: H. Laurens, 1920), p. 139.

19. *Ibid.*, p. 8.

20. Charles Baudelaire, "De la couleur" in "Salon de 1846," in *Oeuvres complètes*, ed. Claude Pichois (Paris: Gallimard, 1976), vol. 2, pp. 424 and 425.

21. If we can believe what Stanley Kubrick says about 2001: A Space Odyssey (and after all, are we not in the register of the fantasmatic?): the black monolith is in fact a mirror. This becomes visible during its second appearance, on the moon, when an astronaut reaches out his hand to touch it.

22. On the fascination of the hole and the relation that links the eye to the hole, I would refer in a general way to the work of Georges Bataille or Jean-Paul Sartre, for example, but also to Luis Buñuel, Lucio Fontana, and Marcel Duchamp.

See also *Fémininmasculin: Le Sexe de l'art* (Paris: Centre Georges Pompidou, 1995), esp. pp. 164ff.

23. Lévi, *Histoire de la magie*, p. 640.

24. On the notion of an interrogative apparition, see Jean-Paul Sartre, *Being and Nothingness*, trans. Hazel E. Barnes (New York: Washington Square Press, 1956), p. 787, and 3.1.4: "The Look," pp. 340–400; see also Jean-Paul Sartre, "The Paintings of Giacometti," in *Situations* (New York: George Braziller, 1965), p. 183.

25. Ambrose Bierce said that all mirrors are "vitreous": "A vitreous plane upon which to display a fleeting show for man's disillusion given." See "Looking-glass," in *The Devil's Dictionary* (Oxford and New York: Oxford University Press, 1999), p. 114.

26. Plato, *Timaeus* 71b; in *The Collected Dialogues of Plato*, eds. Edith Hamilton and Huntington Cairns (Princeton, NJ: Princeton University Press, 1961), p. 1194; *Republic* 10.596d–e in *ibid.*, p. 821; *Phaedrus* 255d in *ibid.*, p. 501; Apuleius, *Apologia* 15, in *The Apologia and Florida of Apuleius of Madaura*, trans. H.E. Butler (Oxford: Clarendon Press, 1909; repr., Westport, CT: Greenwood Press, 1970), p. 41; Diogenes Laertius, *Lives of Eminent Philosophers*, trans. R.D. Hicks (Cambridge, MA: Harvard University Press, 1959), vol. 1, "Socrates," p. 165.

27. Jean-Paul Sartre, "Venise de ma fenêtre," in *Situations, IV* (Paris: Gallimard, 1964), pp. 444–59. Edgar Allan Poe first made a comparison between the Grand Canal in Venice and the black mirror: the "pitchy darkness" of the Grand Canal is continued almost seamlessly on the water's edge by black marble that will become, a few lines later, a "black mirror of marble." Edgar Allan Poe, "The Assignation," in *Poetry and Tales* (New York: Library of America, 1984), p. 201. In several installations, the Canadian artist Richard Purdy explored the scenic possibilities of a black mirror made of a thin layer of water contained in a black geomembrane (La Caduta di Lucifero, 1991, Unrestored, 1995, 2005). This black aqueous mirror, which covers the entire floor of the exhibition space, allows one to see right side up the paintings hung upside down on the walls. The first title of this installation, Lucifer's Fall, perfectly translates the impression of an "endless fall through space and time" (like Alice's fall into the rabbit hole) produced by this "black water in which one cannot see the bottom." See

Richard Leydier, "Wandering into Richard Purdy's Maze," in Richard Purdy, *Unrestored* (Paris: Centre Culturel Canadien, 2005), pp. 40–41.

28. Personal letter, Jan. 15, 1999.

29. Gustave Flaubert, *Correspondance* (Paris: Gallimard, 1973), vol. 1, p. 209.

30. *Ibid.*, vol. 2, p. 279.

31. See Roger Gilbert-Lecomte, *Black Mirror*, trans. David Rattray (Barrytown, NY: Station Hill Press, 1991). One also finds a tremendous melancholy in the poem by Michael Ondaatje, *Claude Glass* (Toronto: Coach House Press, 1979), on the effects of wine and sangria in particular — yet another variation on the Claude glass — which "transports" the poet into the landscape of Spain (I am extremely grateful to Lars Kiel Bertelsen for bringing this to my attention, and for providing me with a copy of this text which is difficult to find).

32. Paul Sédir, *Les Miroirs magiques: Divination, clairvoyance, royaumes de l'astral, évocations, consécrations, l'Urim & le Thummim, miroir des Bhattahs, des arabes, de Nostradamus, de Swedenborg, de Cagliostro, etc.*, 3rd ed. (Paris: Librairie Générale des Sciences Occultes, Bibliothèque Chacornac, 1907), pp. 43 and 21.

33. Armand Delatte, *La Catoptromancie grecque et ses dérivés* (Liège: H. Vaillant-Carmanne; Paris: E. Droz, 1932), p. 99.

34. Jean Starobinski, *Histoire du traitement de la mélancolie des origines à 1900* (Basel: Dokumenta Geigy, 1960), pp. 67ff.

35. Jean Starobinski is also attracted to this hypothesis (personal letter, Jan. 5, 1999).

36. For the occultists, the astral body is made of desire.

37. Sédir, *Miroirs magiques*, pp. 58 and 56.

38. Jean Starobinski, *La Mélancolie au miroir: Trois lectures de Baudelaire* (1989; Paris: Julliard, 1997), esp. pp. 19, 36, 44, 49; Raymond Klibansky, Erwin Panofsky, and Fritz Saxl, *Saturn and Melancholy: Studies in the History of Natural Philosophy, Religion, and Art* (New York: Basic Books, 1964).

39. Arnold Böcklin, *Melancholia*, 1885–1900, oil on canvas, 142.5 x 100 cm, Kunstmuseum, Basel. It is quite strange that Jean Starobinski, with whom I had discussed the relation between the black mirror and melancholy, did not think of this painting, which is nonetheless reproduced in his study on "melancholy in

the mirror"! For my part, I knew the painting precisely from this reproduction, but I had failed to notice this striking detail, which only occurred to me when viewing the painting in Basel.

40. Max Milner, *On est prié de fermer les yeux: Le Regard interdit* (Paris: Gallimard, 1991); Carl Havelange, *De l'oeil et du monde: Une Histoire du regard au seuil de la modernité* (Paris: Fayard, 1988).

41. As Jean Starobinski suggested to me, "Our imagination and our interpretations can without doubt supplement what the interested parties did not say." This unsaid is what flows through the abyssal gap opened by the black mirror, and it thus remains, because of this flowing and fluctuating quality, properly unnameable.

Index

Zone Books series design by Bruce Mau
Typesetting by Archetype
Image placement & production by Julie Fry
Printed and bound by Maple-Vail